HISTORIC PHOTOS OF
MAINE

TEXT AND CAPTIONS BY FRANCES L. POLLITT

TURNER
PUBLISHING COMPANY
NASHVILLE, TENNESSEE PADUCAH, KENTUCKY

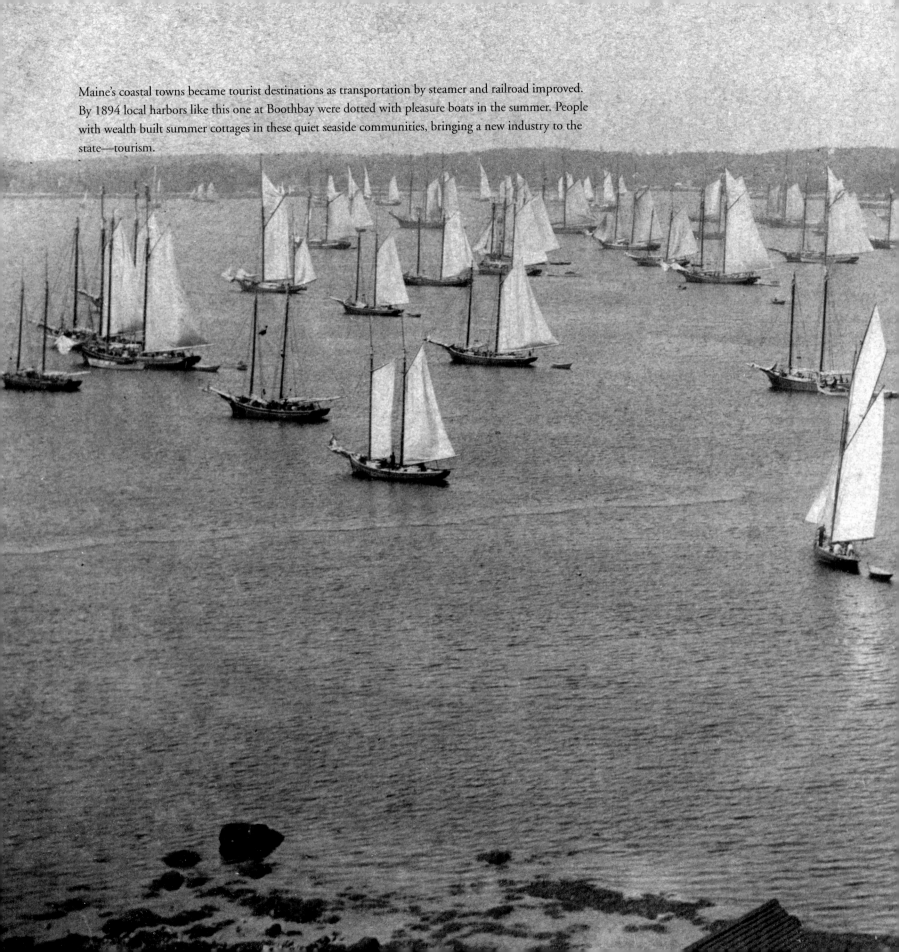

Maine's coastal towns became tourist destinations as transportation by steamer and railroad improved. By 1894 local harbors like this one at Boothbay were dotted with pleasure boats in the summer. People with wealth built summer cottages in these quiet seaside communities, bringing a new industry to the state—tourism.

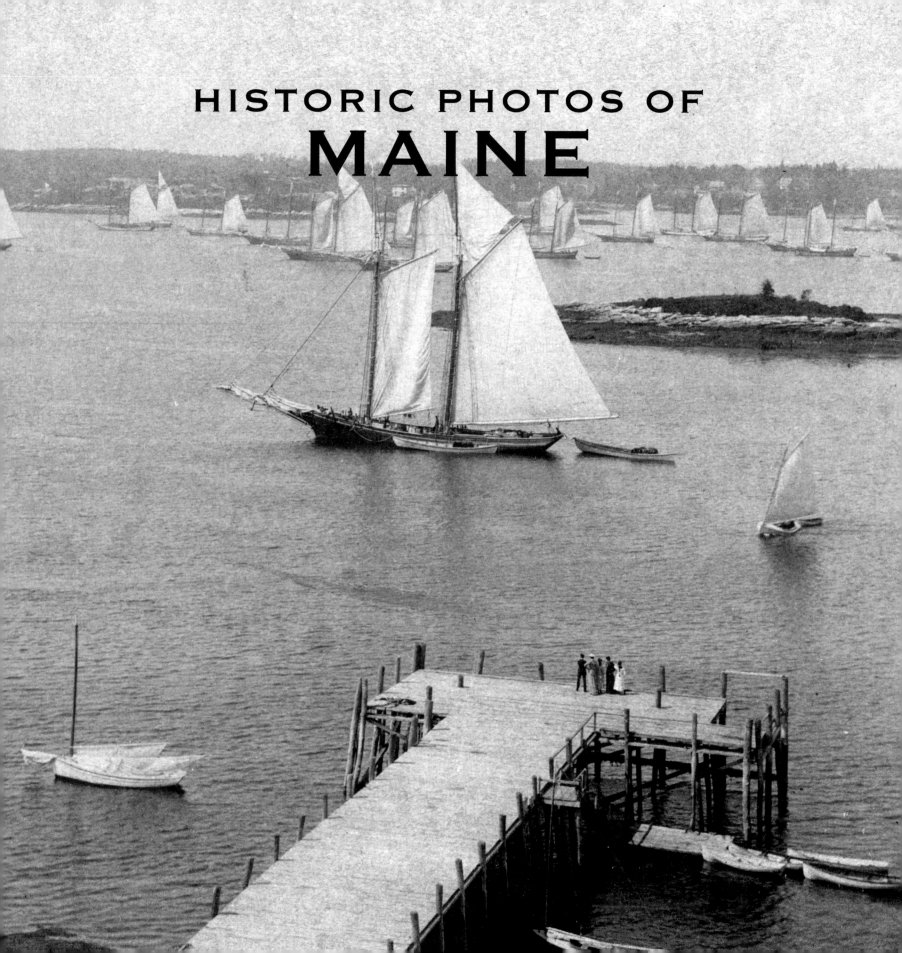

HISTORIC PHOTOS OF
MAINE

Turner Publishing Company
200 4th Avenue North • Suite 950 412 Broadway • P.O. Box 3101
Nashville, Tennessee 37219 Paducah, Kentucky 42002-3101
(615) 255-2665 (270) 443-0121

www.turnerpublishing.com

Historic Photos of Maine

Library of Congress Control Number: 2007938666

ISBN-13: 978-1-59652-425-5

Printed in the United States of America

08 09 10 11 12 13 14 15—0 9 8 7 6 5 4 3 2 1

CONTENTS

ACKNOWLEDGMENTS.. VII

PREFACE .. VIII

LAND AND PEOPLE
(1865–1899) .. 1

THE MAINE ATTRACTION
(1900–1919) .. 51

BETWEEN THE WARS
(1920–1939) .. 103

LIVING IN MAINE
(1940–1980)... 159

NOTES ON THE PHOTOGRAPHS .. 201

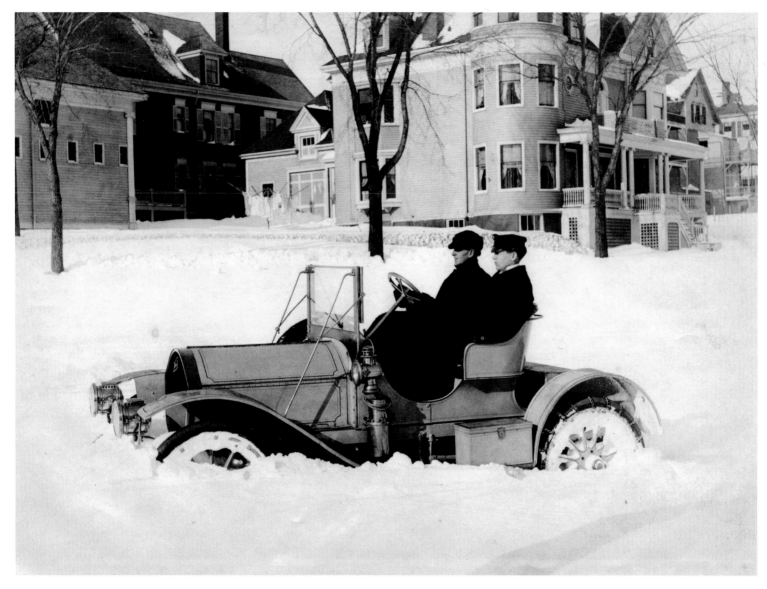

Racecar driver A. L. Dennison with passenger E. H. Cushman of the Portland Company confront a snowdrift in their runabout in 1907. The locale is Portland's Eastern Promenade near the company's facilities on Commercial Street. The next year the Portland Company became the exclusive Maine distributor of Knox automobiles.

ACKNOWLEDGMENTS

This volume is the result of the cooperation and efforts of many individuals and organizations. It is with great thanks that we acknowledge the following for their generous support:

Blethen Maine Newspapers

Library of Congress Prints and Photographs Division

Maine Historical Society

Maine Memory Network

Sanford Historical Committee

Seashore Trolley Museum

We would also like to thank William David Barry, of the Maine Historical Society Research Library, for his valuable contributions and assistance in making this work possible.

PREFACE

Maine has thousands of historic photographs that reside in archives, both locally and nationally. This book began with the observation that, while those photographs are of great interest to many, they are not easily accessible. During a time when Maine is looking ahead and evaluating its future course, many people are asking, How do we treat the past? These decisions affect every aspect of the state—architecture, public spaces, commerce, infrastructure—and these, in turn, affect the way that people live their lives. This book seeks to provide easy access to a valuable, objective look into the history of Maine.

Although the photographer can make decisions regarding subject matter and how to capture and present it, photographs, unlike words, seldom interpret history subjectively. This lends them an authority that textual histories sometimes fail to achieve, and offers the viewer an original, untainted perspective from which to draw his own conclusions, interpretations, and insights.

This project represents countless hours of review and research. We greatly appreciate the generous assistance of the individuals and organizations listed in the acknowledgments, without whom the project could not have been completed.

The goal in publishing this work is to provide broader access to these extraordinary images, to inspire, furnish perspective, and evoke insight that might assist those who are responsible for determining the future of Maine. In addition, we hope that the book will encourage the preservation of the past with adequate respect and reverence.

With the exception of cropping images where needed and touching up imperfections that have accrued over time, no other changes have been made. The caliber and clarity of many photographs are limited by the technology of the day and the ability of the photographer at the time they were made.

The work is divided into eras. Beginning with some of the earliest known photographs of Maine, the first section records photographs through the end of the nineteenth century. The second section spans the beginning of the twentieth century

through the World War I era. Section Three offers a glimpse of the years between the wars, and the last section covers the World War II era to recent times.

In each of these sections we have made an effort to capture various aspects of life through our selection of photographs. People, commerce, transportation, infrastructure, religious institutions, and educational institutions have been included to provide a broad perspective.

We encourage readers to reflect as they encounter the state of Maine, its cities, its countryside, and its unique qualities. It is the publisher's hope that in utilizing this work, longtime residents will learn something new and that new residents will gain a perspective on where Maine has been, so that each can contribute to its future.

Todd Bottorff, Publisher

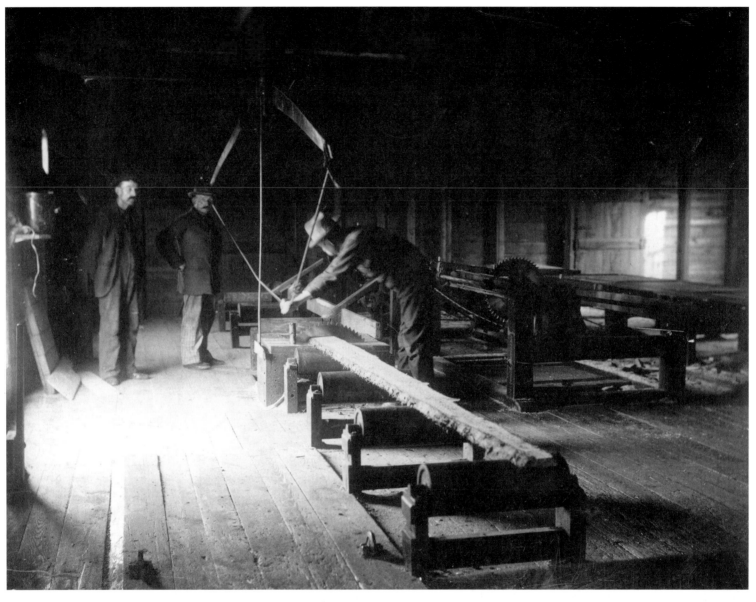

This interior view of men working in one of the J. G. Deering & Son lumber mills in Biddeford around 1880 gives us a glimpse into how work was done without the aid of electricity. The tools in this mill were powered by the Saco River and daylight through the door provided illumination.

LAND AND PEOPLE

(1865–1899)

The light of dawn touches Maine first, of all the fifty United States. The honor goes in winter to Mount Cadillac, in spring and fall to Mount Katahdin, and in summer to Mars Hill. The People of the First Light—the Wabanaki—enjoyed the abundance of food found in the forests, sea, and shore, migrating through Maine with the seasons.

Maine, or Norumbega, as it was called in the age of European discovery, was completely covered in deep forests with five large rivers leading to the sea. Ocean sailors reported that for several miles around their ships, the calm sea was alive with fish. By the mid 1500s, Wabanakis and Europeans were engaged in a lively interchange of cultures and economies—fishing, fur trapping, and trading with each other.

By the time photography was introduced in the 1840s, Maine had achieved statehood, having separated from Massachusetts in 1820. Industries such as shipbuilding, shipping, railroad building and metalworking, fishing and lumbering, and water-powered mills for shoes, textiles, and tanning were in full swing, providing the livelihood for most Mainers. In 1828, African Americans established the Abyssinian Church in Portland as a reaction to prejudice in established churches. Irish immigrants were arriving in large numbers because of the potato famine in Ireland. Then in 1861 war broke out within the United States, threatening the union. Maine citizens volunteered to fight in the Civil War in order to preserve the union and abolish slavery.

After General Joshua Chamberlain and the troops of the 20th Maine witnessed the ending of the war in April 1865, Maine returned to its peacetime economies. Maine's forests were cut for lumber and paper, the rivers were dammed for power, fish and vegetables were canned, transportation became easier, potato farming took root in Aroostook County, and thousands of French Canadians were admitted south to work in the mills. Louis Sockalexis, a Penobscot Indian, was the first native American signed to a major league baseball team, and the first-known peace flag was raised in Eliot in 1894.

Nature, transportation, the movements of peoples, and sweeping social and political events were shaping Maine and marking her people as independent, self-reliant, provincial, and cosmopolitan.

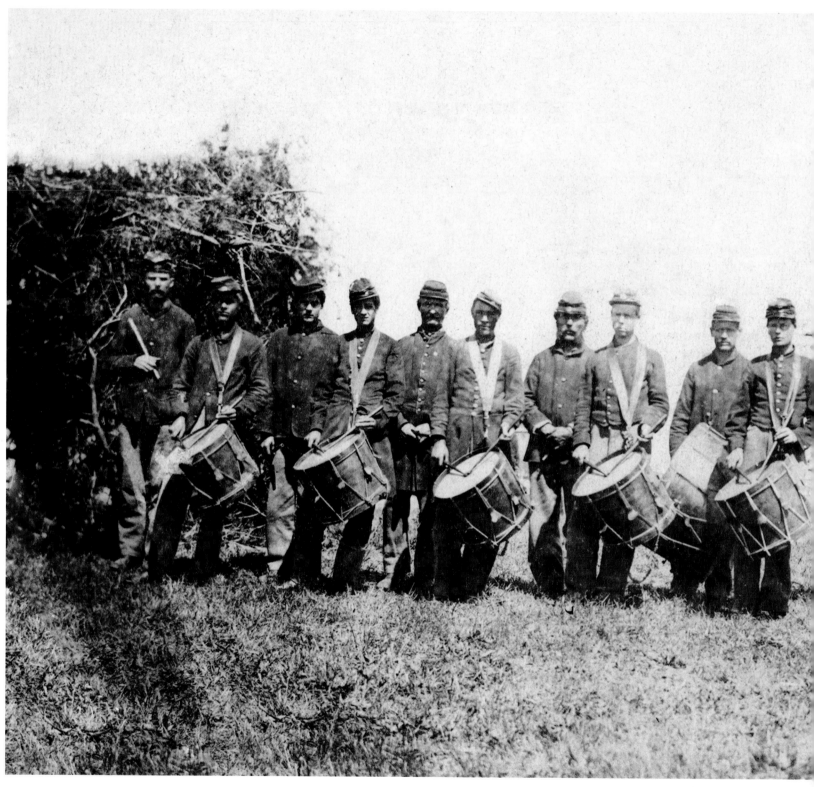

2

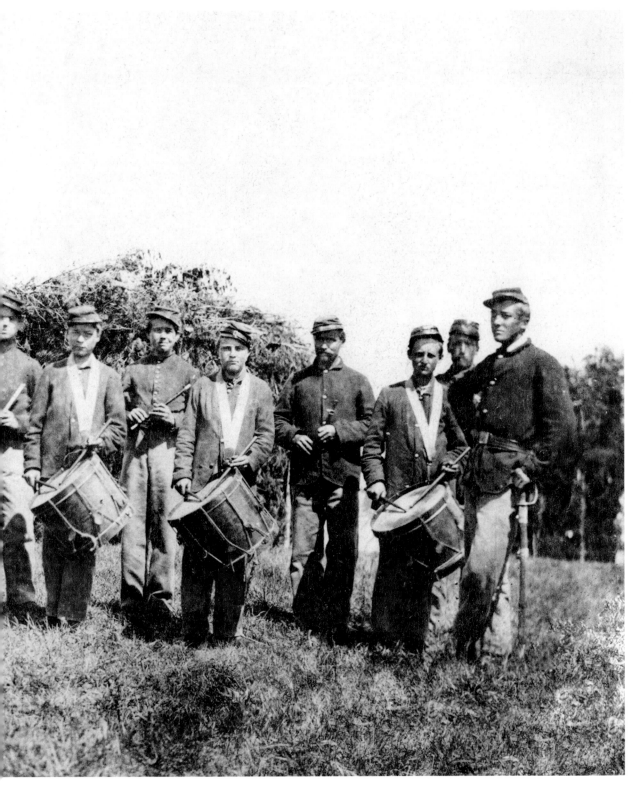

The 30th Maine Drum and Fife Corps members assembled for this 1865 photograph at an unknown location. Daniel Skilling (fourteen years old) of Portland is standing at far-right. Other members of the corps included teenagers from Palmyra, Lewiston, Bethel, Lebanon, Acton, Skowhegan, and Buckfield and forty-four-year-old Jacob Keane of Turner. The regiment fought in seven battles in Louisiana and Virginia.

Joshua L. Chamberlain was made major general in the Union Army in March 1865. Maine-born and Bowdoin College–educated, he served valiantly during the Civil War, being wounded six times. He is remembered for his role in holding the Federal line at Little Round Top during the Battle of Gettysburg, and for his honorable treatment of the soldiers under his command and of Confederate troops, at the moment of their surrender on April 12, 1865, at Appomattox Court House. Chamberlain had his men stand at attention and salute the Confederate soldiers as they passed by.

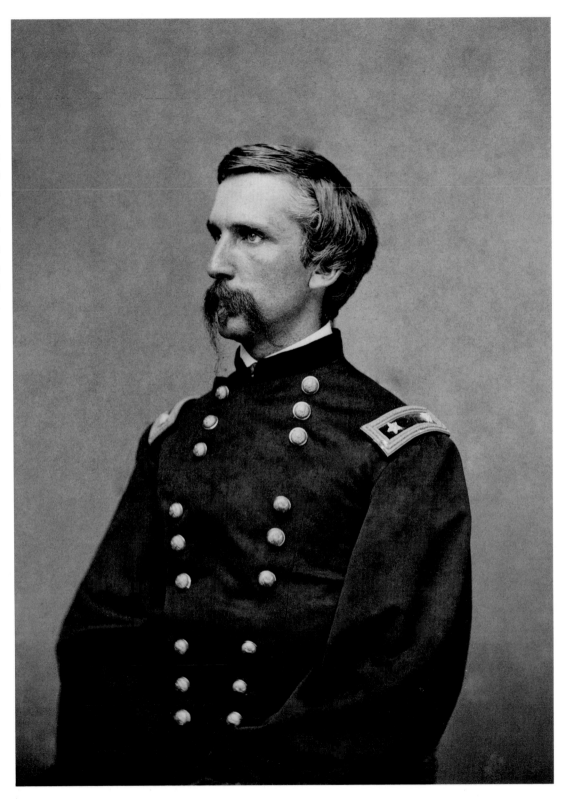

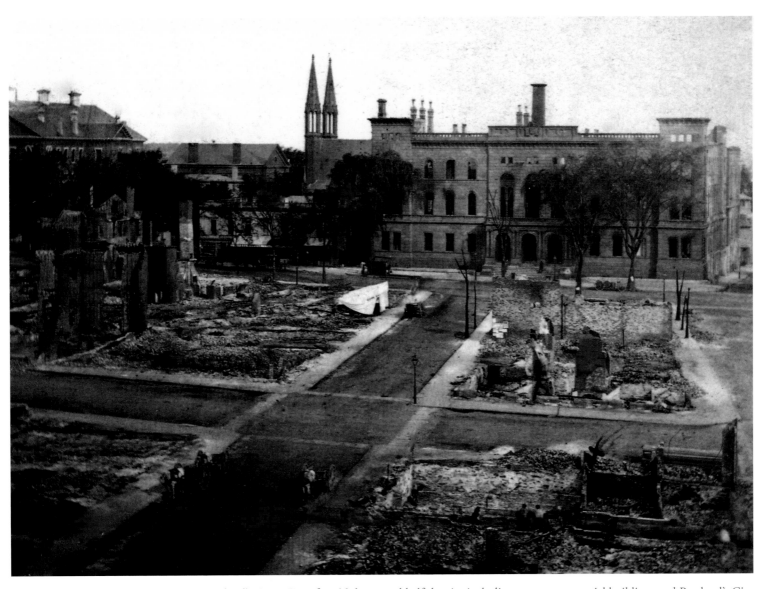

Portland's Great Fire of 1866 devastated half the city including many commercial buildings and Portland's City Hall downtown. The fire was started by either stray fireworks or a cigar on July 4. Ten thousand residents were left homeless and 2,000 buildings were destroyed. Afterward, the city installed a fire alarm system, and in 1868 contracted to pipe in water from Sebago Lake.

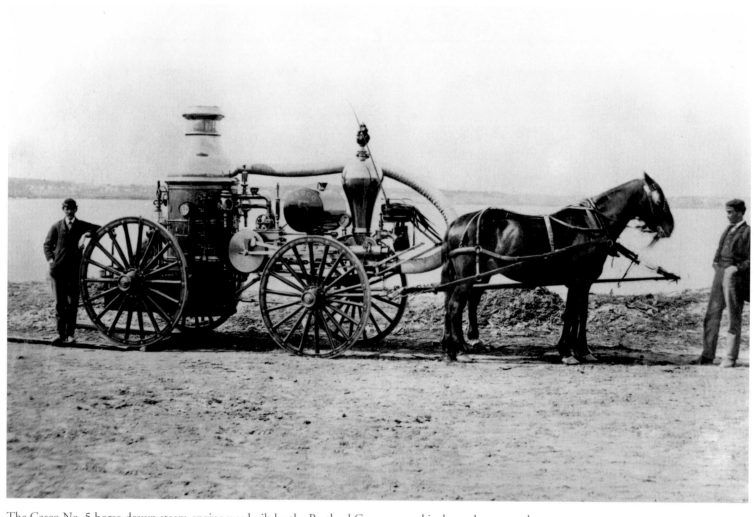

The Casco No. 5 horse-drawn steam engine was built by the Portland Company and is shown here near the company's facilities along the Portland waterfront at the moment it was rolled out of the shop in 1864. It cost $3,200 and could pump 400 gallons a minute. The engine was destroyed while battling the Great Fire of 1866.

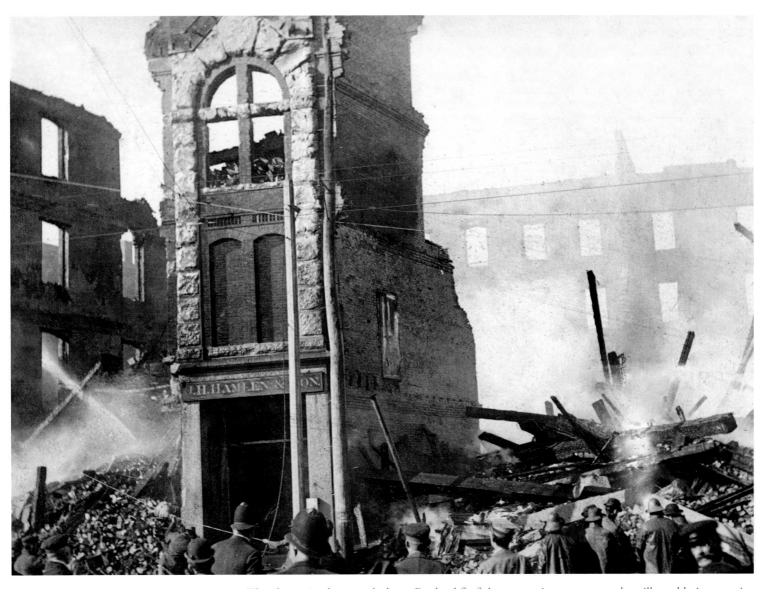

This dramatic photograph shows Portland firefighters spraying water onto the still smoldering remains of the J. H. Hamlen & Son building at 293 Commercial Street during the Great Fire of July 4, 1866, which destroyed a large section of the city. J. H. Hamlen & Son was a thriving cooperage company that supplied wooden parts and fittings for ships.

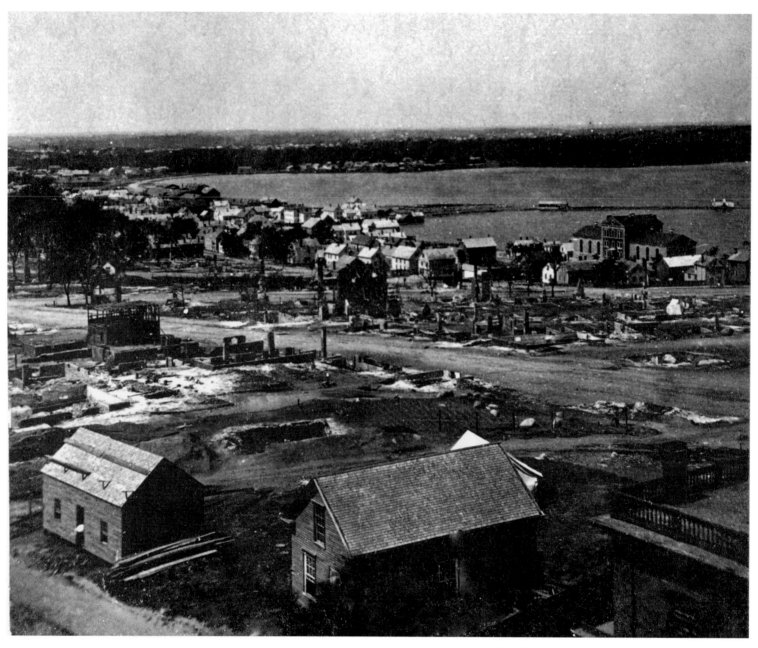

Photographers traveled from great distances to capture the dramatic scenes of destruction after Portland's Great Fire. Stereographs like the one from which this image is derived were very popular at the time. The photographer John P. Soule was standing on top of the Portland Observatory looking westerly over Munjoy Hill when he captured this image on July 12, 1866.

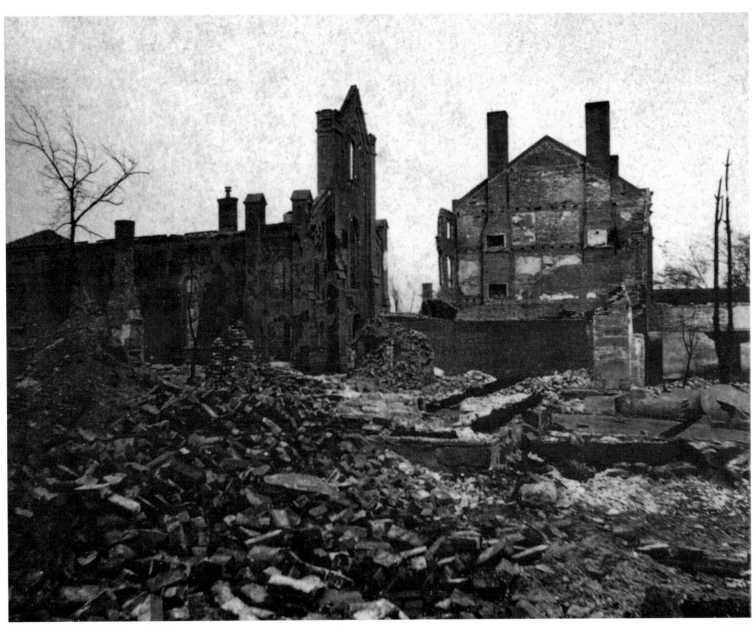

St. Stephen's Episcopal Church lies in ruins seven days after the Great Fire of 1866 that swept across Portland. High winds spread the flames from west to east across the city, making it the worst urban fire in America up to that time.

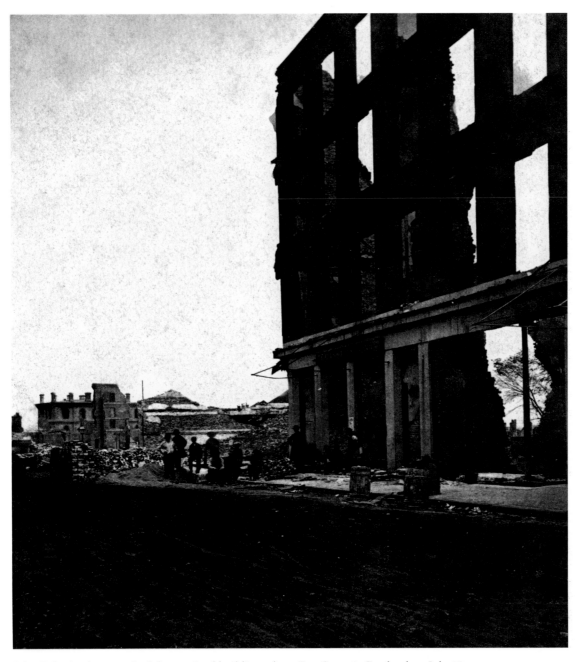

John P. Soule photographed these ruined buildings along Free Street in Portland on July 12, 1866, after the July 4 fire.

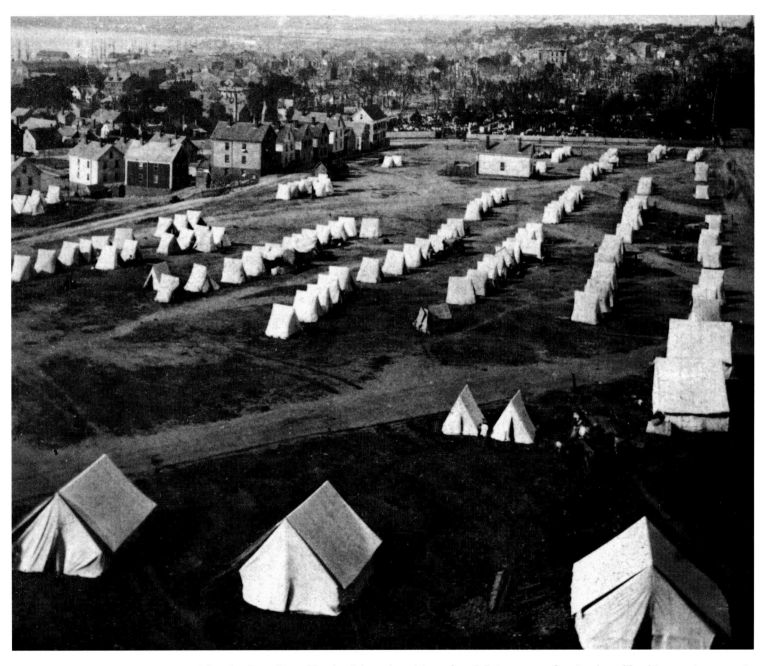

After the Great Fire of Portland, homeless citizens found their way to refuge in places like this tent city, set up in the Munjoy Hill neighborhood. The tents were provided by the U.S. Government. This image was captured by John P. Soule on July 12, 1866, seven days after the blaze. Soule went on to photograph the same subject, after the Great Boston Fire of 1872.

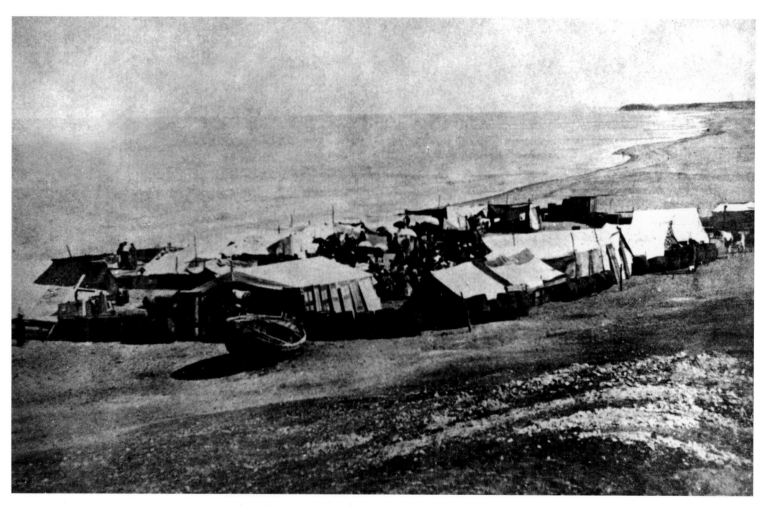

On this beach along the Mediterranean Sea near Jaffa, Palestine (now Israel), in September of 1866 is the tent encampment of the 156 religious settlers from the Jonesport, Maine, area, who went there to await the second advent of the Messiah. Known as the Jaffa Colony, all but 54 persons perished. The colony disbanded two years later.

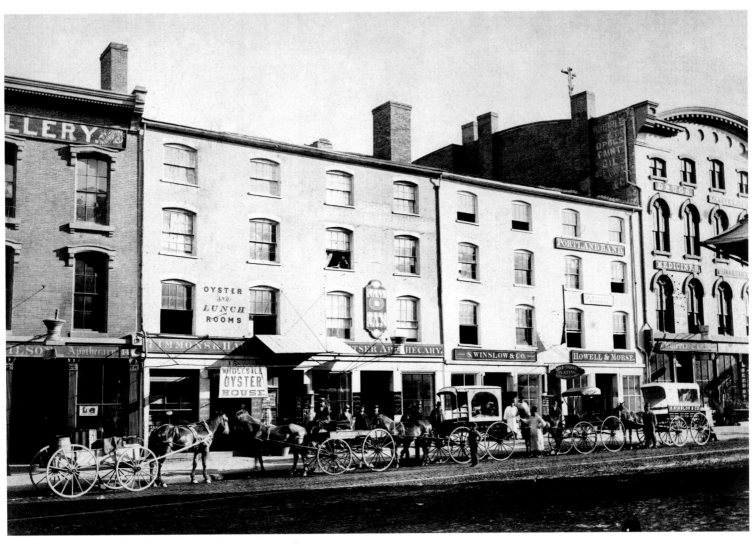

Carriages and shops line a section of Congress Street in the 1870s, known then as Market Square but now called Monument Square. Shown here are storefronts for a photography studio; Luther C. Gilson, Apothecary; an Oyster House; Francis Sweetser, Apothecary; S. Winslow & Co.; and Howell & Morse. A thoughtful observer looks over the scene from a second-floor window.

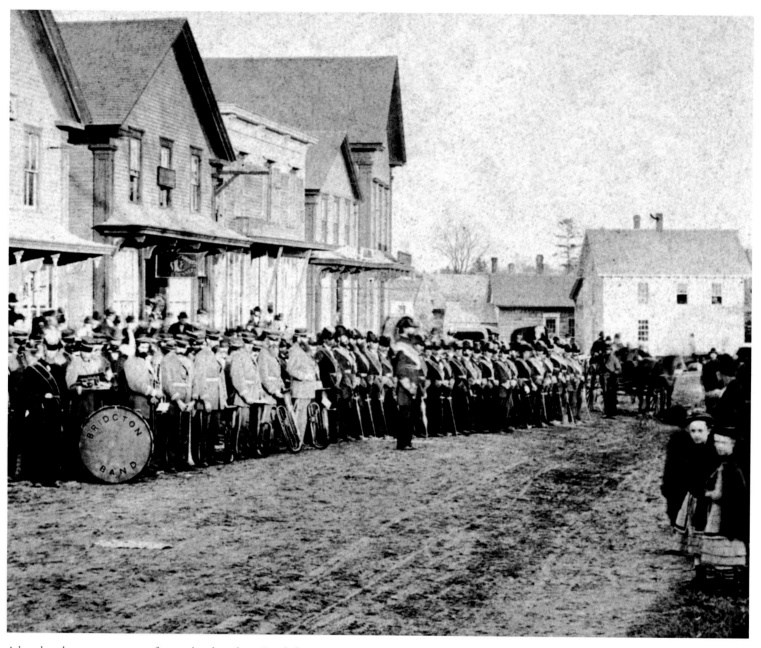

A band and young spectators face each other along Pondicherry Square in Bridgton sometime during the 1870s. Two bands were active at this time in Bridgton: the Bridgton Cadet Band and the Bridgton Brass Band. The Union and Confederate armies used drum-and-bugle corps to communicate to the troops. After the Civil War ended in 1865, those same musicians carried the music on by participating in these local bands.

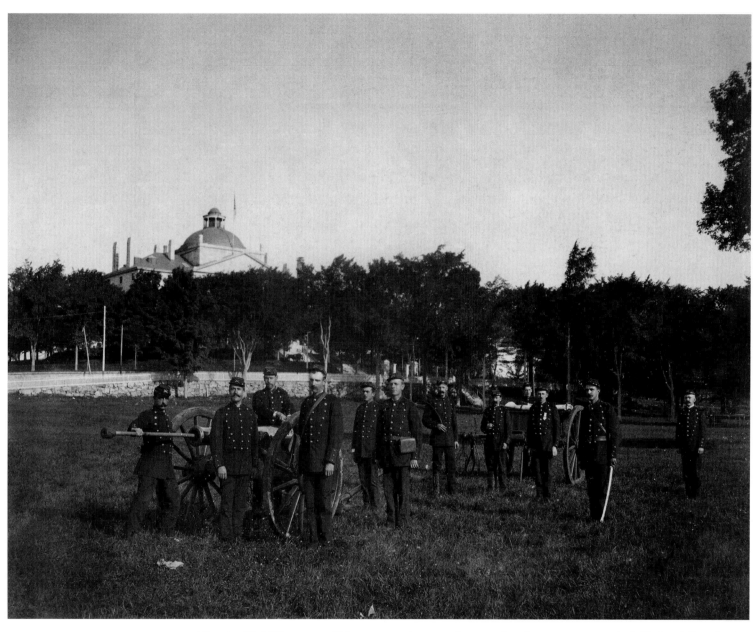

After the Civil War, state militias regrouped to serve in somewhat the same way as today's National Guard units. Sometime in the 1870s near the state capitol at Augusta, Maine's Militia poses with artillery pieces.

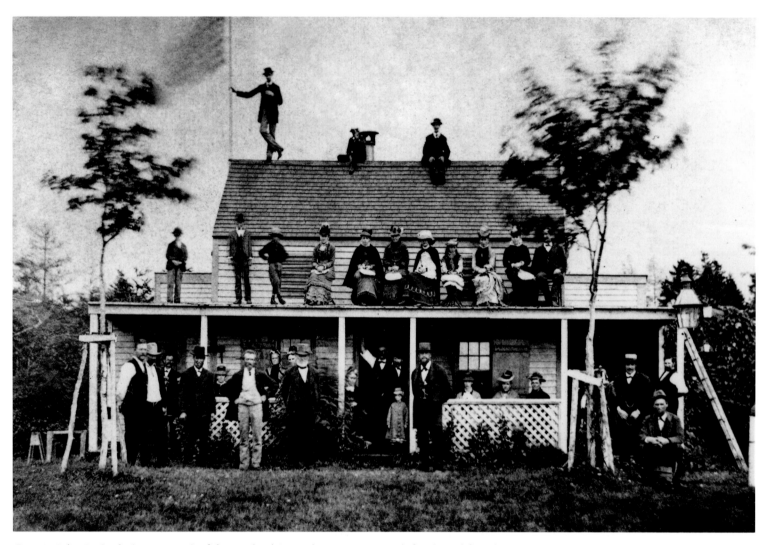

Captain John B. Coyle (1805–1885) of the Portland Steamship Line poses with family and friends at a cottage along the Nonesuch River in Scarborough around 1871. Posing at rooftop for formal photographs was common at the time—this group is flaunting the idea.

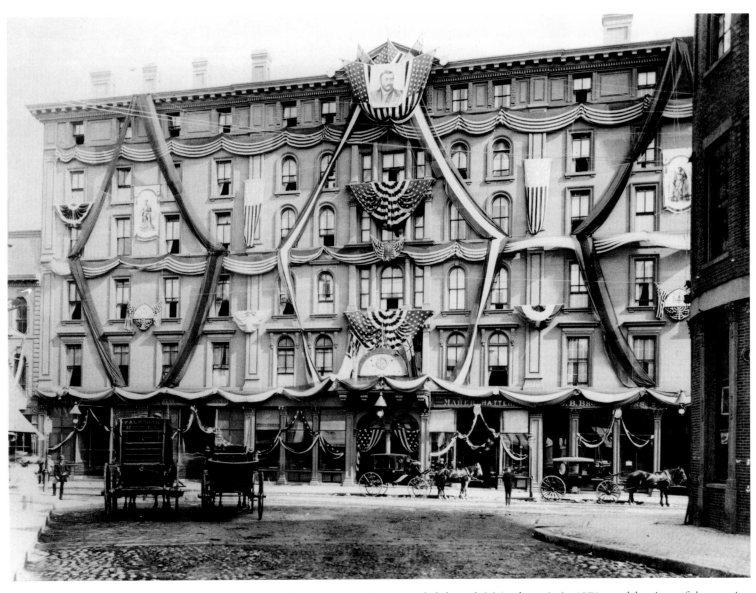

President Ulysses S. Grant traveled through Maine by train in 1871 to celebrations of the opening of a section of the European and North American Railway in Bangor and at the international boundary with New Brunswick. The Falmouth Hotel in Portland welcomed the president by decorating its large facade with patriotic bunting.

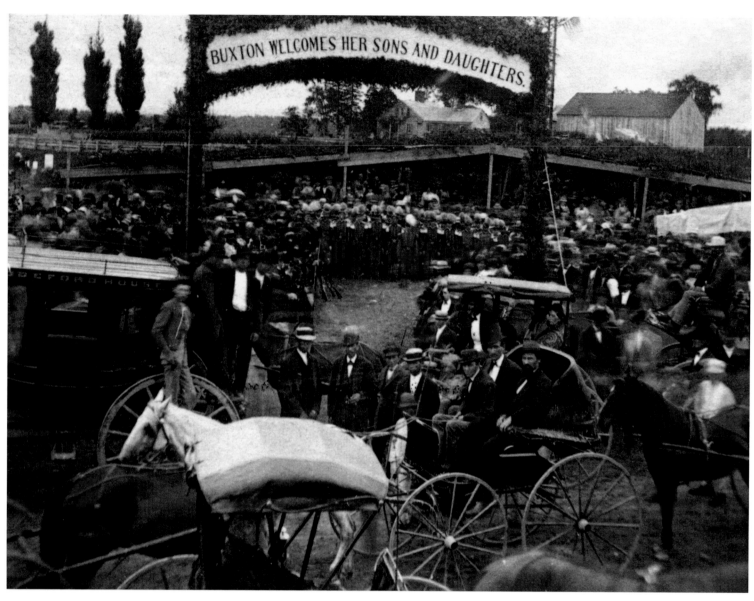

On August 14, 1872, Buxton celebrated its 100th year by having a large centennial celebration with ornate arches, decorations, a feast, and many speeches by dignitaries, including General Joshua L. Chamberlain (1828–1914) and Cyrus Woodman (1814–1889). Townspeople worked for two days before the event to prepare enough food for approximately 4,000 attendees.

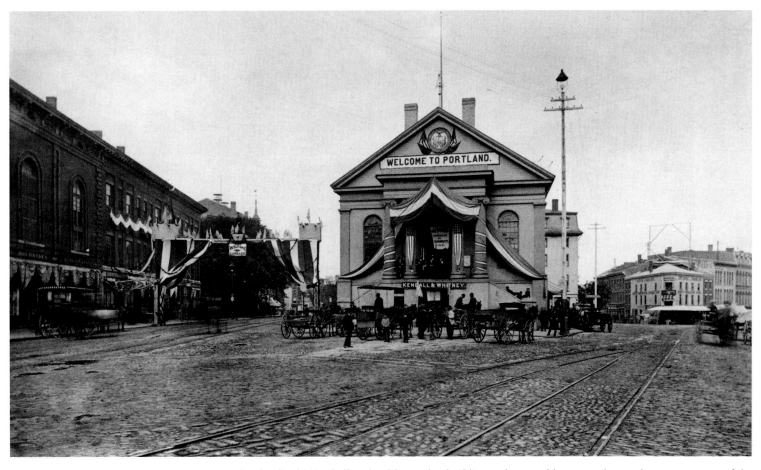

Portland's old city hall and public market building is decorated here to welcome the encampment of the Grand Army of the Republic around 1879. The G.A.R. was a fraternal organization composed of veterans of the Union Army. This area is now part of Monument Square, and the "new" city hall is located farther north along Congress Street.

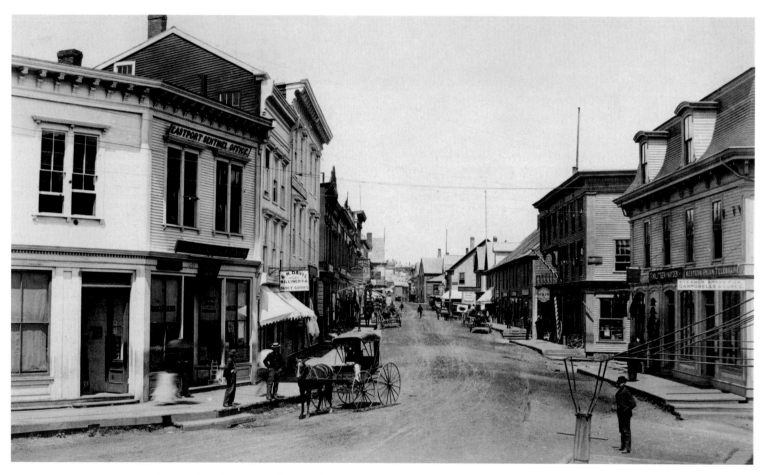

In this view from around 1880, downtown Eastport could boast having the *Eastport Sentinel* newspaper, a public library, banks, a telegraph office, a United States signal station, the port for two steamship lines, and the end of the stage line to Calais and Machias. Between 1833 and 1875, Eastport had become a thriving shipbuilding and shipping port. Sardine canning was just emerging as an industry—in 1882, 18 canneries were in operation here.

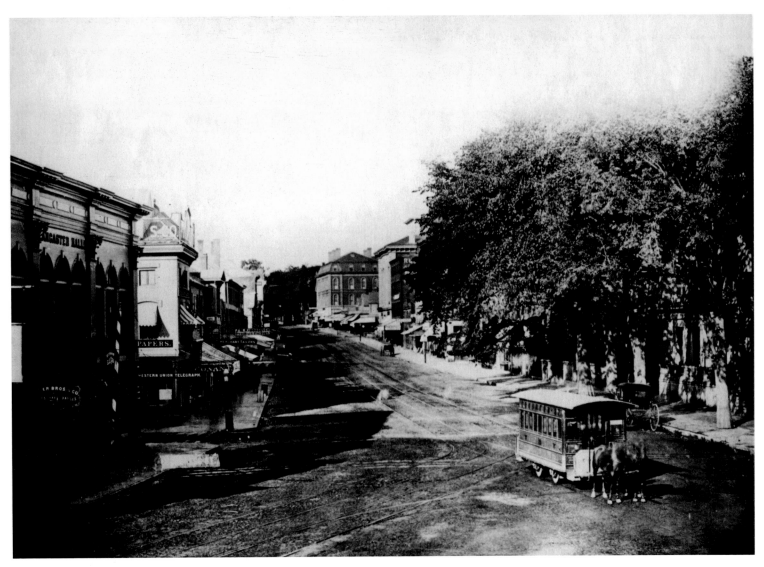

This area of Congress Street in Portland around 1885 shows a horse-drawn trolley passing the Wadsworth-Longfellow House. On October 12, 1863, the Portland and Forest Avenue Railroad opened for service. The fare from India Street to the end of the line at Clark Street was 5 cents. Horses were worked half a day and on every third day rested.

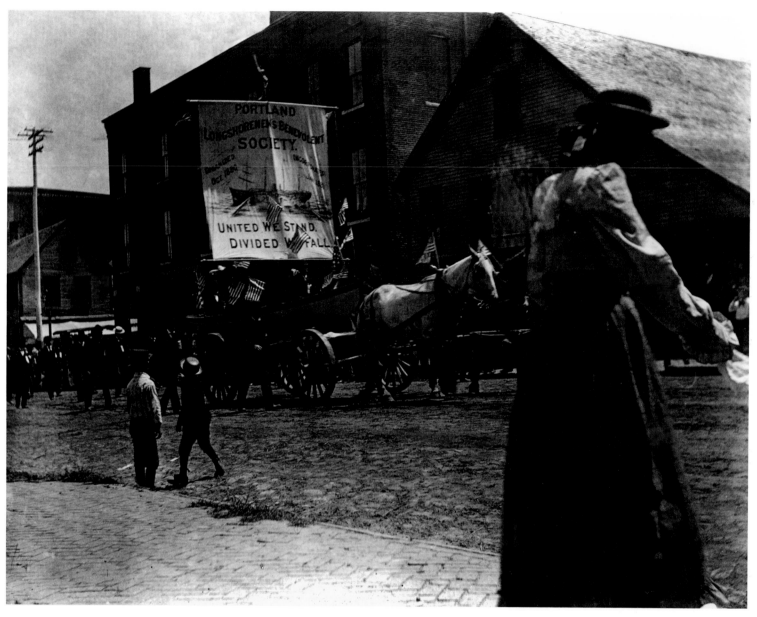

Predominantly Irish in membership, the Portland Longshoremen's Benevolent Society was organized in 1881. Because Portland served as Canada's "winter port," this dockworkers union had close ties with unions in Montreal. Flying the Stars and Stripes and proclaiming "united we stand, divided we fall," the society's 1881 parade float is shown here rolling down Cumberland Avenue.

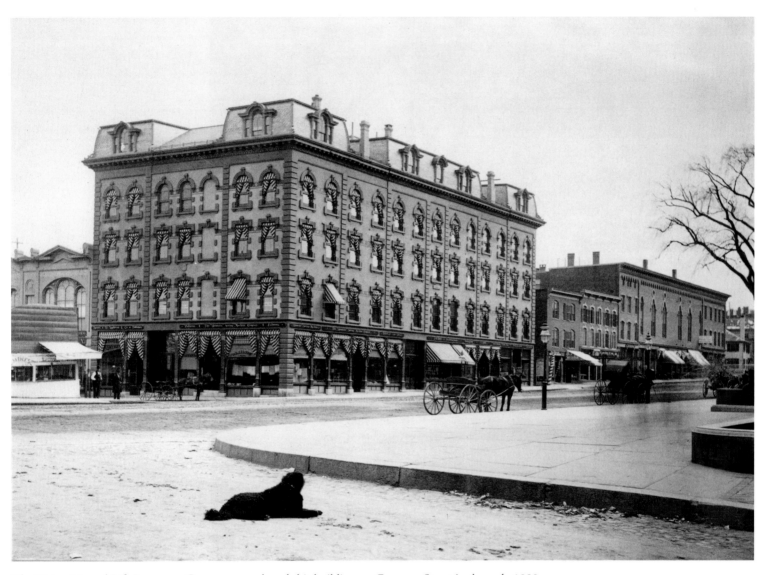

The Union Mutual Life Insurance Company purchased this building on Congress Street in the early 1880s when it moved its corporate headquarters from Boston to Portland.

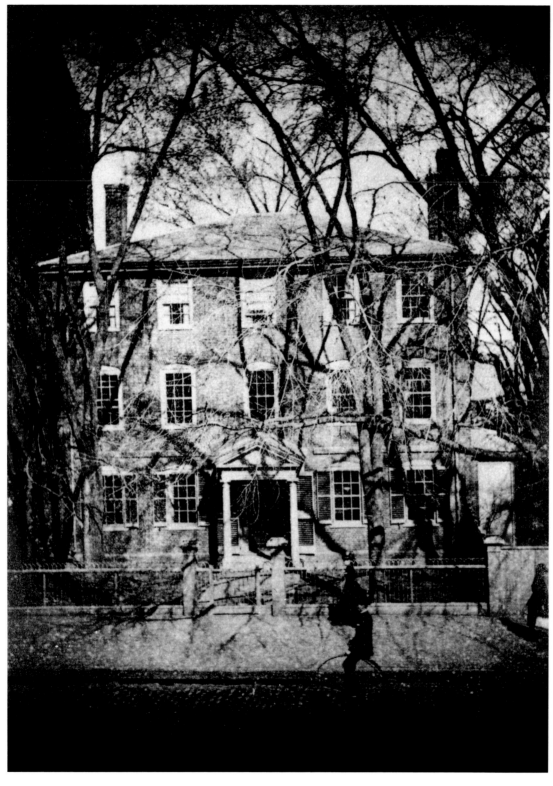

An 1880s photograph of the Wadsworth-Longfellow House on Congress Street in Portland, today home to the Maine Historical Society. This was the family home of poet Henry Wadsworth Longfellow (1807–1882), where he penned the poem "Rainy Day," which includes the famous line "into each life some rain must fall." A man riding a penny-farthing is visible on the street.

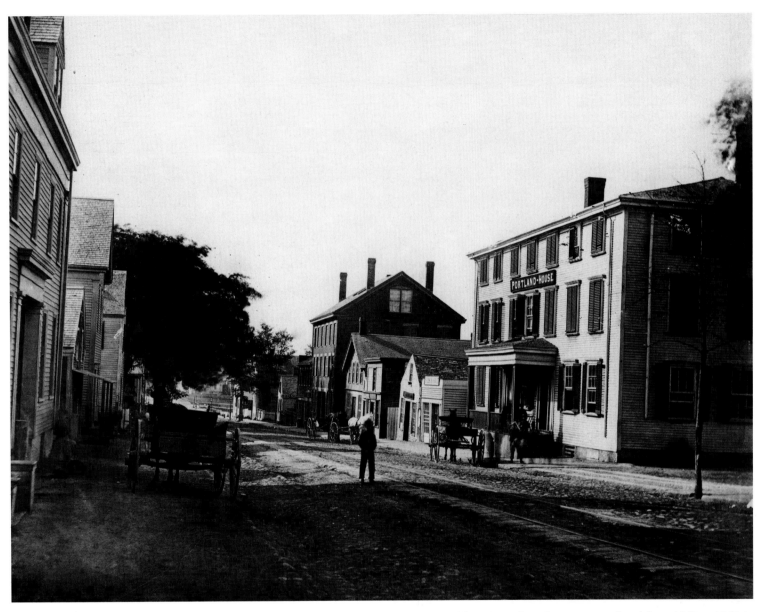

The Portland House on Forest Avenue (then Green Street) was run as a hotel from 1861 to 1862 in Portland. J. Ward was proprietor and the hotel register shows Bigelow Sanborn of Standish as the first patron, signing in on Wednesday, November 20, 1861. This image shows the building about two decades later, around 1882.

This is the town of Lisbon Falls as it appeared in the 1880s. Because of the waterpower provided by the nearby Androscoggin River, mills of all kinds were built here. In 1864, the Worumbo Manufacturing Company began producing fine woolen products, including wool suitable for the best ladies' gowns.

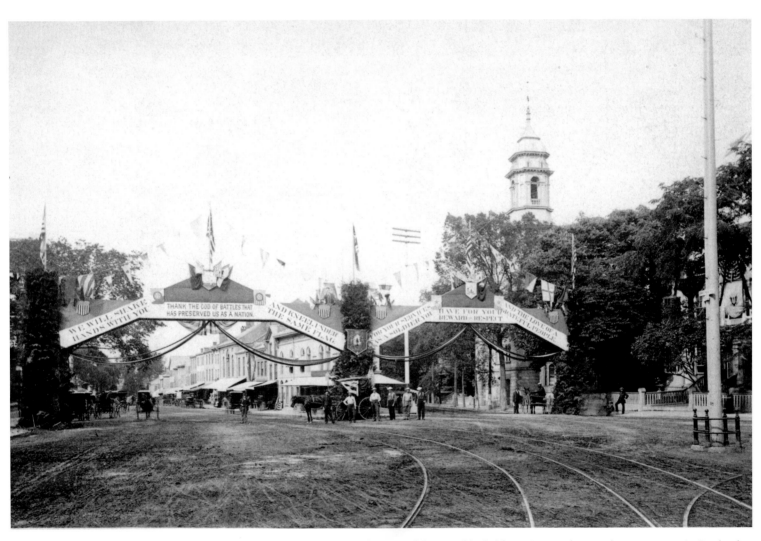

On June 22-27, 1887, the Grand Army of the Republic held its nineteenth annual encampment in Portland at Congress Square. This fraternal organization's members were veterans of the Union Army and held great political power up to the early 1900s. Annual state and national meetings were called "encampments" and attracted thousands of members.

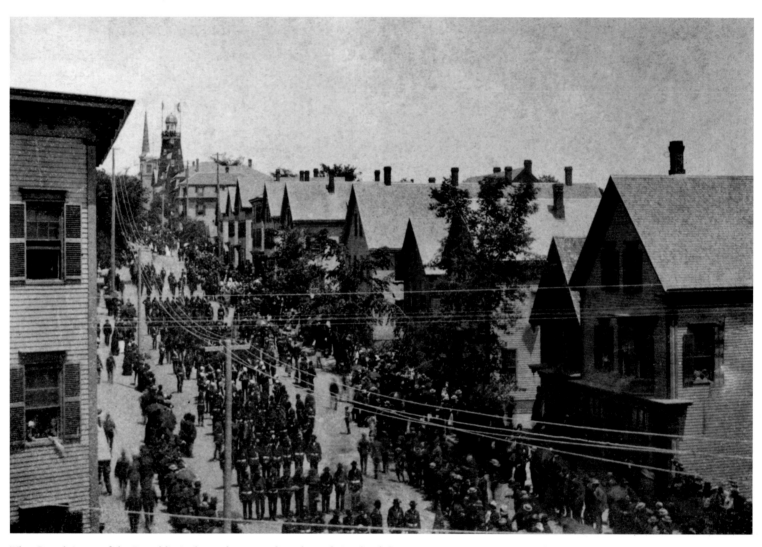

The Grand Army of the Republic is shown here parading through Portland during its 1885 encampment. The annual meetings were meant to promote the organization's three goals: fraternity, charity, and loyalty. By 1890, the organization included more than 400,000 members and thousands of local posts.

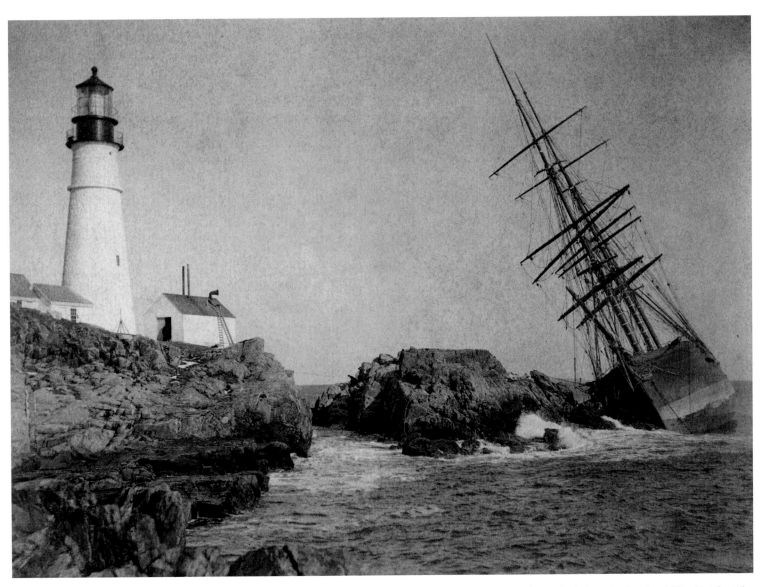

On Christmas Eve 1886, the bark *Annie C. Maguire* crashed up along the rocks below the Portland Head Light. The lighthouse keepers, Joshua and Mary Strout, ran a line to the ship and helped all ashore. One week later a winter storm destroyed the ship, but only after everything of value had been removed.

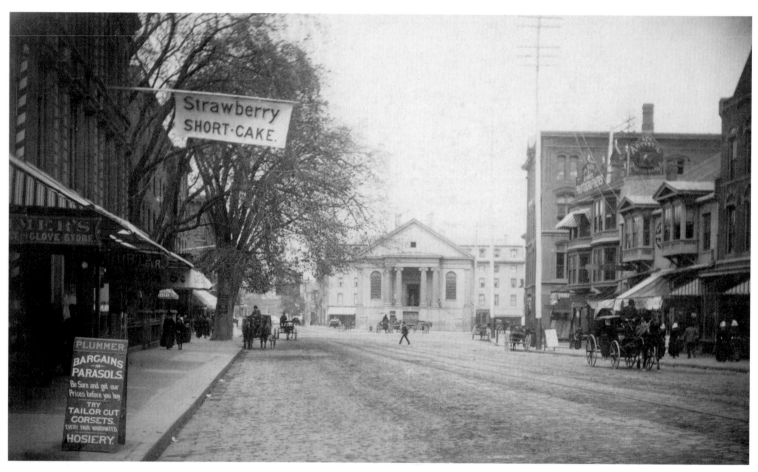

This 1888 view down Portland's Congress Street shows the market building at center in the distance, and signs advertising bargains in parasols, tailor-cut corsets, and strawberry shortcake. Portland's first city hall (1864–1866) was located in this building at what is now known as Monument Square. The building was razed in the 1890s to make way for the Soldiers and Sailors Monument.

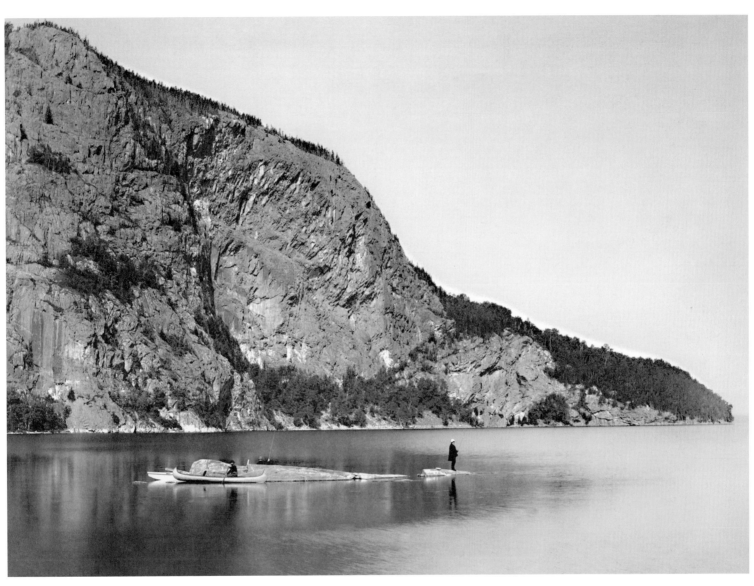

Mount Kineo beside Moosehead Lake on August 1, 1888, dwarves the three fishermen below who are casting their lines hoping for strikes. John Dunn, an amateur photographer, frequented these regions, fishing, hunting, camping, and taking photographs. Author Henry David Thoreau traveled the area three times, writing "strange that so few ever come to the woods to see how the pine lives and grows and spires."

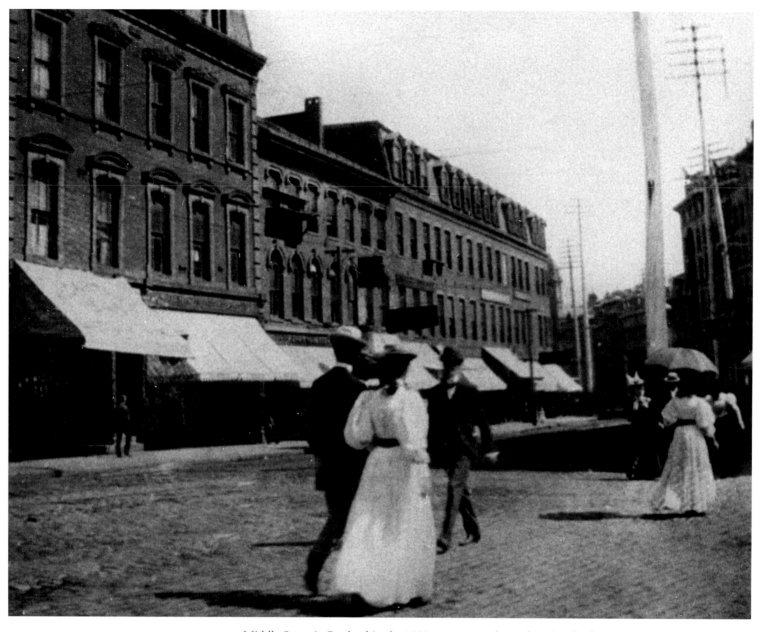

Middle Street in Portland in the 1890s sports couples in their Sunday best, strolling along arm in arm. Extremely tall utility poles dominate the skyline. Portland had telegraph service in 1847, gas lanterns in 1864, telephones in 1878, and electricity service in homes by 1883.

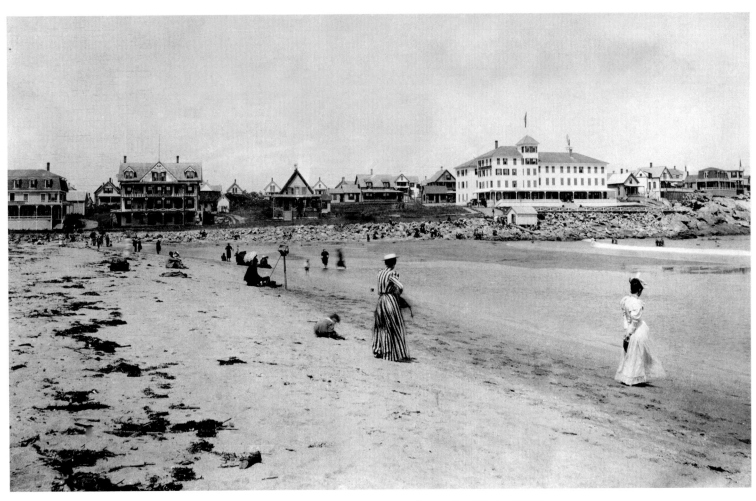

Bathers and tourists enjoy Short Sands Beach in York in the late 1890s with the white walls of Union Bluff Hotel in the distance at far-right. Vacationers arrived here for month-long stays, escaping the smog-filled cities of Boston, New York, and Philadelphia.

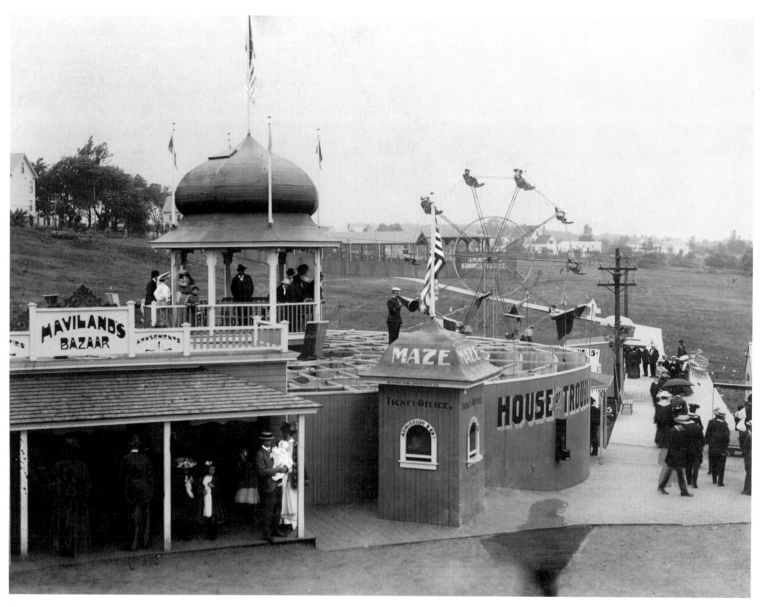

Old Orchard Beach began entertaining summer visitors with its amusement parks and seaside amenities in the late 1800s as improved train service along the coast brought a stream of summer visitors to Maine's coastal communities. Family groups here are visiting the Maze at Seaside Park (10 cents admission), and Haviland's Bazaar around 1890, while a man with a bullhorn stands over the maze, presumably to assist patrons as they find their way through it.

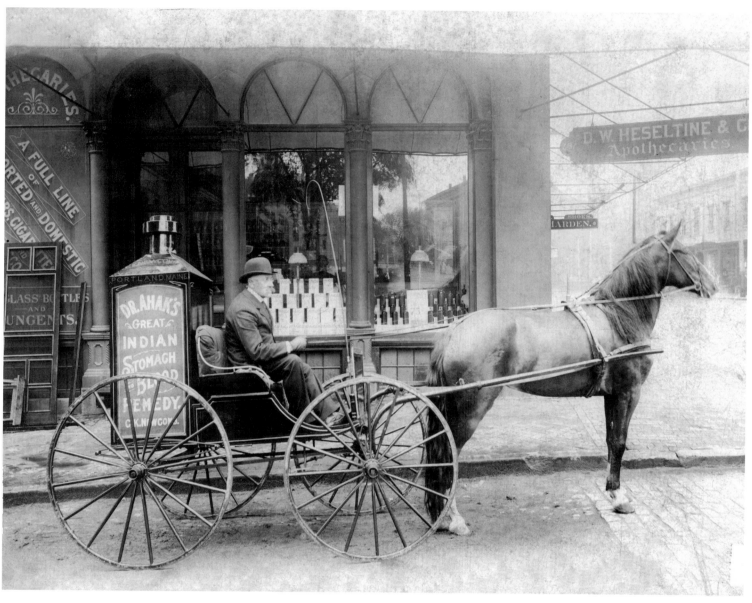

"Dr. Ahak's Great Indian Stomach and Blood Remedy" is advertised on this buggy, parked in 1890 at the D. W. Heseltine & Co. Apothecary at the corner of Congress and Myrtle streets in Portland. Patent medicines were big business at this time, quaintly named and with extravagant claims about their medicinal properties.

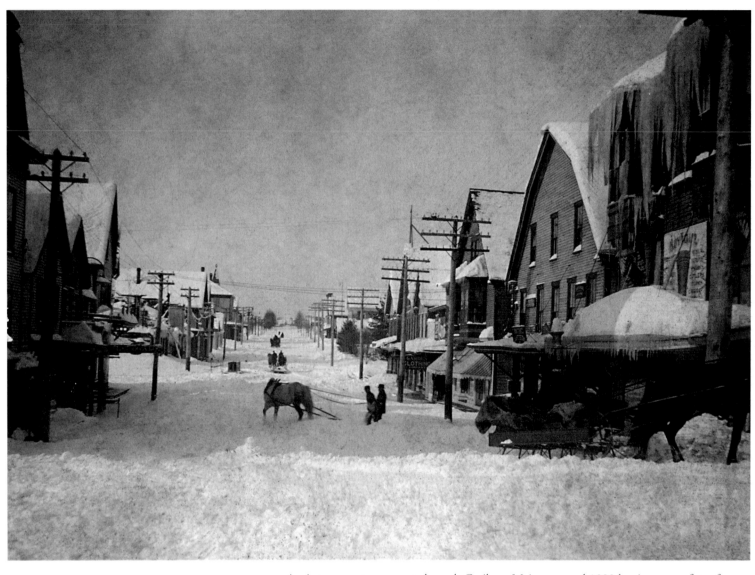

A winter snowstorm swept through Caribou, Maine, around 1890 leaving many feet of snow. These horse-drawn sleighs on Sweden Street are carrying passengers while the horse at middle may be pulling a small plow to clear the street.

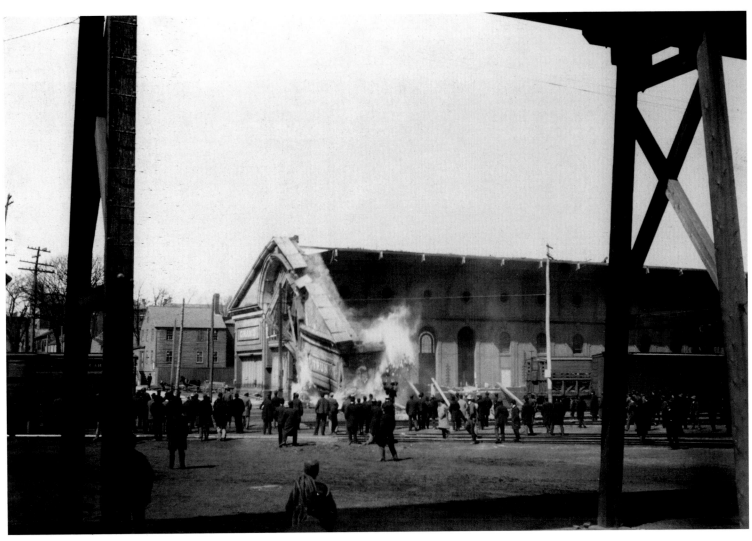

In 1894, this Grand Trunk Railroad station on Commercial Street was abandoned and later razed. Spectators here gaze at the demolition, in progress. The Grand Trunk opened another terminal on India Street in 1903.

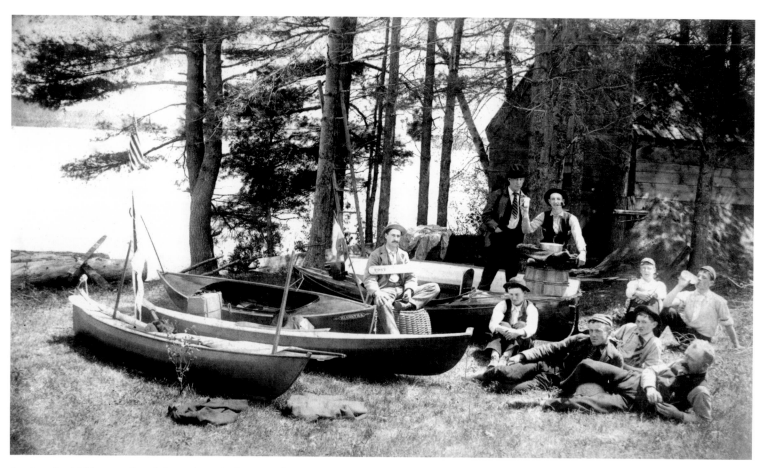

During the 1890s, sporting clubs such as the Brunswick Canoe Club sprang up all over the country. Maine was moving from an agriculture-based economy to an industrial one, permitting recreational and social activities to flourish. Those pictured include canoeists Ben Furbush, Carl Day, Ernest and Herbert Merryman, Ralph and Fred Fish, Fenno Elliott, and Buzz Mitchell.

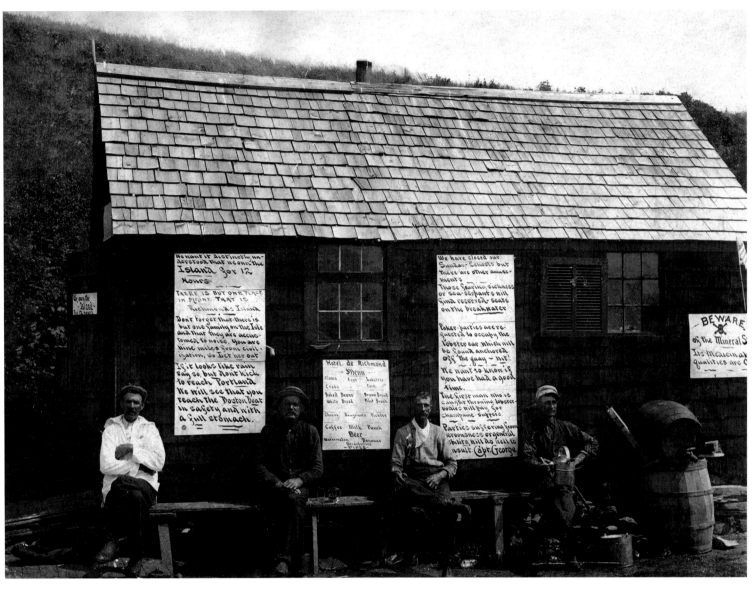

Four Jordan family members, Maurice, George Steve, John, and Walter, pose at the Richmond Island boat dock with information and admonishments to the island's visitors. With characteristic "Downeast Maine" humor, a menu, advice, information about the residents' preferences, and rules for visitors' conduct are posted, as well as the words "we own the Island for 12 Hours."

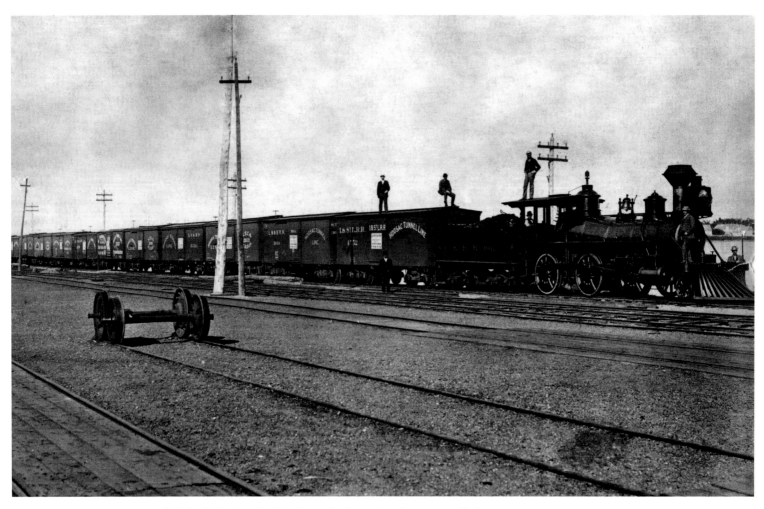

This Eastern Railroad train, called the "Salt Train," idles alongside the Portland Company facilities on Portland's waterfront around 1890. These tracks passed between the company's buildings and Portland Harbor, running along Commercial Street. The Eastern Railroad and the Boston & Maine Railroad had just signed a lease agreement May 9, 1890, to merge operations.

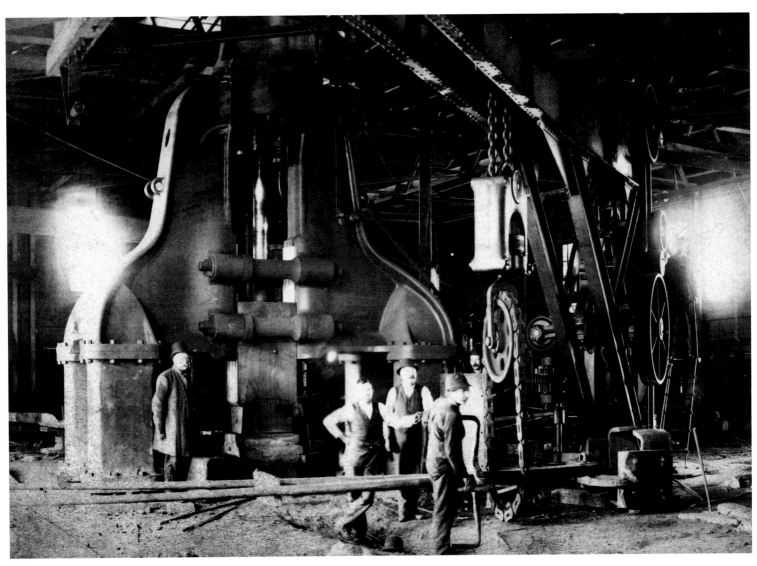

Around 1890 Portland Company employees stand near a traveling crane and the furnaces in one of the two foundry buildings along Portland's waterfront. The company was established in 1846 by John A. Poor, primarily to build locomotives for the Atlantic and St. Lawrence Railroad. It later supplied cast metal parts for trains, ships, trucks, fire equipment, automobiles, lighthouses, and power and paper company operations.

This large crowd, gathered in May 1889, is observing the laying of the cornerstone for the Soldiers and Sailors Monument. Members of the Grand Army of the Republic, Bosworth Post No. 2, had this monument erected in memory of the many who gave their lives preserving the Union. To make way for the memorial, they prevailed upon the City of Portland to remove the Market Building.

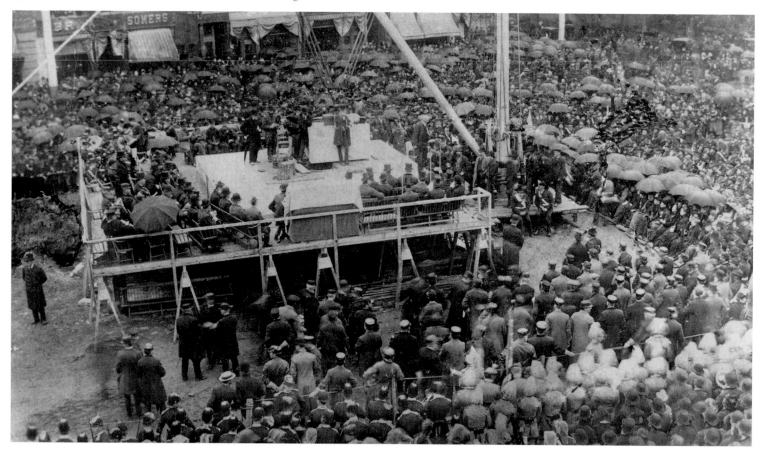

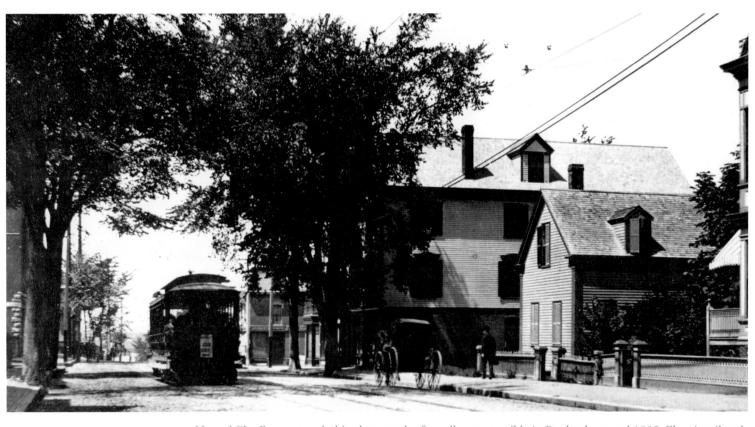

Harry Miles Freeman took this photograph of a trolley car, possibly in Portland, around 1895. Electric railroads began service in the area in 1891. The Portland Railroad Company had more than 100 open cars engaged over the years. Open cars ran in the summer, and were especially popular for evening rides to resorts owned and operated by the railroad.

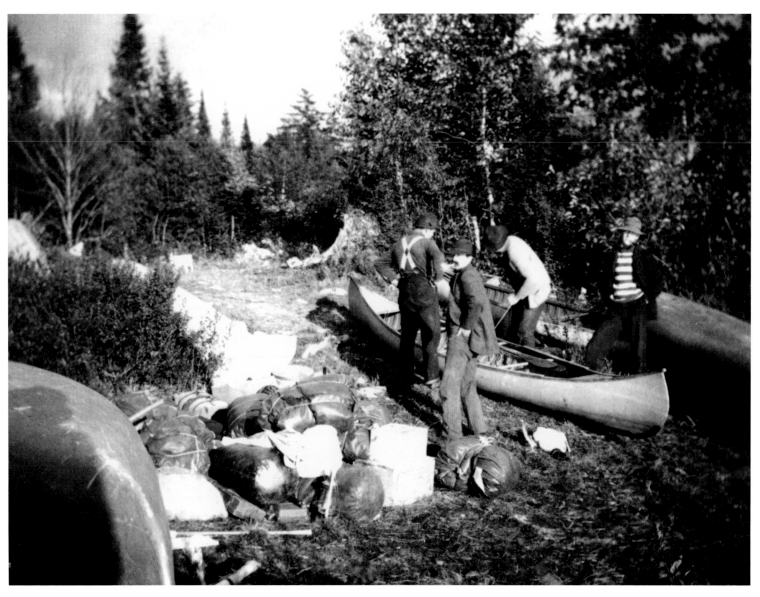

At the close of a hunting and fishing expedition to the Moosehead and Ragged Lake region at Bearbrook Landing in 1895, John W. G. Dunn and his companions are waiting for horse teams to transport gear. Members of these trips were known as "sports." The Maine guides who led these sports were Henry and Fred Tremblay, Walter Meservey, and John Mansell.

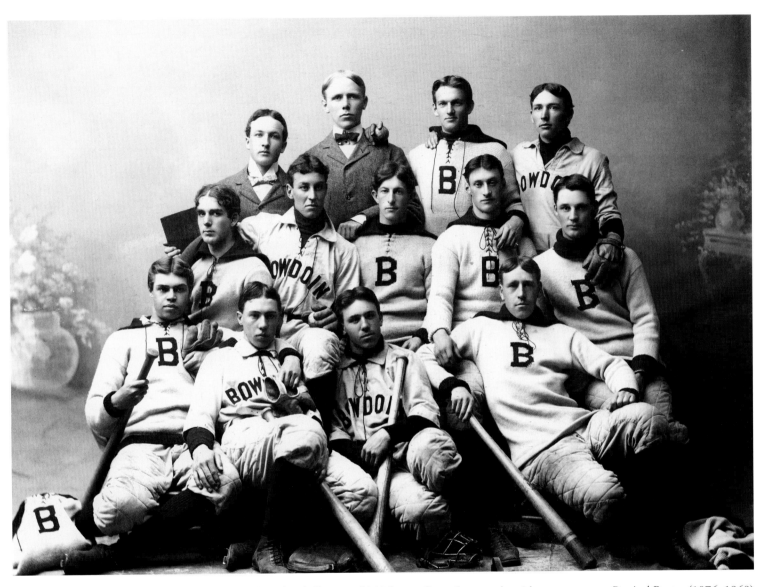

The Bowdoin College baseball team of 1896 poses for a photograph, with team manager Percival Baxter (1876–1969) standing in the back row. Baxter went on to become governor of the state and was instrumental in creating Baxter State Park. As governor he eschewed federal involvement, insisting that the park be managed by the state. He bought much of the land around Mount Katahdin himself, later giving it to the park.

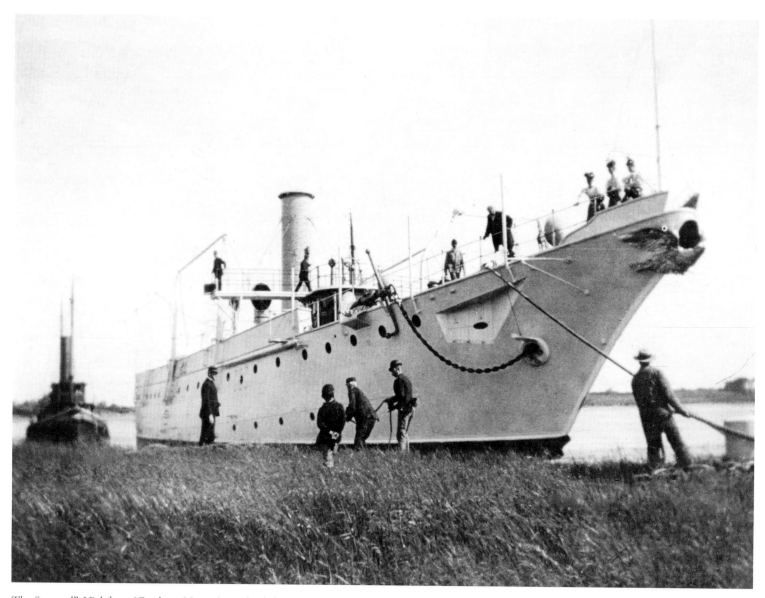

The "second" *Vicksburg* (Gunboat No. 11) was built by the Bath Iron Works and launched on December 5, 1896. This photograph shows the *Vicksburg* arriving at the Kittery Navy Yard on June 22, 1897, where it was then placed in commission in October, with A. B. H. Lillie in command. A new "composite" method was used to build this ship, with copper laid over the steel below water level.

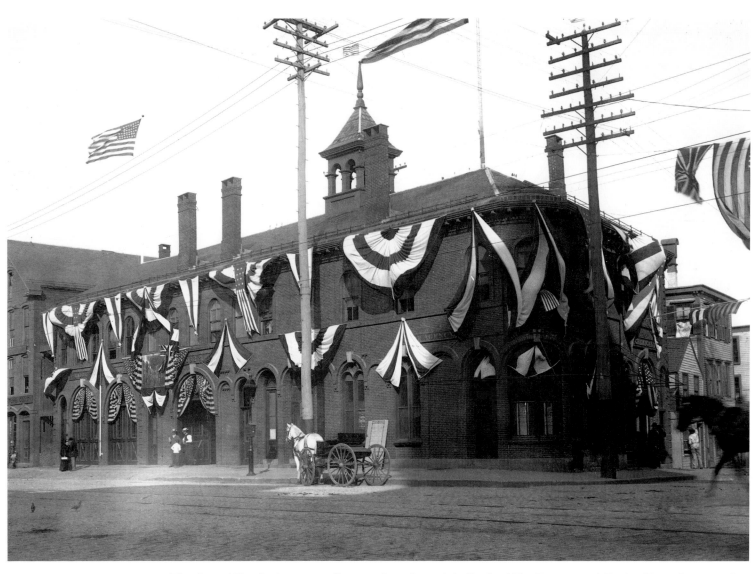

The Central Fire Station at 380 Congress Street housed the Portland Fire Department's Engine No. 5 Company. It is shown here in 1898, decorated for Independence Day celebrations. Melville N. Eldridge was chief engineer.

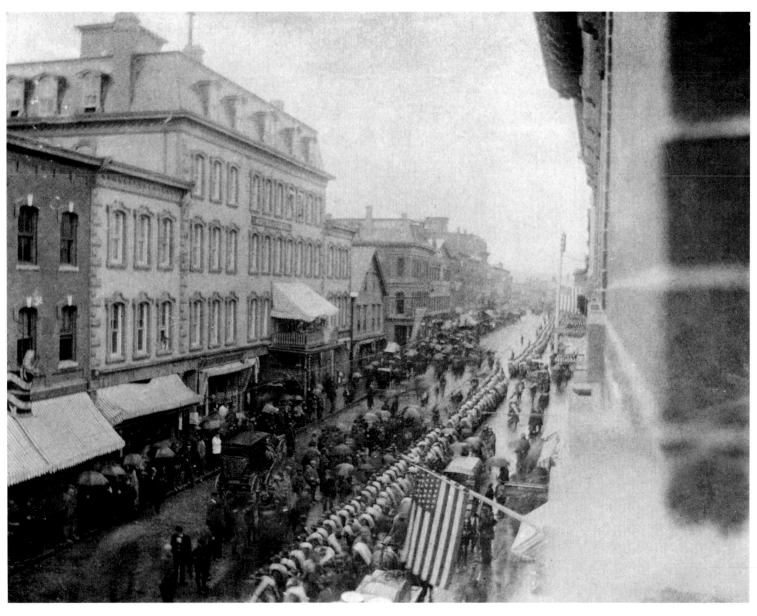

The Spanish-American War lasted from April 25 to August 12, 1898. Here in Augusta, Maine, in the month of August, soldiers are being mustered along Water Street.

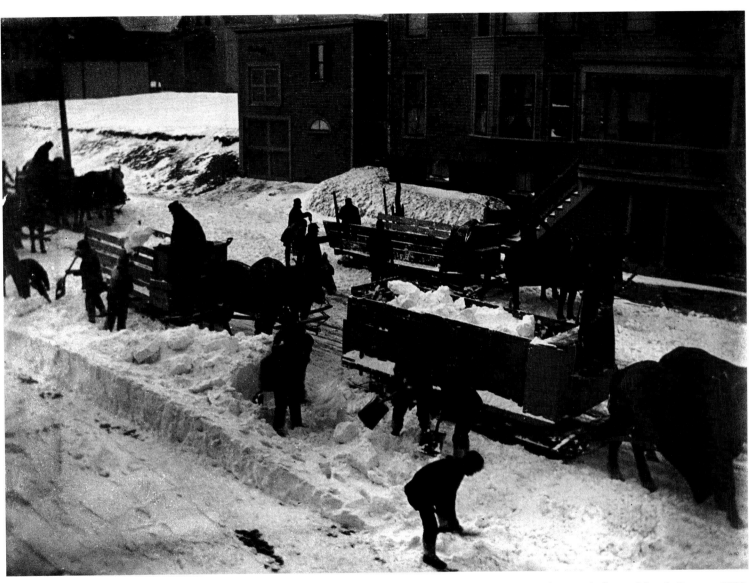

Snow removal along Maine's many roads is always a challenge. Here in January 1899, men wielding shovels and using horse teams to haul sleds are removing snow from Morning Street in Portland.

The Westbrook, Windham & Naples
Railway opened a line from Westbrook
to South Windham around 1899.
Passengers and freight were transported
along the route to South Windham, but
the line never went beyond that point.
This car is heading south in Westbrook
near the First Congregational Church.
A conductor, motorman, and trailer
brakeman worked on these cars.

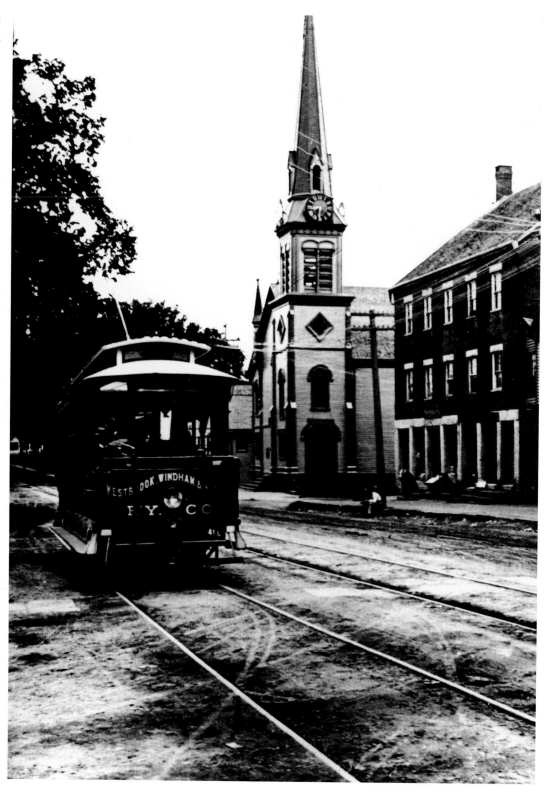

THE MAINE ATTRACTION

(1900–1919)

In the late nineteenth and early twentieth centuries, Maine began to attract tourists who desired to experience the natural beauty found here. As railroads, steamers, and roads improved, people from "away" could visit without undue strain. Hunting and fishing camps dotted the inland areas of Rangeley, Moosehead Lake, and the Allagash region. Elegant resorts attracted families for the summer, railroad lines catered to daytrippers from points south, summer homes were built, and Maine soon had a booming tourist industry. Mainers were learning that the natural beauty of their state was something of value in and of itself.

An upwelling of interest in world religions brought Baha'is, Buddhists, and Hindus to Green Acre in Eliot. Artists traveled to Monhegan and other coastal and inland communities to capture Maine's natural beauty on canvas. Literary scholars summered in Maine's serene surroundings, and U.S. presidents vacationed here. Maine rural dwellers began to find their towns populated by citizens with wholly different values and interests. To accommodate these seasonal visitors, Mainers became wilderness guides, opened restaurants, offered small craft boating and horseback riding, and other services.

Issues of justice were bearing fruit at this period in history. Women's suffrage was voted into law. A labor union's efforts on behalf of its members extracted better treatment and wages in Portland after the streetcar workers went on strike in 1916. In 1907 the Maine State Child Labor Committee was organized, and soon thereafter Lewis W. Hine came to photograph child workers at Maine mills and canneries for the National Child Labor Committee. Maine witnessed a peace treaty between the Russians and Japanese, signed on its shores in 1905.

The paper industry boomed into vibrant life with the Great Northern Paper Company's creation of the mill town of Millinocket, built virtually overnight. Fishing along the coast and the canning industry continued to be a mainstay for coastal communities. Potatoes ruled the north.

The 35,000 and more Mainers who went overseas to fight and work in World War I came back with a wholly different view of the world. Maine's pristine wilderness and coastline areas continued to attract outsiders and at the same time Mainers were traveling to the "outside" in greater numbers.

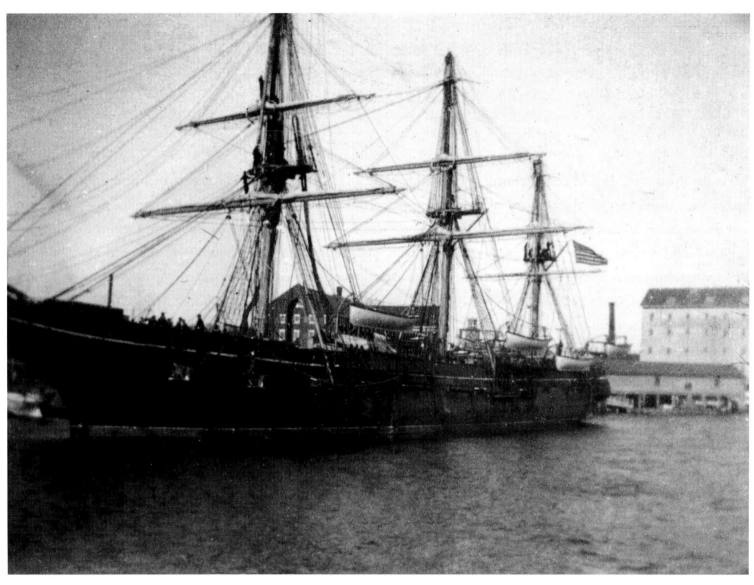

A three-masted vessel is docked at the Portsmouth Naval Shipyard (then known as the Kittery Navy Yard) around 1900. The shipyard has been building government vessels since 1800. Some of the sailing ships built were the ironclad *Agamenticus,* USS *Essex,* USS *Portsmouth,* and USS *Kearsarge.*

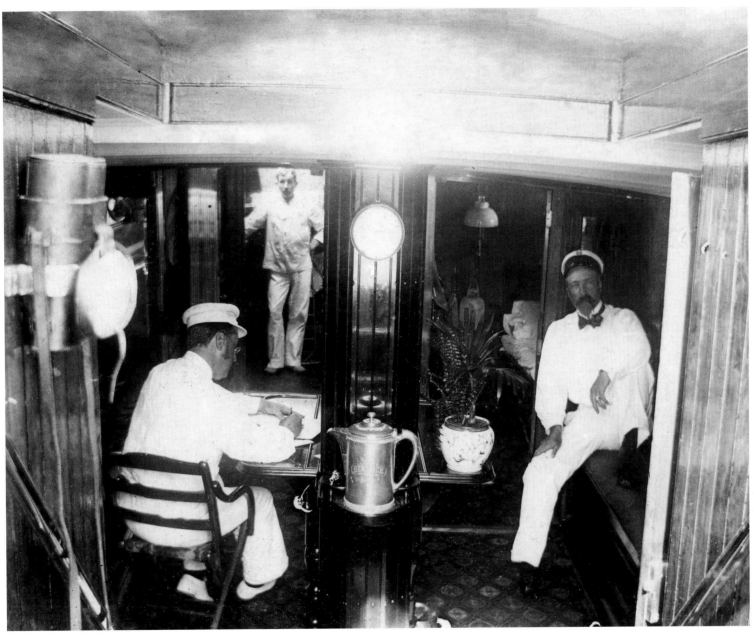

This interior view of the racing yacht *Beatrice* shows members of the crew and owner James C. Hamlen. Hamlen inherited the proprietorship of the Portland-based company J. H. Hamlen & Sons, a cooperage that made wooden fittings for ships. Yacht racing among the wealthy was a very keen sport around 1900.

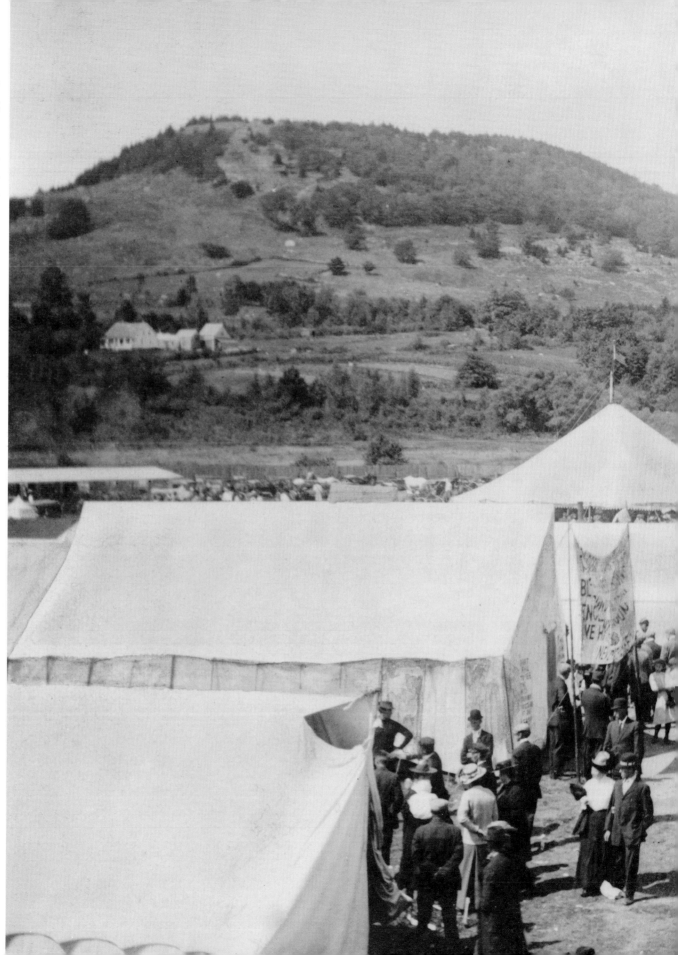

The Blue Hill Fair around 1900, showing the racing track, pavilions, and fairgoers. An annual event since 1891, this fair is usually held over the Labor Day weekend. Agricultural fairs in the state are a time for farmers and their families to view new agricultural equipment, sell livestock, compete for prizes in animal husbandry and crop production, enjoy social events, and have bake-offs, among other activities.

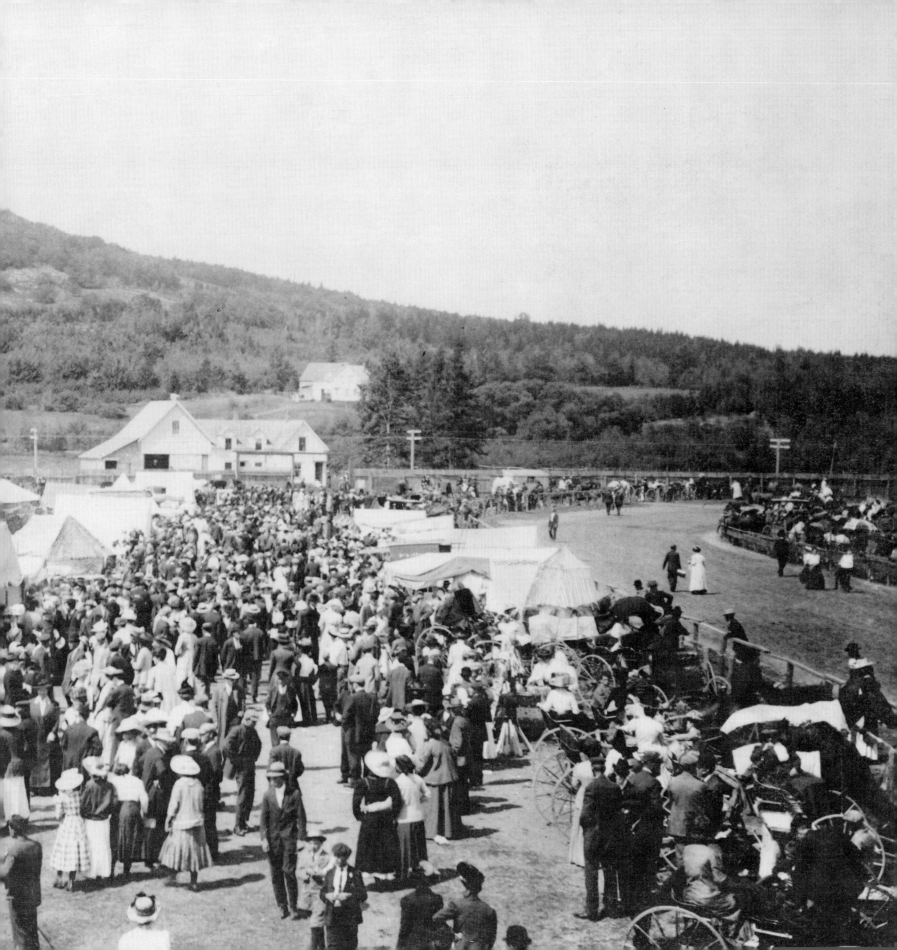

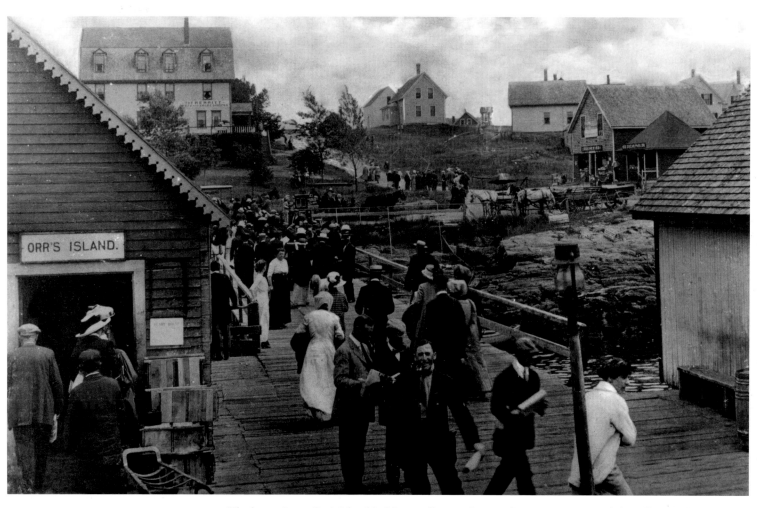

The busy pier at Orr's Island in Harpswell around 1900 shows passengers and the village buildings in the distance. In 1881 the Harpswell Ferry Line began carrying passengers to the outer Casco Bay islands of Bailey and Orr's. In 1907, economic conditions led to the merger of Harpswell and the Casco Bay Steamboat Company, forming the Casco Bay and Harpswell Steamboat Company.

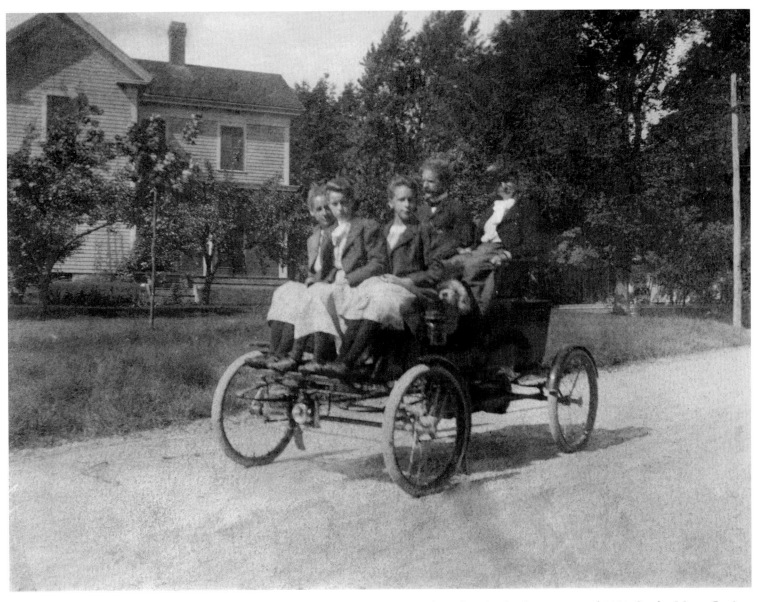

This family enjoys a ride in their Stanley Steamer around 1903. Stanley Motor Carriage Company automobiles, powered by steam, were first invented and produced by Maine natives Francis E. and Freelan O. Stanley.

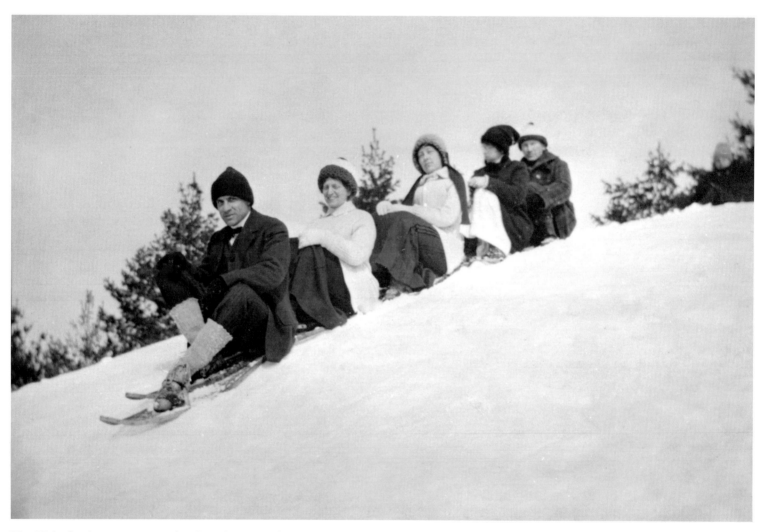

The Hicks family creates a snowshoe "train" instead of using a sled or toboggan. The party perches at summit waiting for the photographer to complete the shot before they slide downward.

Seven boys play baseball on a Waterville street around 1900. Their makeshift bat is a very long piece of lumber. Interested women look on in the background.

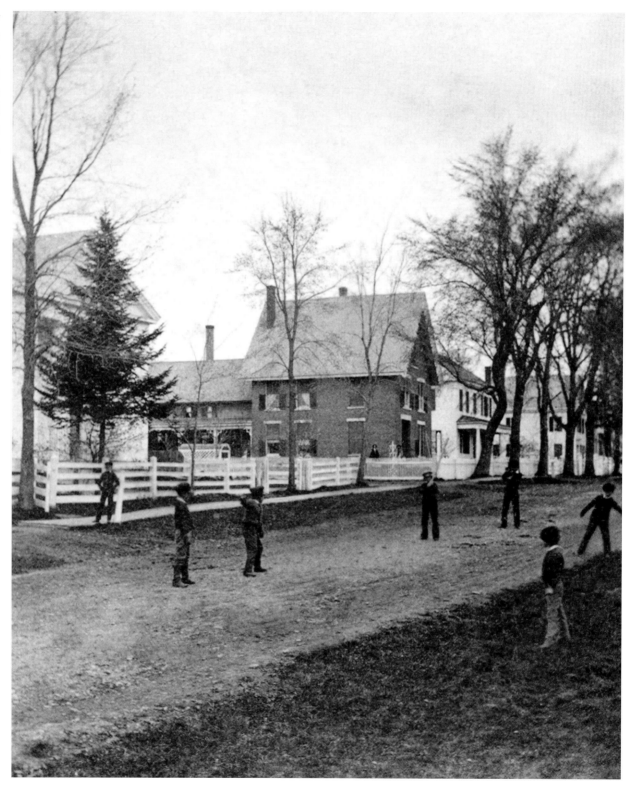

The steam tug *Cumberland* on dry land in 1910 is ready for launch. She was built in Rockland for the Central Wharf Towboat Company. With much effort, the boat would be slid along the planks of wood (the ways) into the water.

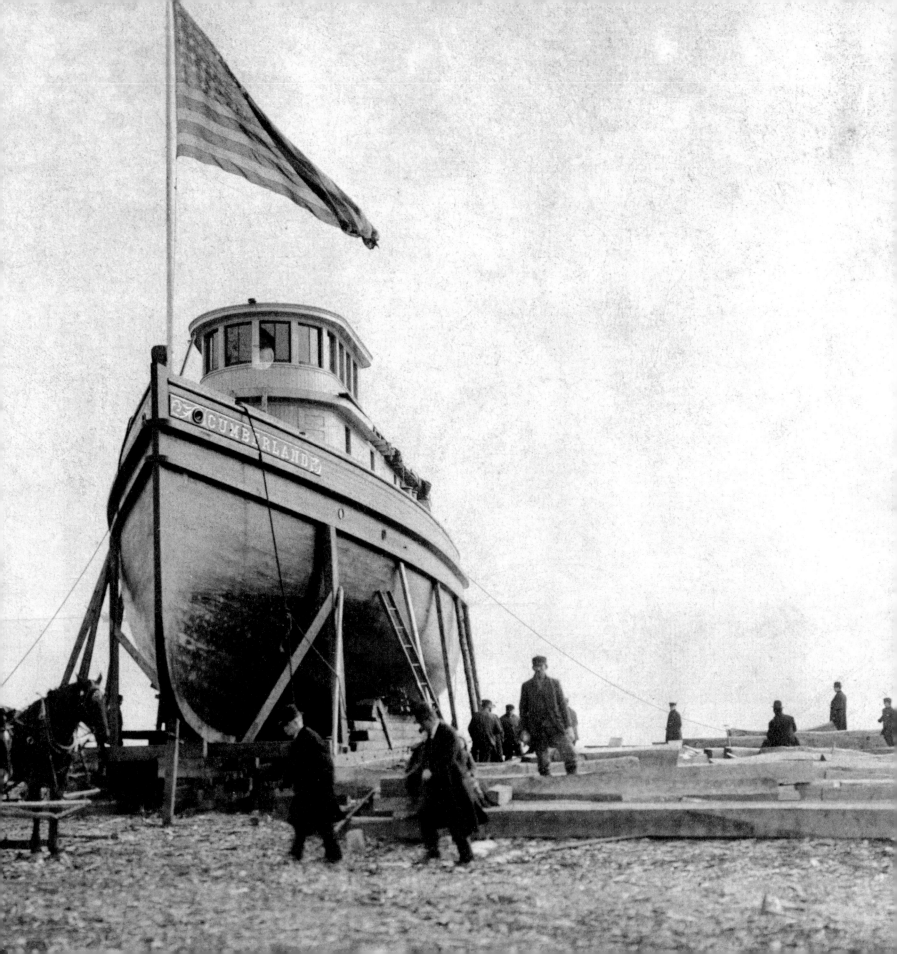

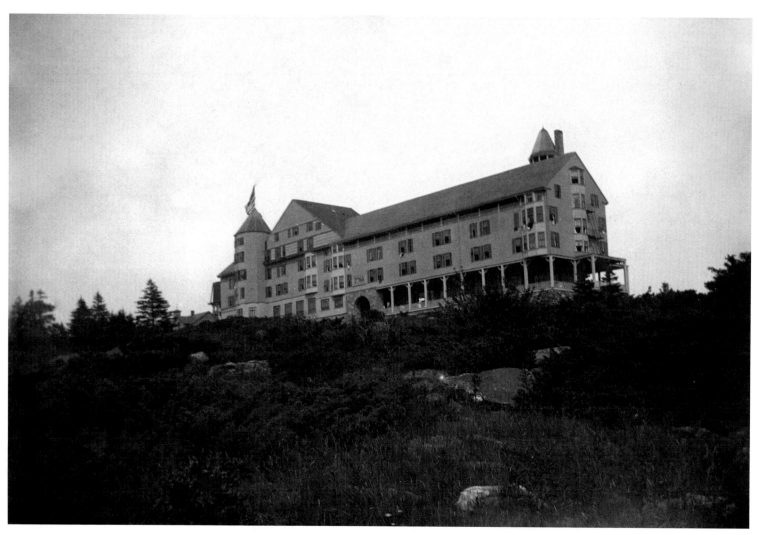

Cushing Island was and is a privately owned island in Casco Bay. Lemuel Cushing bought the island in 1859 and planned to make it into a summer resort. He built the Ottawa House Hotel and in 1883 hired landscape architects Frederick Law Olmsted and Charles Eliot to develop a planned summer colony. Rebuilt after a fire in 1888 and shown here around 1900, the Ottawa House Hotel catered to British Canadians.

The Portland Head Light in Cape Elizabeth at the entrance to Casco Bay is shown here around 1900. It is one of the oldest of Maine's lighthouses, the oldest operating lighthouse, and considered the most photographed lighthouse in America. The original lighthouse was built in 1791 of rubblestone. The Strout family were longtime lighthouse keepers here, and at the time of this image, either Joshua or Joseph Strout was in residence. The pyramid-shaped structure holds the fog bell.

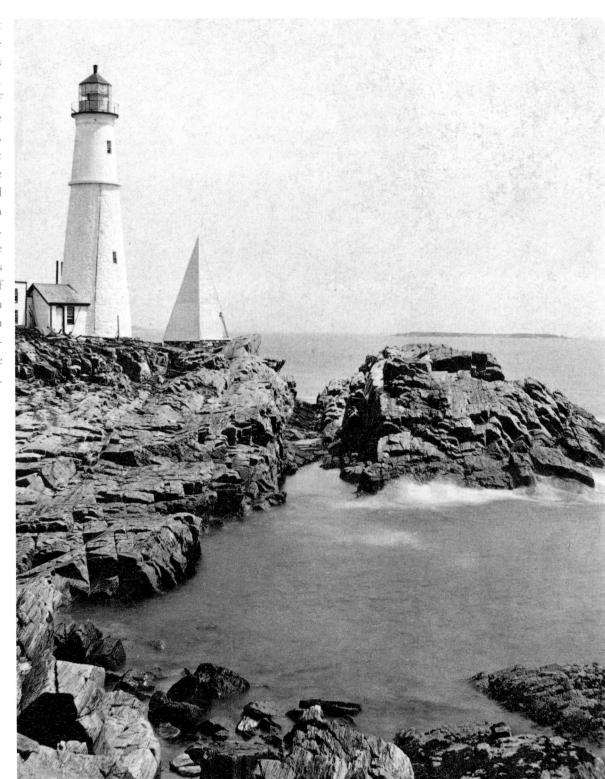

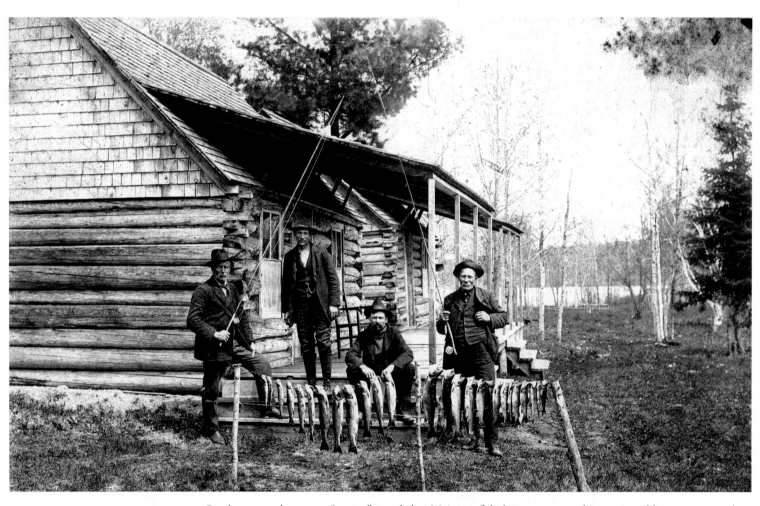

Outdoorsmen, known as "sports," traveled to Maine to fish, hunt, camp, and canoe in wilderness areas such as this one at Oak Point Camps on Portage Lake. Situated at the entrance of the Allagash Wilderness, access to Oak Point in 1900 was by train to Moosehead Lake, then by steamer across to Lily Bay, and finally by wagon. This large catch of trout represents one day of legal fishing for out-of-state visitors.

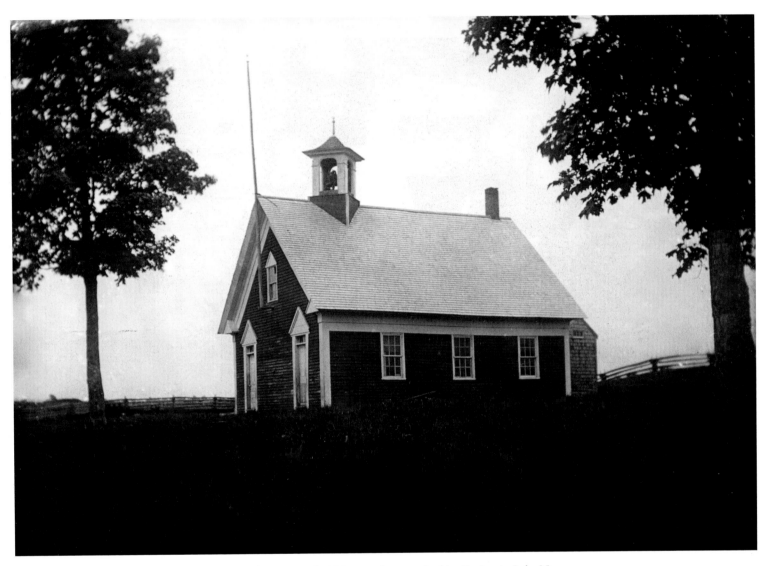

The Center School in Atkinson, Maine, in view here around 1900, was photographed by Benjamin Lake Noyes, an amateur photographer and medical doctor who lived in Stonington. Rural schoolhouses in Maine became commonplace after 1887, when the state passed a law making education compulsory for children.

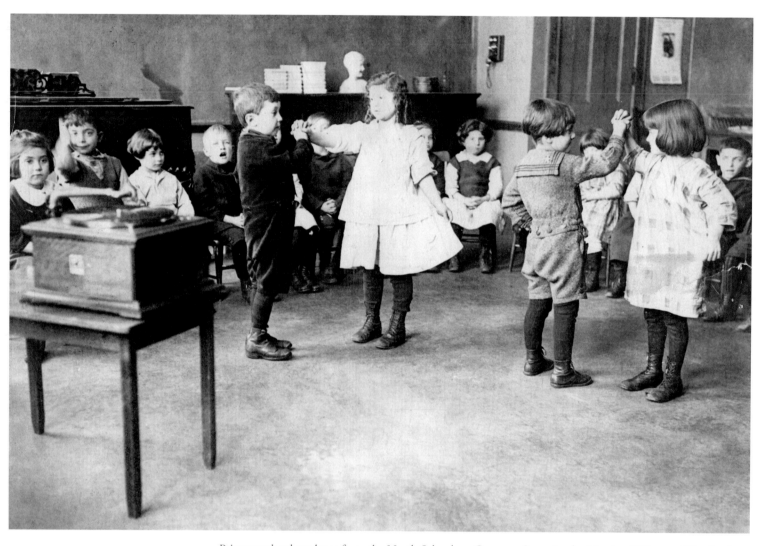

Primary school students from the North School on Congress Street in the Munjoy Hill area of Portland are practicing formal dance steps in the early 1900s. A phonograph sits in the left foreground of the image.

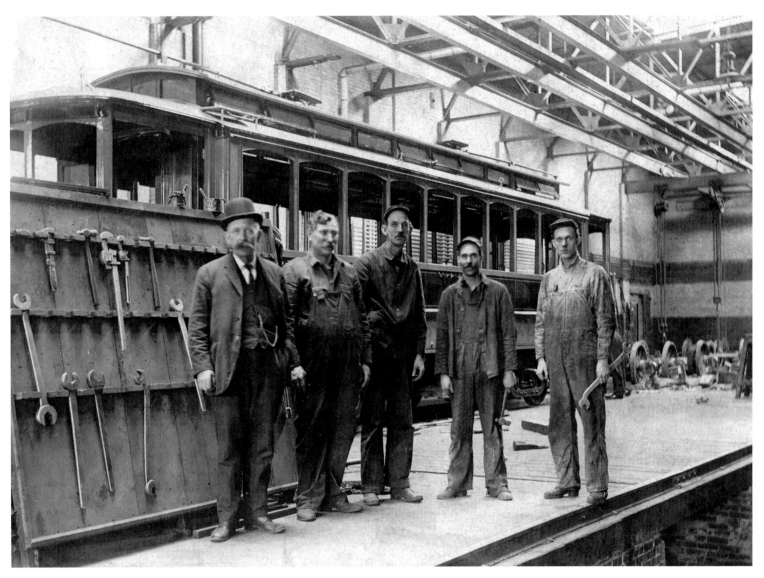

These trolley, or street railroad, employees pose for the camera around 1900. First named the Portland and Forest Avenue Railroad Company in 1860, the company changed its name to the Portland Railroad Company in 1869. This facility was located at Stevens Avenue in Portland.

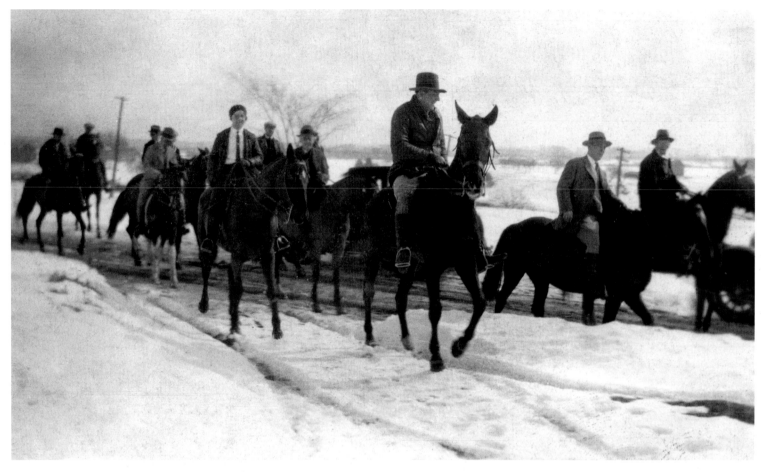

Pictured here is a riding club's annual event to Poland Springs. This photograph is part of the J. H. Hamlen & Sons collection and presumably one or more of the Hamlen family members is pictured. The Hamlen Company was an important Portland-based cooperage providing wood products for ships.

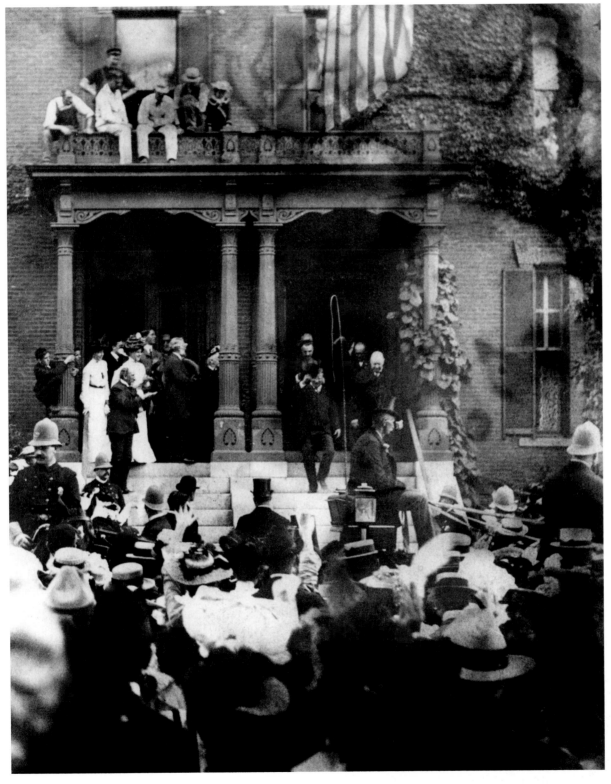

President Theodore Roosevelt (1858–1919) waves his hat to a crowd of well-wishers outside the home of his friend Thomas B. Reed (1839–1902) in Portland, August 26, 1902. Roosevelt spent two college summers (1878 and 1879) at Island Falls, camping, fishing, and exploring, and later wrote the essay "My Debt to Maine" about his experiences.

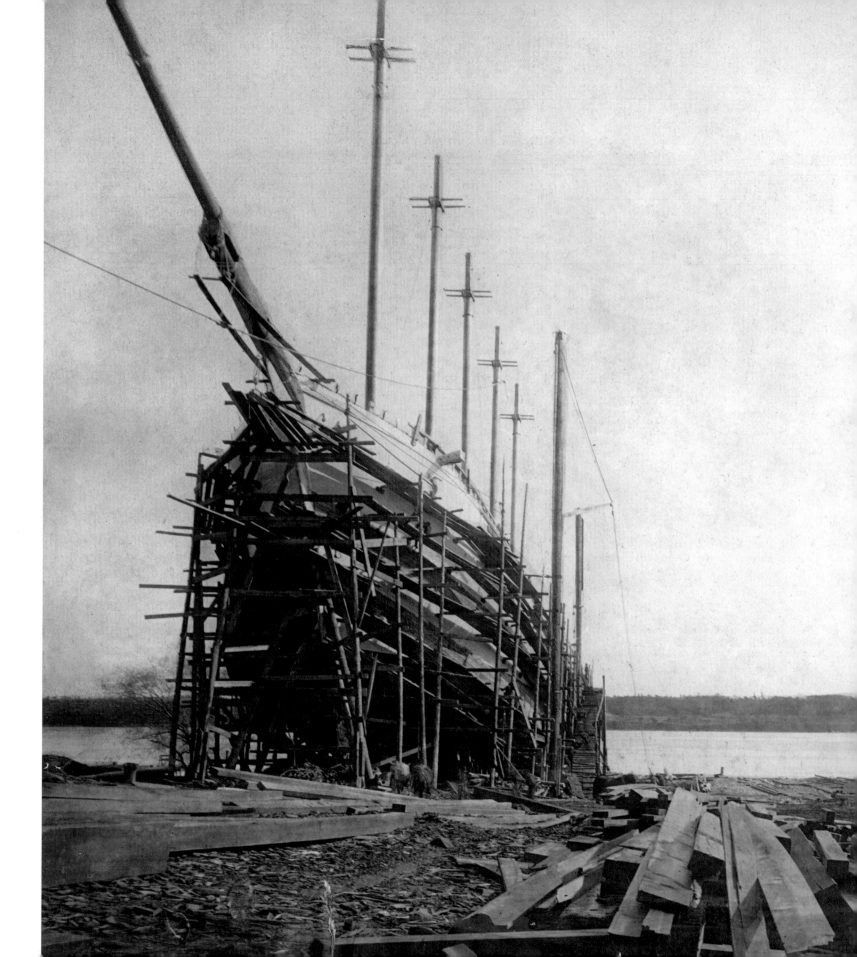

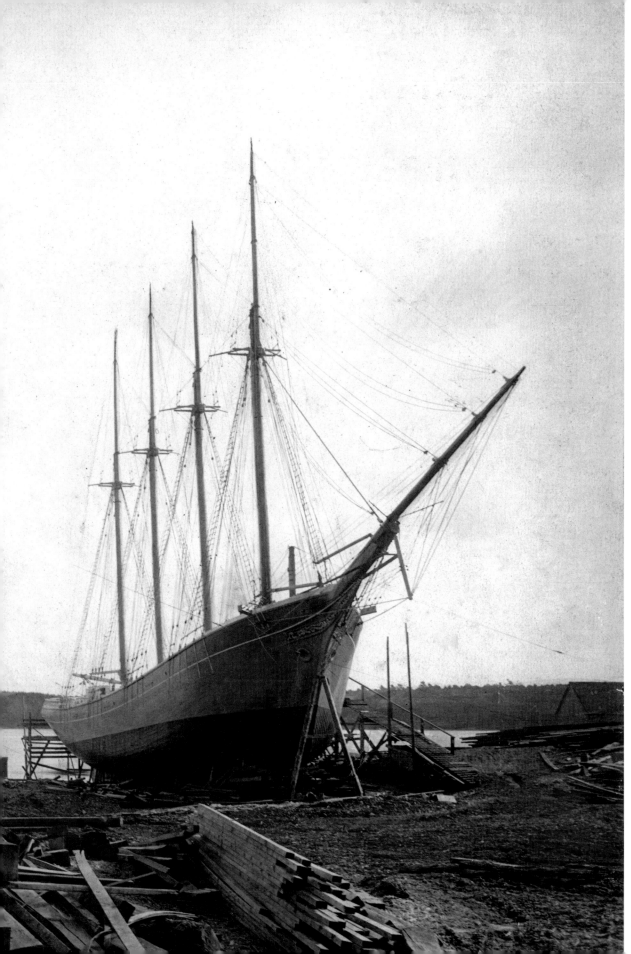

These two vessels under construction at the Percy and Small Shipyard in Bath in 1902 are the five-masted schooners *Elizabeth Palmer* and *Florence Penley.* The *Penley* was launched March 31, 1902. Between 1894 and 1920 this shipyard built 41 large schooners. It was the last in Maine to build large wooden sailing ships.

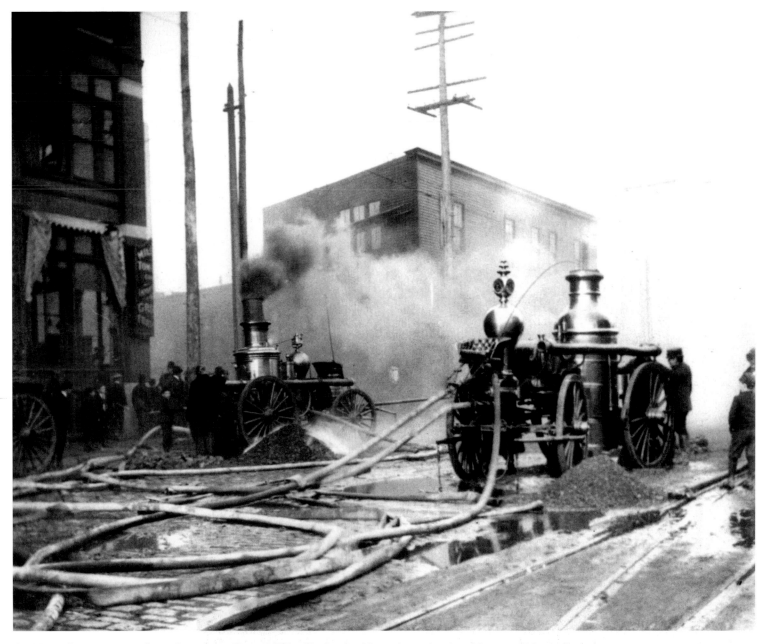

On November 9, 1903, a three-alarm fire at Brown's Wharf in Portland brought out engines No. 2 and No. 9 of the Portland Fire Department, and probably a third, out of view to the left. Both engines were built in the 1870s. Melville N. Eldridge was chief of the fire department at this time.

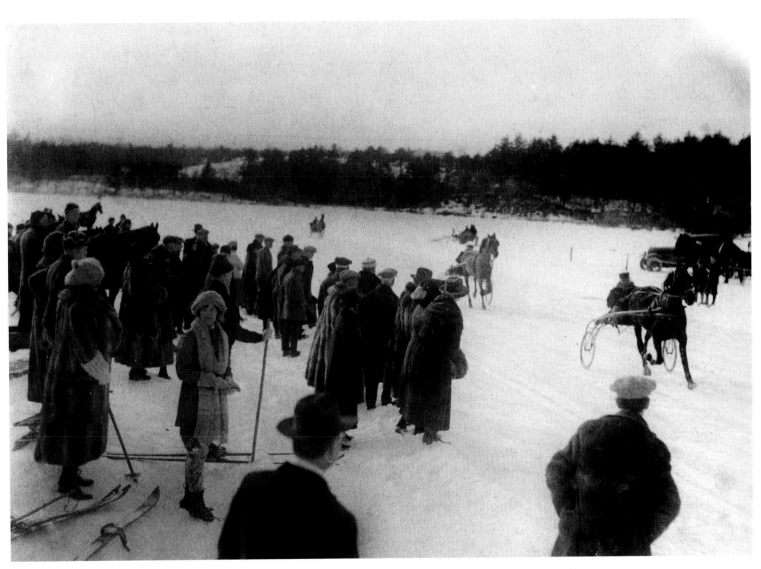

The Poland Spring House, a fashionable resort run by the Ricker family, hosted many recreational events throughout the year, including sled dog races and golf. This harness race, on the ice at Poland Spring with spectators in fur coats, may have been one such event.

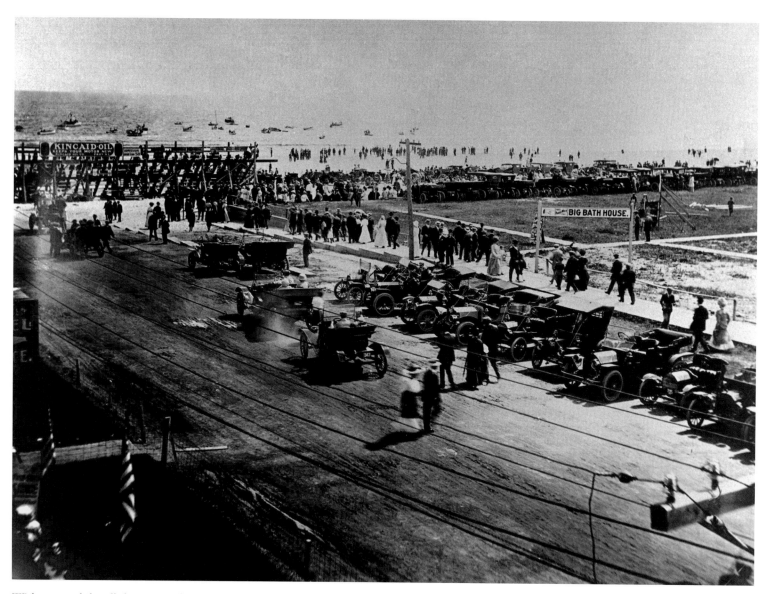

With automobiles all the rage in the early 1900s, venues were needed to prove which models were "best." Speed-racing was one way to do so, and the two-hour period either side of low tide made the sand at Old Orchard Beach a level and well-packed racing surface. The many tourist amenities nearby included a grandstand, pier, and railroad service.

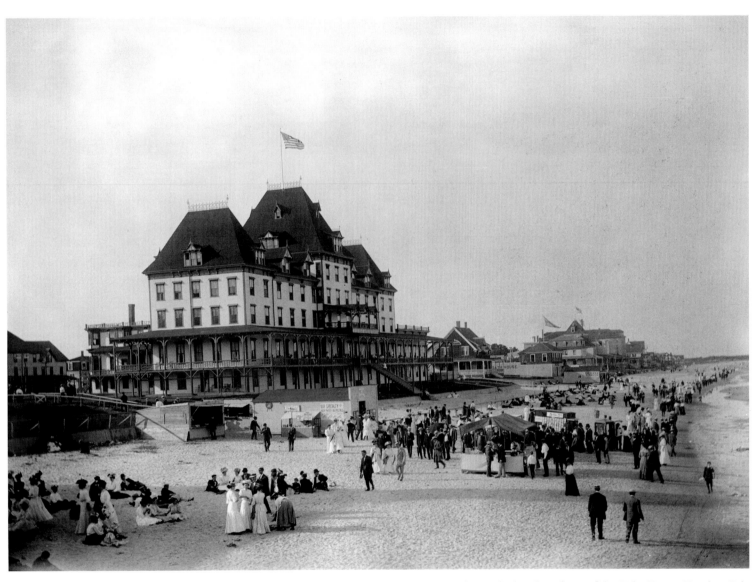

A summer's day at Old Orchard Beach shows vacationers lining the beach in front of the Fiske House Hotel on July 21, 1907. Most people are dressed not in bathing costumes but in long dresses and suits. Many are visiting together in small groups and looking over the concessions. A drinks booth, photograph-postcard shop, tintype concession, and bathhouse are visible.

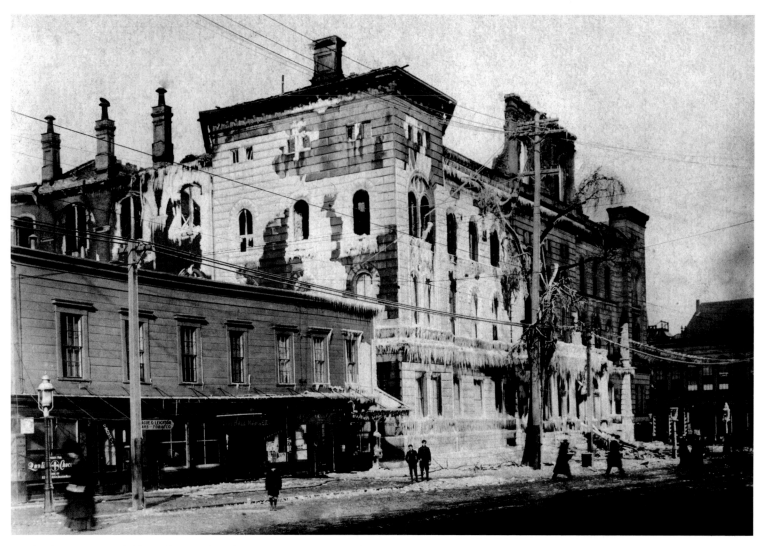

Portland's second city hall was destroyed in the early morning hours of January 24, 1908, by an electrical fire. Fire companies from nearby Saco, Biddeford, Lewiston, Auburn, and Bath were called in, but the fire destroyed many of Cumberland County's records. Icicles, formed by the water used by the fire companies, hang from the building.

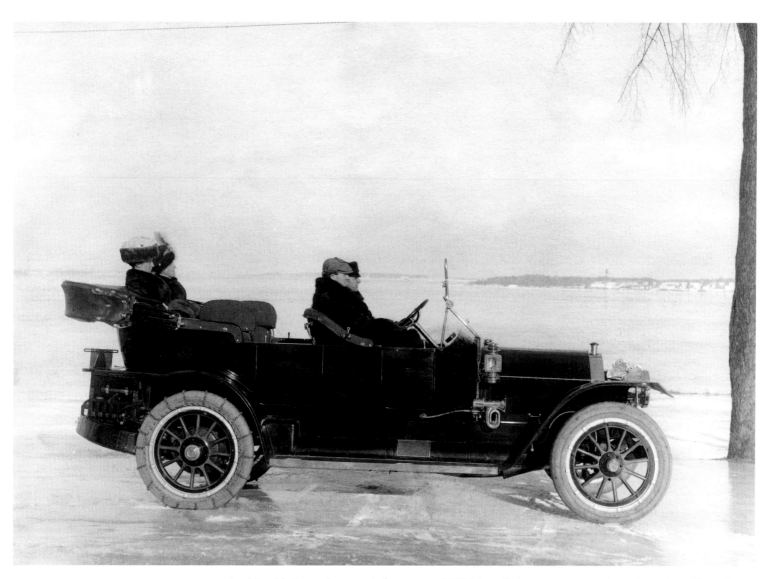

In this midwinter photograph from around 1909, bundled-up passengers enjoy a drive along Casco Bay in Portland in an air-cooled Knox automobile. Chains on the rear tires improved traction. This may have been an advertising shot for the Portland Company, which was the local dealership for the Knox.

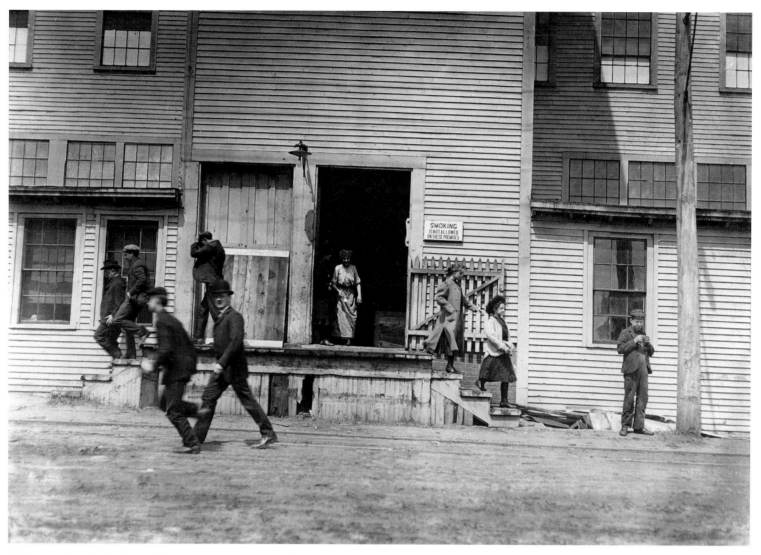

Workers at the Sanford Manufacturing Company in Sanford leave the building at noon in April 1909. Textile manufacturing companies were leading employers in Maine, with the largest mills in Lewiston, Auburn, Sanford, and Waterville. French Canadians were admitted south to work in these facilities. Lewis Hine photographed this scene at the request of the National Child Labor Committee.

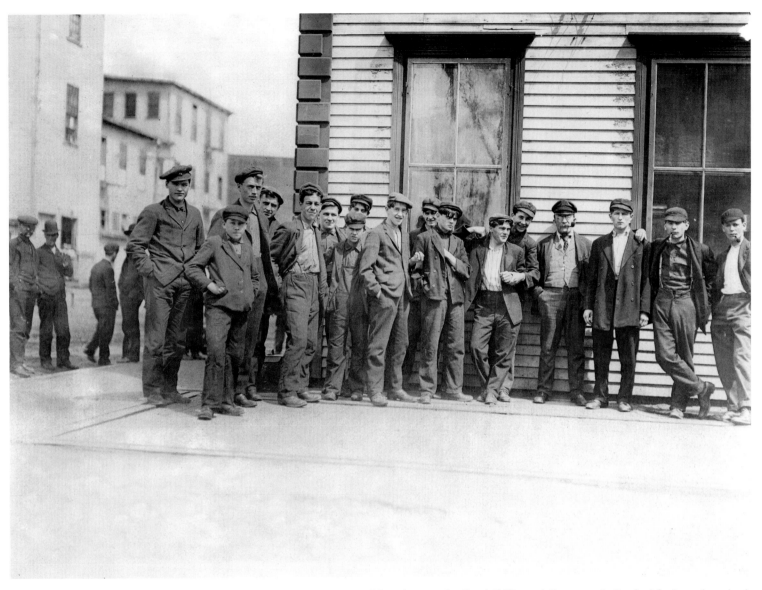

Noon hour at the Goodall Worsted Company in Sanford finds workers, both men and boys, posing for the camera in front of one of the mill buildings. Hired by the National Child Labor Committee, Lewis Hine photographed many scenes of people, not just children, at work.

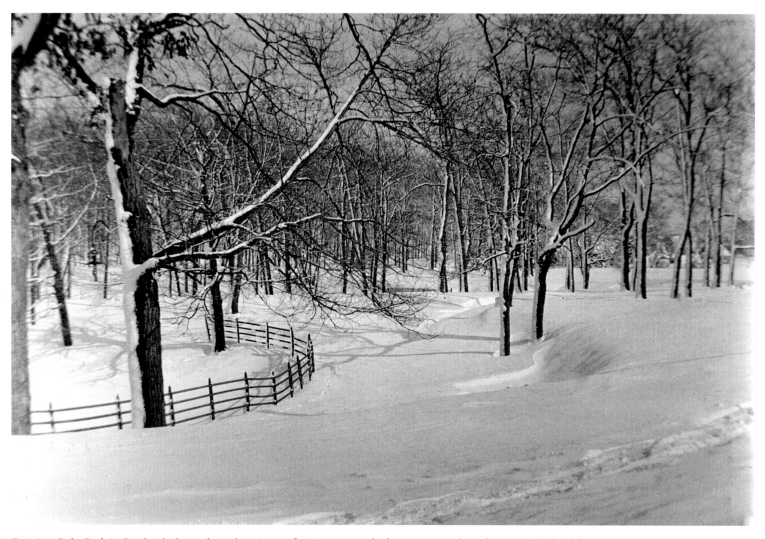

Deering Oaks Park in Portland, shown here the winter of 1909-10, was the largest city park in the state. The land for this park was acquired in 1879 from the Deering, Preble, and Fessenden families as part of the rebuilding of the city after the devastating 1866 fire. Its grove of white oaks was considered its crowning glory.

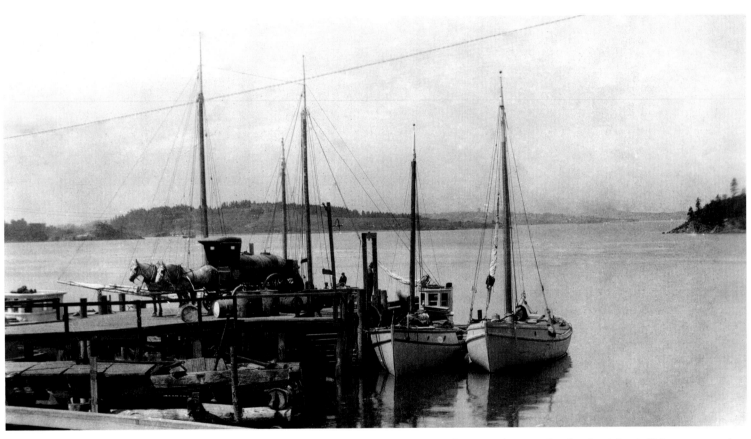

Alfred Enden, freelance photographer for the *Atlantic Fisherman* magazine, captured this image of fishing vessels at the Lubec public landing around 1910, with Passamaquoddy Bay in the background. Lubec is the easternmost town in the continental United States.

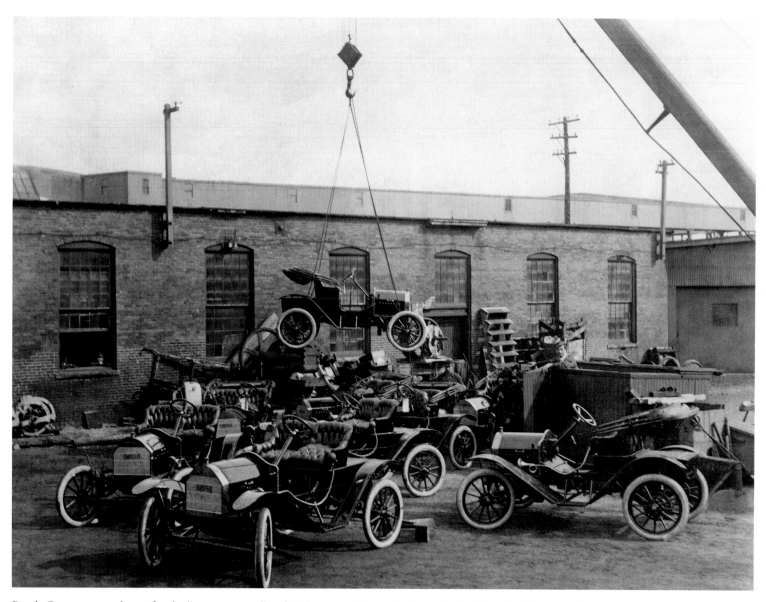

Brush Company runabouts for the "common man" and Cole automobiles are being unloaded from freight cars at the Portland Company facilities at the northern end of Commercial Street. Around 1910 the Portland Company began selling these cars, as well as Thomas and Knox Company vehicles.

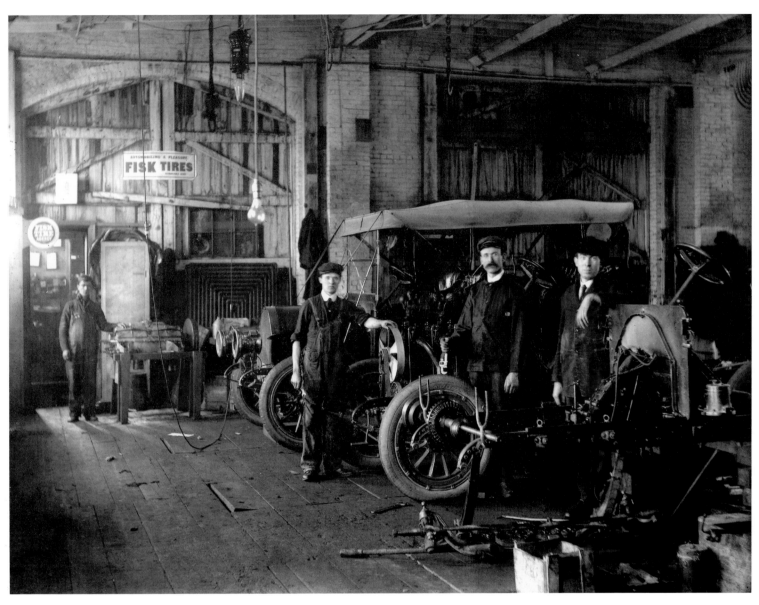

The Portland Company manufactured all kinds of cast-metal products, but in the early 1900s it also began selling and servicing automobiles and selling automobile tires. This is an interior view of the shop where Portland Company mechanics are working on Knox automobiles.

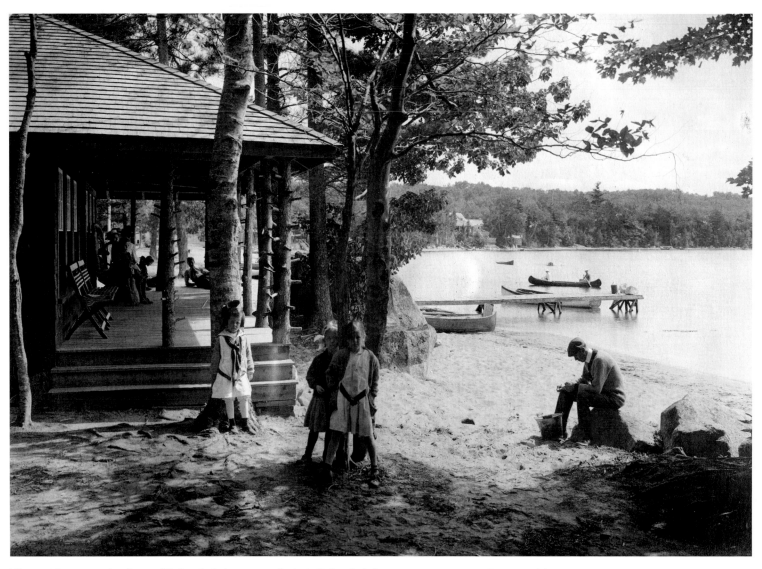

Three girls pose at the shore of Belgrade Lakes, around 1910. Belgrade Lakes attracts many vacationers and is host to a number of summer camps and vacation homes. This may be a view at Camp Abena.

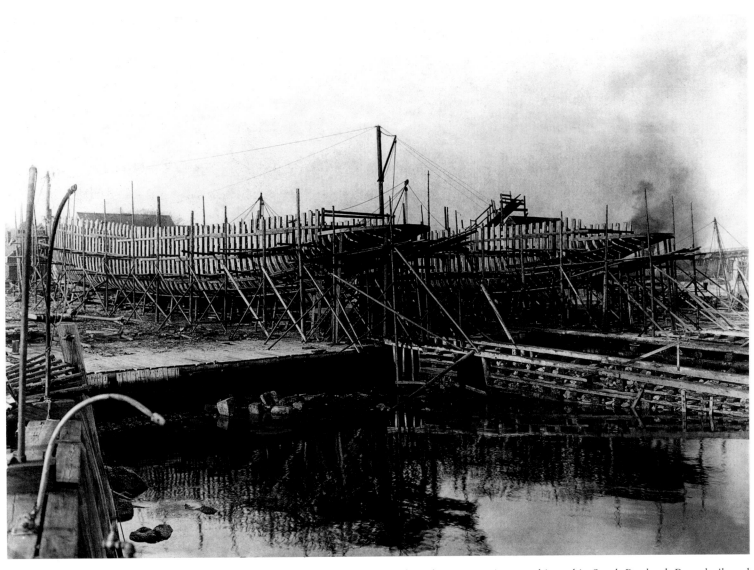

Here are the beginnings of two vessels under construction at a shipyard in South Portland. Boats built and outfitted by the Portland Company included towboats, fishing vessels, yachts, dredges, freighters, fireboats, and ferries. This image is part of the Portland Company collection of photographs.

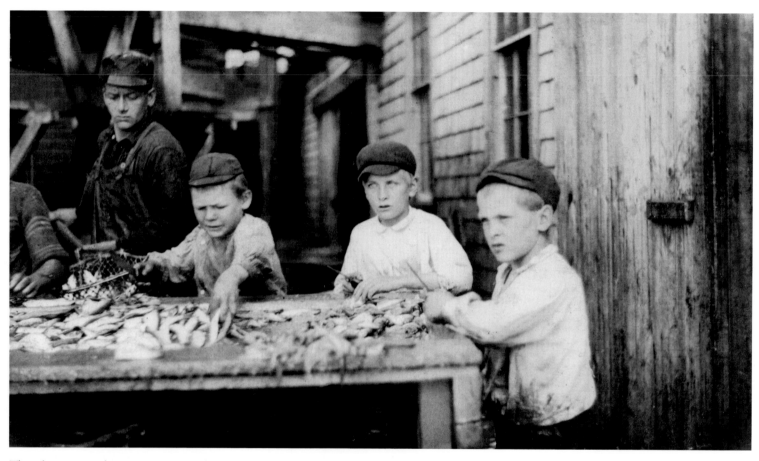

These boys are working in Eastport at the Seacoast Canning Company Factory #4 in August 1911. They are aged 10 to 12 years. Well-known photographer Lewis Hine was hired by the National Child Labor Committee to take pictures of working school-aged children and the conditions of the working environments.

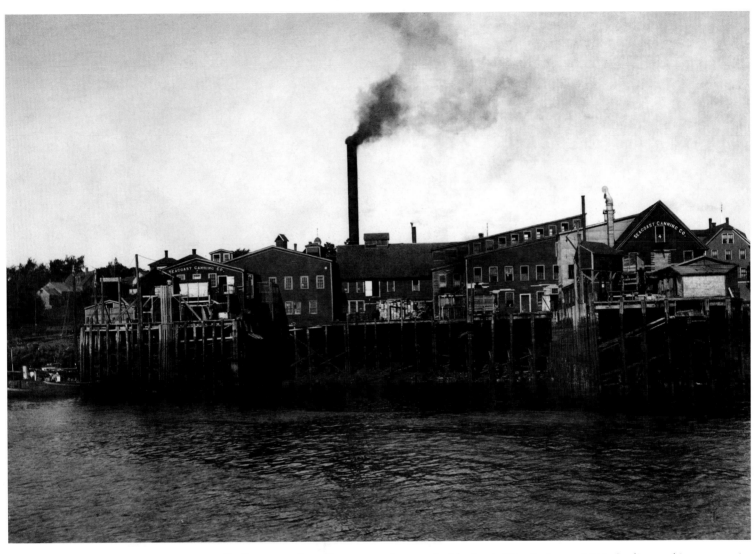

Sardine canneries at Eastport as photographed by Lewis Hine in August 1911. Sardine-packing companies in Eastport included the Sea Coast Packing Co., L. D. Clark & Sons, George O. Grady & Co., John Greenlaw, MacNichol Bros., and Blanchard Hiram.

Lewis Hine photographed these boys holding cans of sardines, the product of their work. They are standing outside the Seacoast Canning Company Factory #2 in Eastport in August 1911.

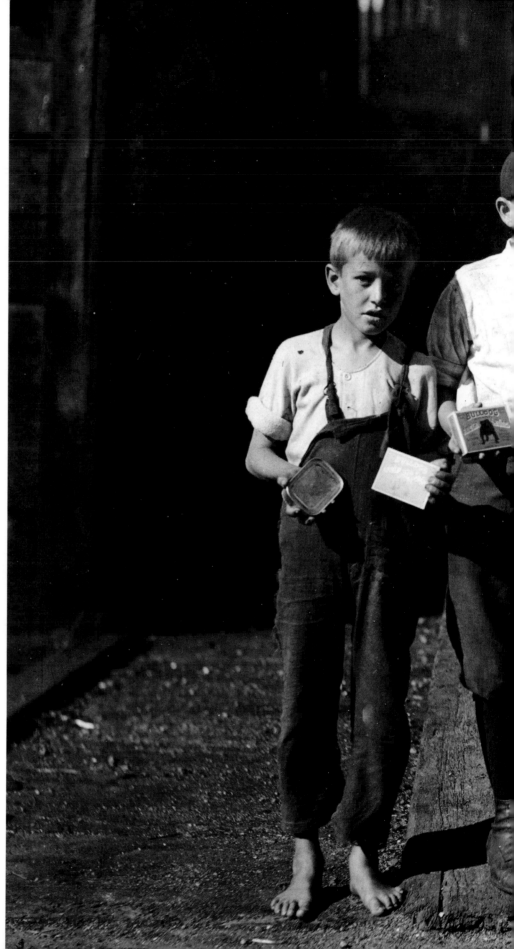

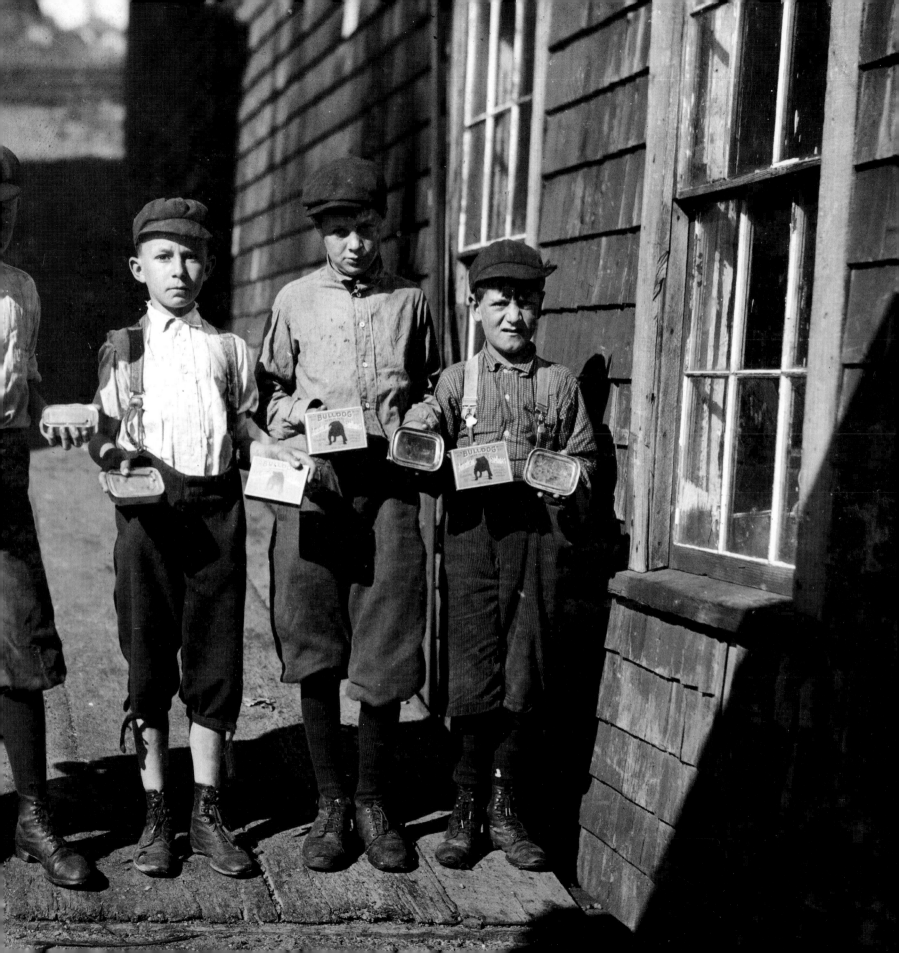

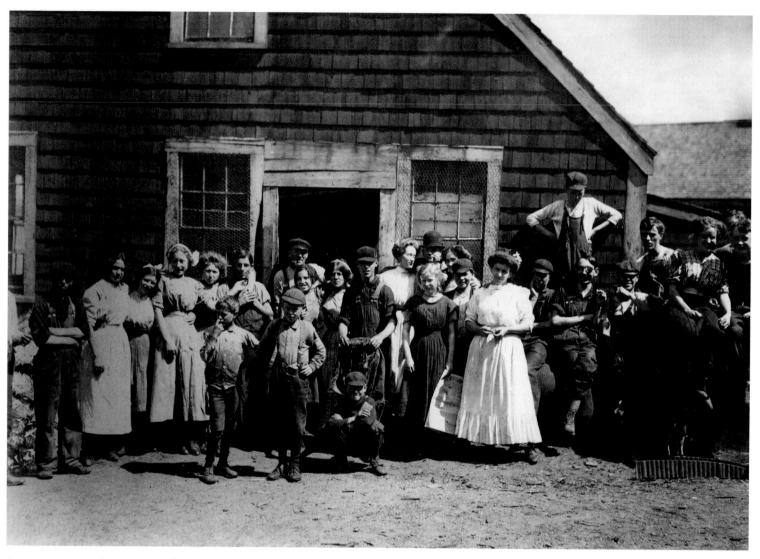

Seacoast Canning Company employees pose for a group photograph in front of Factory #4 in Eastport during the summer of 1911. Lewis Hine documented children working in factories and the working conditions in those factories across the United States. His assignment was to showcase the unpleasant conditions under which children were working, yet these employees are pleased to be the subjects of this photograph.

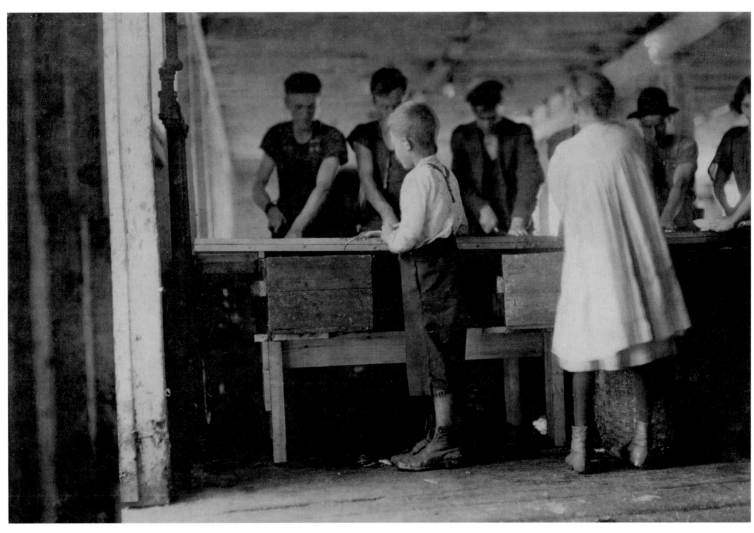

This is the interior of a cutting shed in Eastport, where Clarence, age 8, and Minnie, age 9, spend their days. On the shelf are two of the boxes used as measures—the children were paid 5 cents a box.

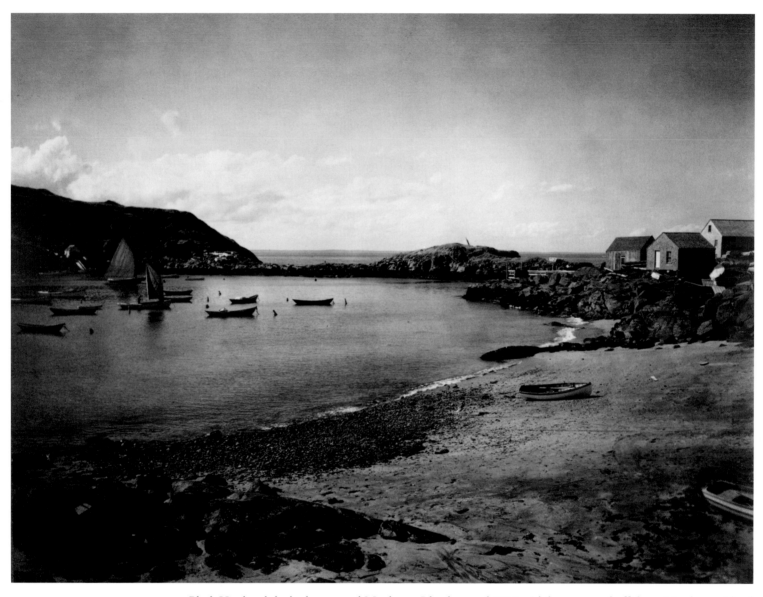

Black Head and the harbor around Monhegan Island around 1913 with boats on and off shore. Monhegan Island was becoming very popular as a tourist destination and artist colony. The cliffs on the eastern side of the island drop 160 feet to the sea, and the dramatic action of the sea beside these rocks drew painters and photographers to capture the scene either on canvas or through the camera's lens.

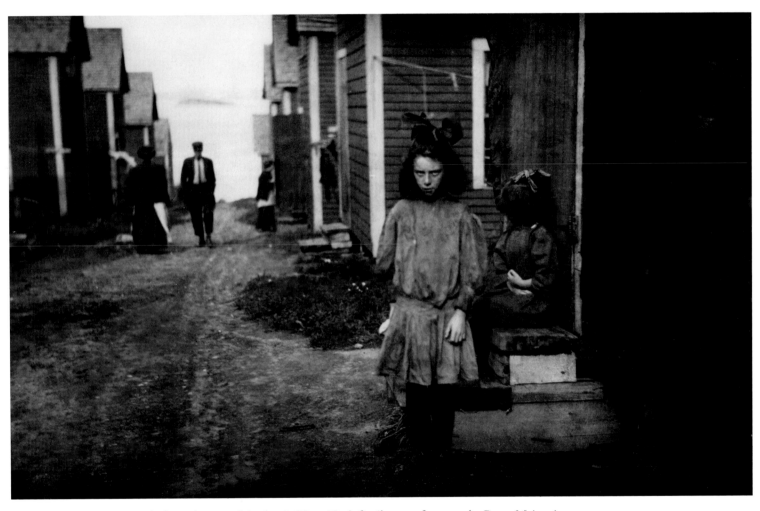

Nan de Gallant, age 9, stands for a photograph by Lewis Hine. Nan's family came from nearby Perry, Maine, in the summer months to help with the sardine canning.

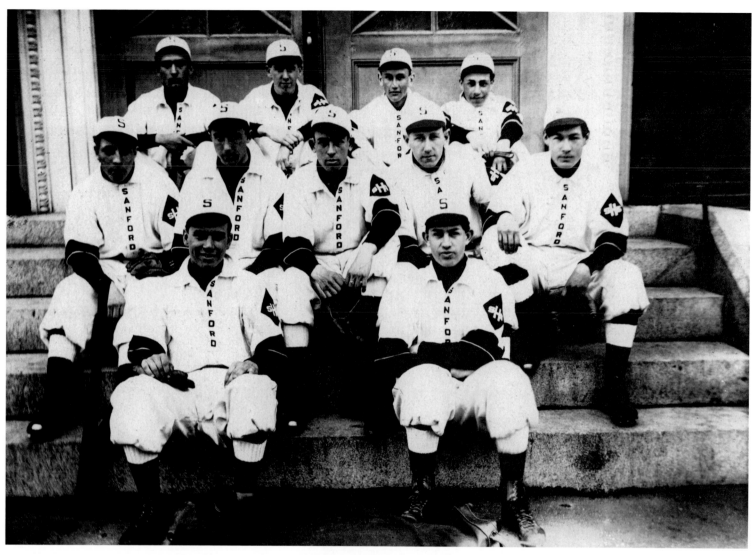

The Sanford High School baseball team of 1912 sits for a group photograph. Front row, left to right, are Winfred Allen and Meyer Shalit; second row: Clarence Thompson, Leon Plaisted, Irmont Frost, Orville Morrill, Ivan Simpson; third row: Joseph Bernier, Charles Crossland, Clarence Thyng, and Silas Albert.

This advertising photograph shows a 1914 Knox-Martin 3-wheeled tractor with a piano or lumber trailer attached. "Portland Company" is prominently written on both vehicles. In the early 1900s the Portland Company sold Knox cars and trucks, placing new locomotives, automobiles, or, in this case, a truck and trailer, outside their facilities next to the harbor for publicity shots.

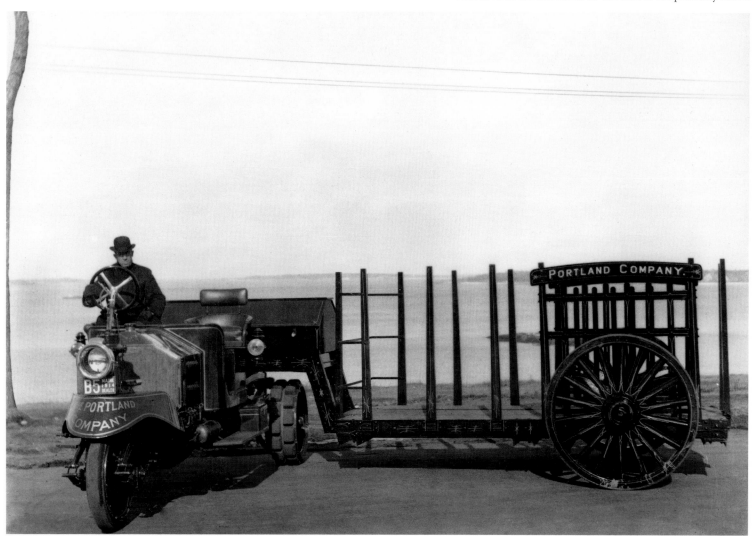

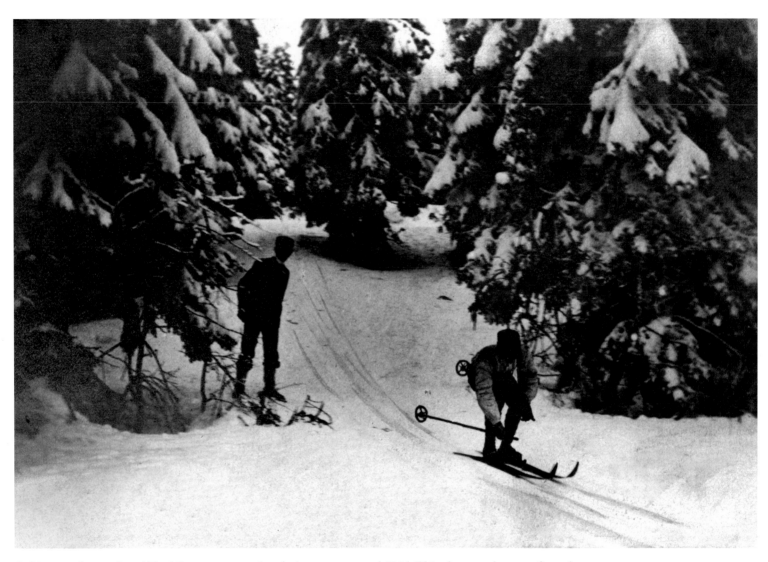

A ski racer schusses downhill while a spotter watches during a race around 1914. This photograph comes from the records of the Theodore A. Johnson Company, which manufactured skis, sleds, and snowshoes in Portland. Skiing remains a very popular winter sport in Maine.

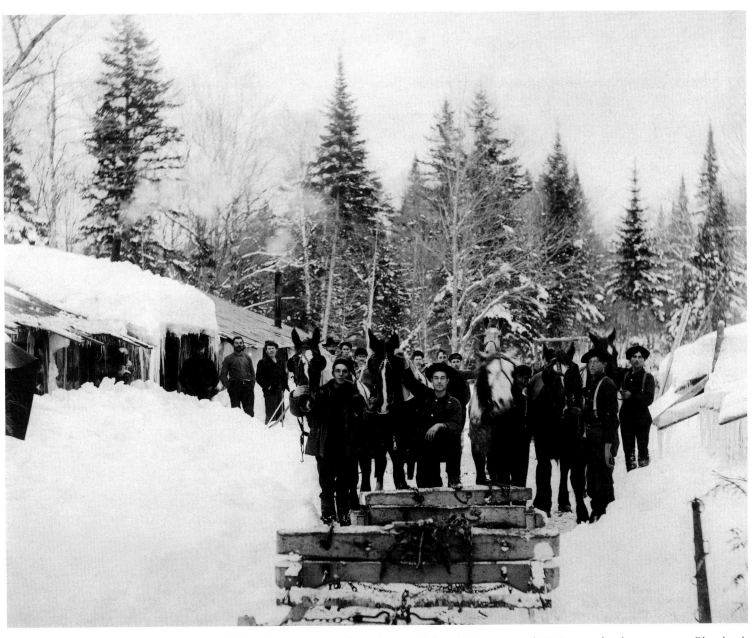

Lumbermen and their horse team pose for a photograph in midwinter around 1915 near a lumber camp near Blanchard. The lives of lumbermen and loggers were rugged—they lived the year long in lumber camps with few comforts and in close quarters. Their work involved felling trees, lopping branches, and harnessing horse or ox teams and sleds to drag the logs from the woods and transport them to the mills.

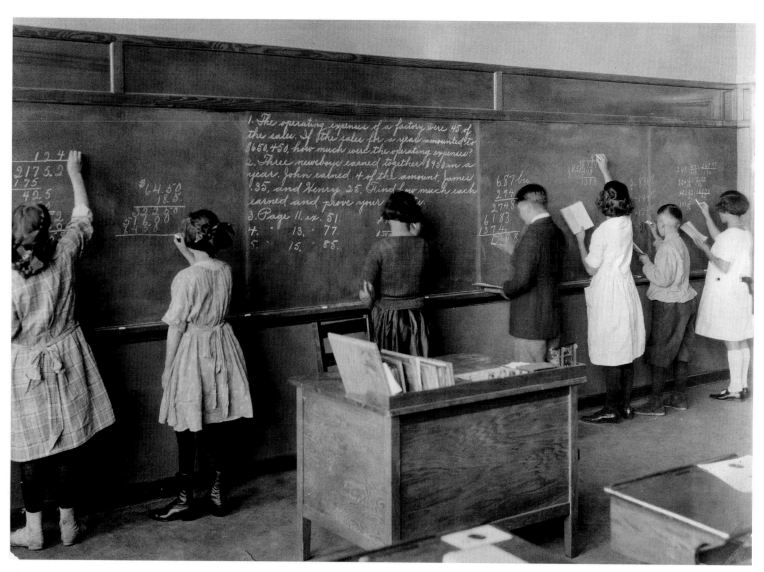

Students at the North School in Portland are busily working on their lessons at the blackboard around 1915. Blackboard question #2 sets up this puzzle: "Three newsboys earned together $975 in a year. John earned .4 of the amount, James .35, and Henry .25. Find how much each earned and prove your [results]." The youngsters all seem to be closing in on their answer.

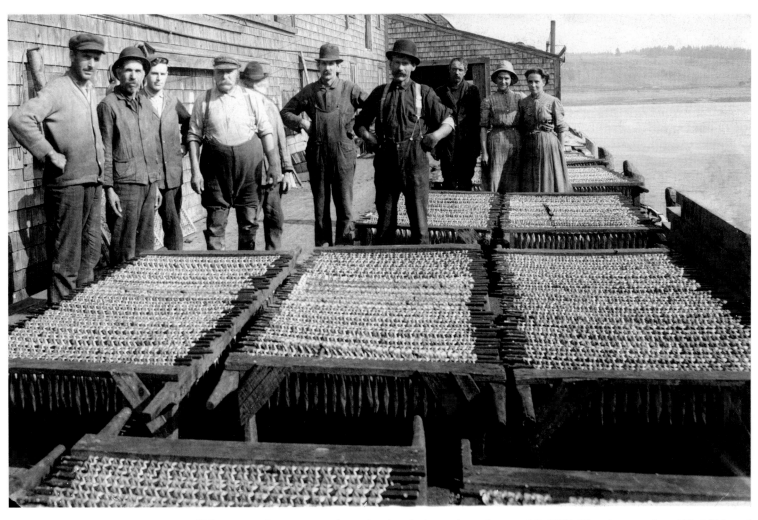

Fishermen and women stand near herring drying racks on January 16, 1917. The photographer, Alfred Elden of Portland, was a freelance journalist for the *Atlantic Fisherman*, a trade periodical published from 1921 to 1951. The fishing industry was an economic mainstay for coastal communities in Maine.

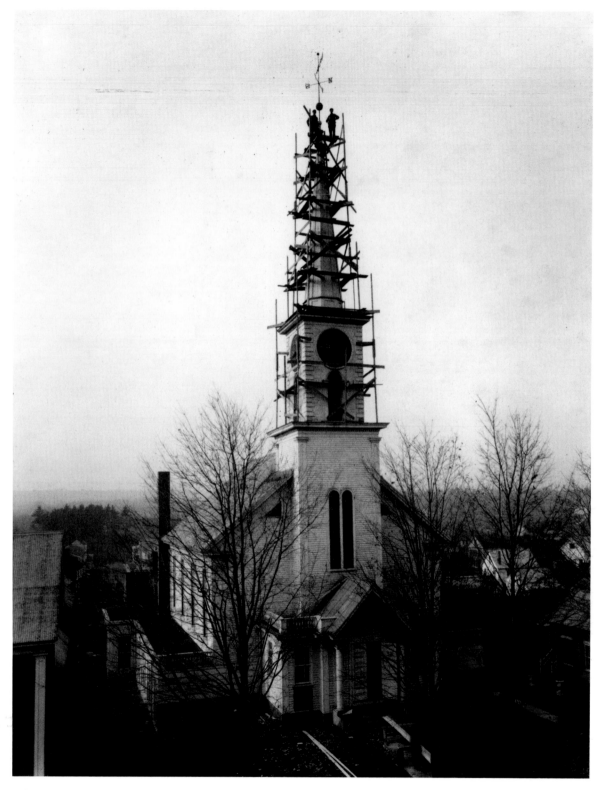

The North Parish Congregational Church in Sanford was struck by lightning on August 23, 1917. This Fred Philpot photograph shows scaffolding and laborers repairing the steeple.

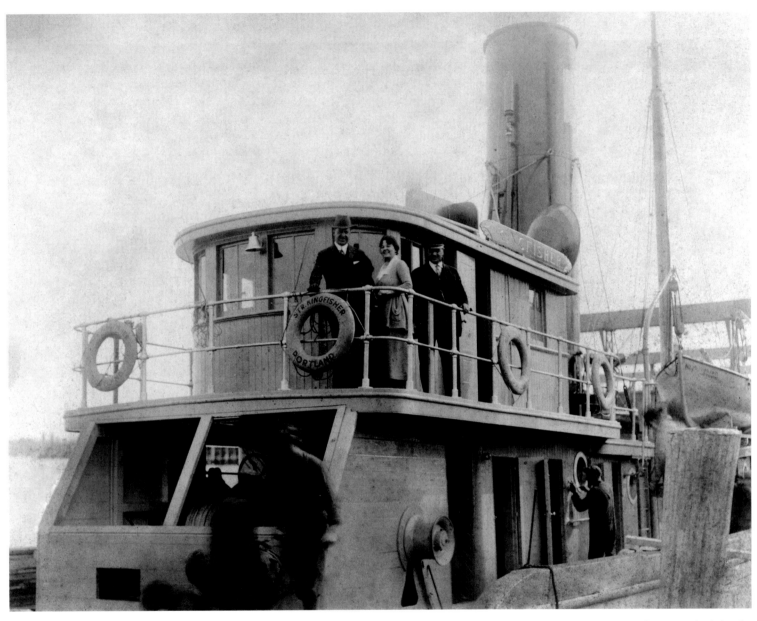

The fishing trawler *Kingfisher* is pictured around 1917 soon after it was built by the Portland Company, with crew and non-crew aboard. The East Coast Fisheries Company out of Rockland commissioned this boat.

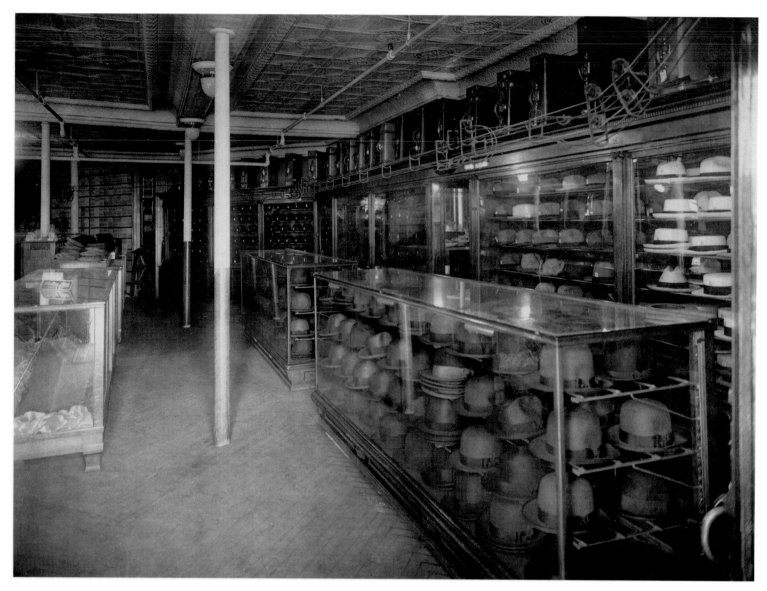

Displays of men's hats in the hat department at A. H. Benoit's Portland store in 1919 show the styles popular just after World War I. Store founder Arthur Henri Benoit was born in Quebec, worked in the textile mills in Biddeford, and joined as a partner with C. H. Webber at a new Westbrook store in 1890. He became full owner of the A. H. Benoit Company soon after and created the largest men's clothing company in Maine.

BETWEEN THE WARS

(1920–1939)

"Let us, then, be up and doing, / With a heart for any fate; / Still achieving, still pursuing, / Learn to labor and to wait." (Henry Wadsworth Longfellow). This verse captures the tone of Maine's condition during these two decades between the great wars. Maine's forests were disappearing, being cut and milled into lumber and paper. A speech by Governor Percival Baxter to the legislature in 1921 regarding land around Mount Katahdin highlights the growing interest in conservation.

"Maine is famous for its twenty-five-hundred miles of seacoast, with its countless islands; for its myriad lakes and ponds; and for its forests and rivers. . . . This park will prove a great attraction, not only to the people of Maine who will frequent it, but also to those who come from without our state to enjoy the free life of the out of doors. The park will bring health and recreation to those who journey there, and the wildlife of the woods will find refuge from their pursuers, for the park will be made a bird and game sanctuary for the protection of its forest inhabitants."

After World War I, Maine's economy entered a small decline. The agricultural products grown for the soldiers were no longer needed, and Maine farmers were making little money. Many left their farms to work in factories. Paper-mill towns prospered but textile mills were losing business to mills in the South. Bath Iron Works closed for a time.

Automobile travel began to overtake railroads as roads improved and cars became affordable. Automobile races were held along the low-tide line of Old Orchard Beach in the 1920s and air travel was an exciting new phenomenon. Maine hosted two air shows at Old Orchard in the mid 1920s.

The Great Depression swept the country in 1929, but Maine did not vote for Franklin D. Roosevelt and his New Deal in 1933. Mainers, suspicious of federal involvement and excessive government spending, voted against FDR's ticket. "As Maine goes, so goes the nation," had gone the popular saying. In 1936, neither Maine nor Vermont voted to reelect Roosevelt and the saying became, "As Maine goes, so goes Vermont." Notwithstanding the vote, Maine benefited from New Deal programs such as the National Youth Administration, the Civilian Conservation Corps, and the Works Progress Administration.

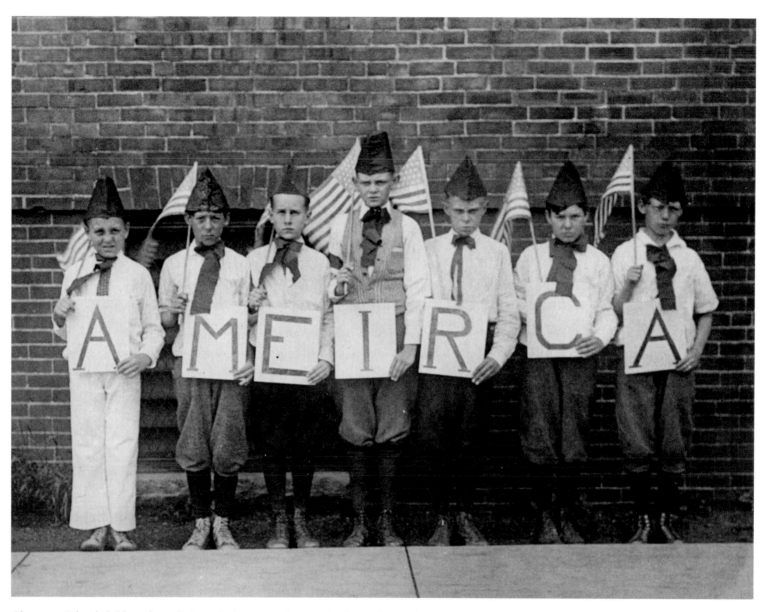

Chapman School children show their patriotism around 1920, displaying letters that spell "America" (well, almost). At this time in Portland, Americanization classes were held to teach immigrants and their children American civic life, American culture, and English. This may have been one of those classes.

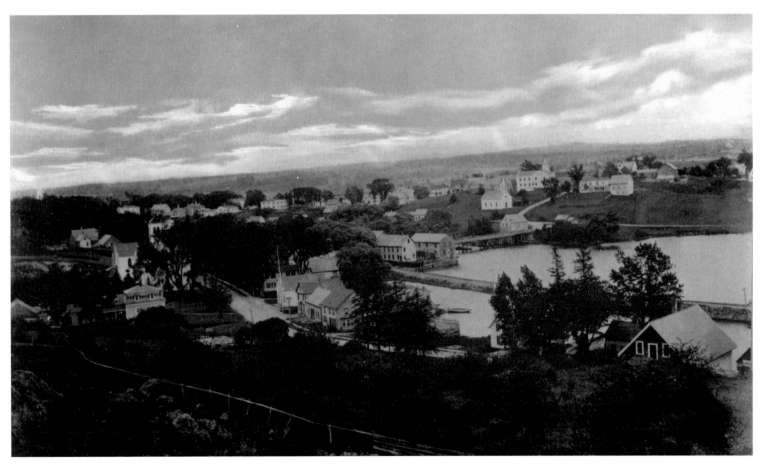

East Machias lies on the northern seacoast of Maine and in 1920 was primarily a fishing village. Machias means "bad little falls" in the Passamaquoddy language. In June 1775, citizens of the town were so outraged at British conduct that a group of them, led by Jeremiah O'Brien and Benjamin Foster, commandeered two boats and attacked and captured the British vessel HMS *Margaretta*. This is considered the first naval battle associated with the American Revolution.

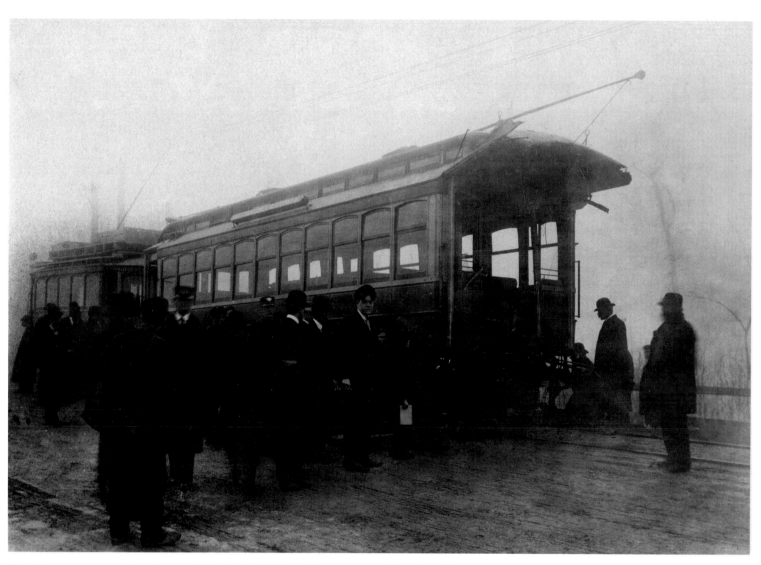

Would-be passengers and employees of the Portland Railroad Company stand beside a trolley car around 1920. Mechanical difficulties would explain why some of the men are on their knees, apparently making an inspection or perhaps repairs.

Santa Claus visits the North School in Portland, around 1920. The school is located in the Munjoy Hill neighborhood on Congress Street. During the early 1900s there were large numbers of immigrant children in attendance.

The Chapel at Bowdoin College was designed by architect Richard Upjohn in the Romanesque style and built between 1844 and 1855. In 1855, this building served as a chapel for worship, home for the Peucinian and Athenaean societies' libraries, and an art gallery. In the 1920s, when this photograph was made, the building served as chapel and academic classroom space.

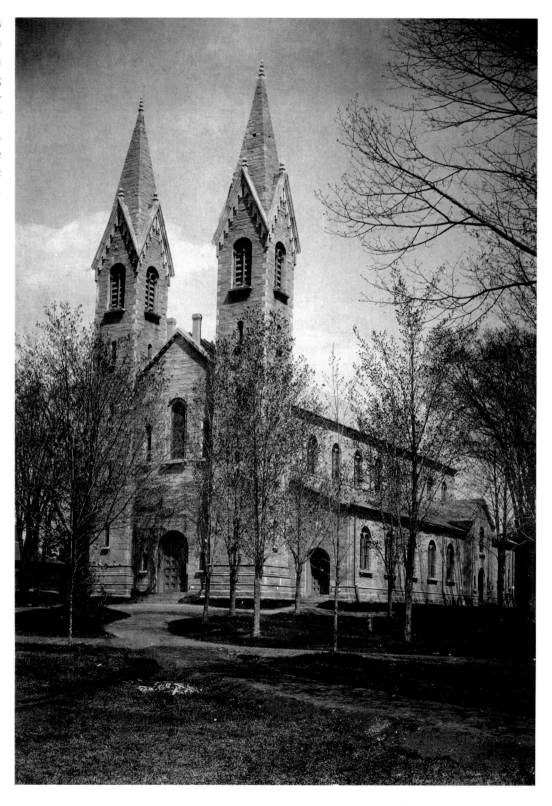

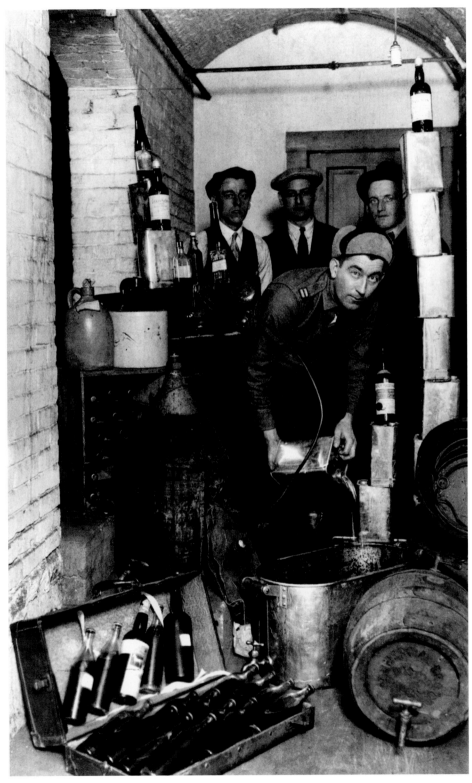

On January 20, 1920, Prohibition, the law prohibiting the production, sale, and transportation of intoxicating liquors, was enacted as the 18th Amendment to the Constitution. This photograph shows Horace McClure, Sagadahoc County's sheriff, pouring contraband liquor seized by his department into metal tubs at the county courthouse sometime after the law was signed.

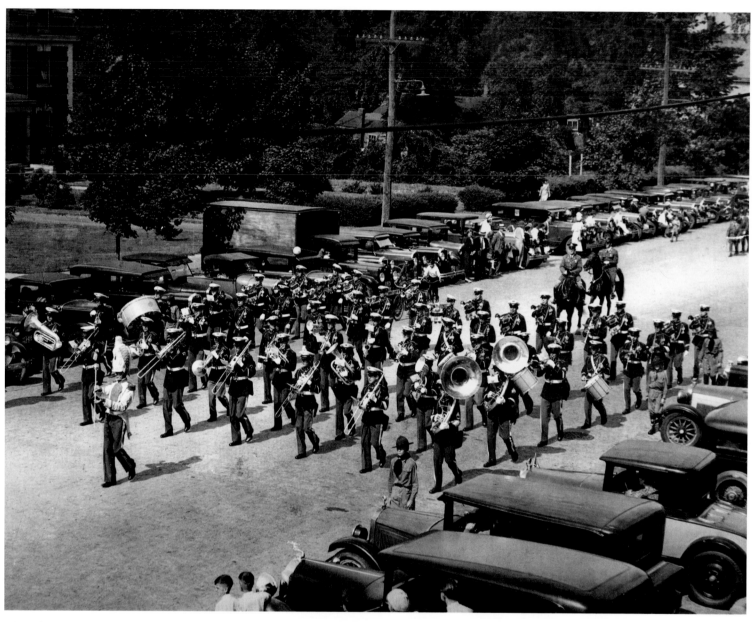

The Fifth United States Infantry was billeted in Fort Williams at Cape Elizabeth from 1922 to 1939. The regiment adopted the first celebration of Organization Day in 1923, in commemoration of the victory at Lundy's Lane during the War of 1812. This may be one of those commemorations by the Fifth. Shown here is the Infantry's marching band parading through the streets of Cape Elizabeth, around 1923.

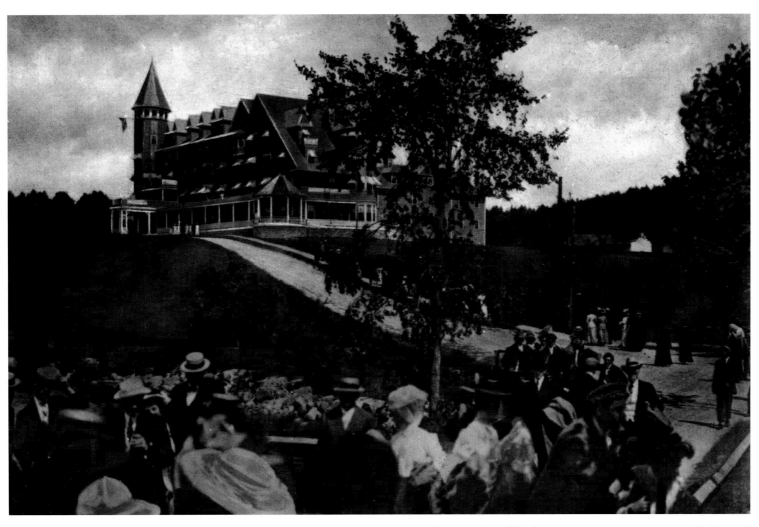

When the Bay of Naples Inn opened its doors to the first steamboat full of passengers in 1900, it had a staff of 85 and its own dock and baggage station at lakeside. In the 1920s, when this photograph was taken, the inn was attracting large numbers of vacationers, many of whom spent the entire summer season there.

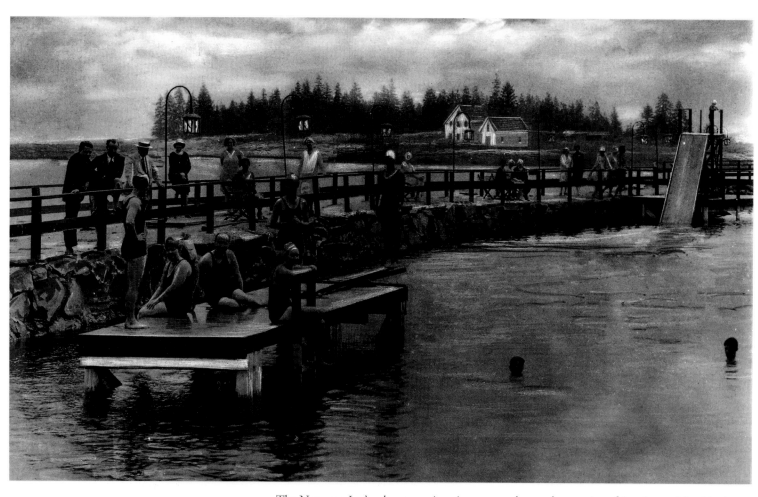

The Newagen Inn's saltwater swimming area at the southern point of Southport Island is shown here with bathers and onlookers enjoying the scene, around 1920.

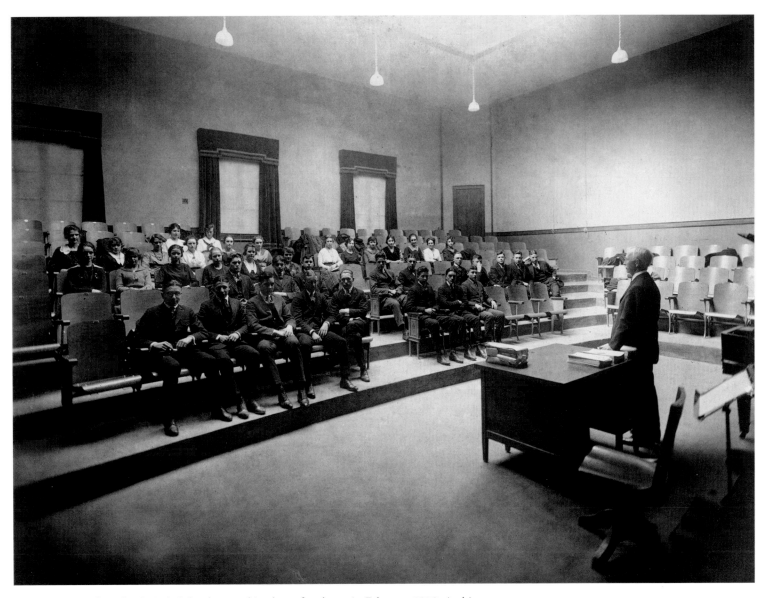

The new wing of Portland High School opened its doors for classes in February 1919. Architects William R. Miller and Raymond Mayo of Portland were the designers. The design of the lecture hall, shown here, was considered their crowning achievement.

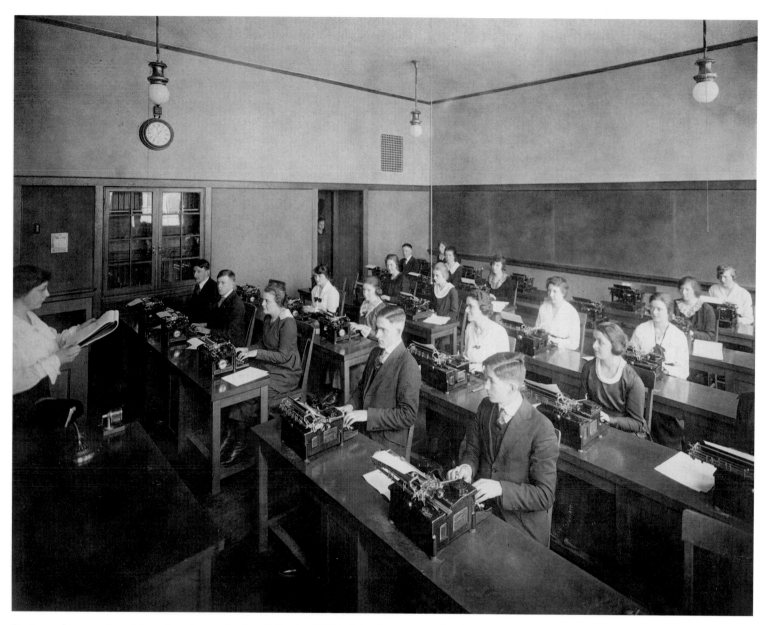

Business classes such as this typing class at the "new" Portland High School were considered quite modern. Two typing classrooms were included in the school's design by architects Miller and Mayo. The new school opened for classes in 1919. Portland High School is the second-oldest public high school still in operation in the United States, having originally begun classes for boys in 1821.

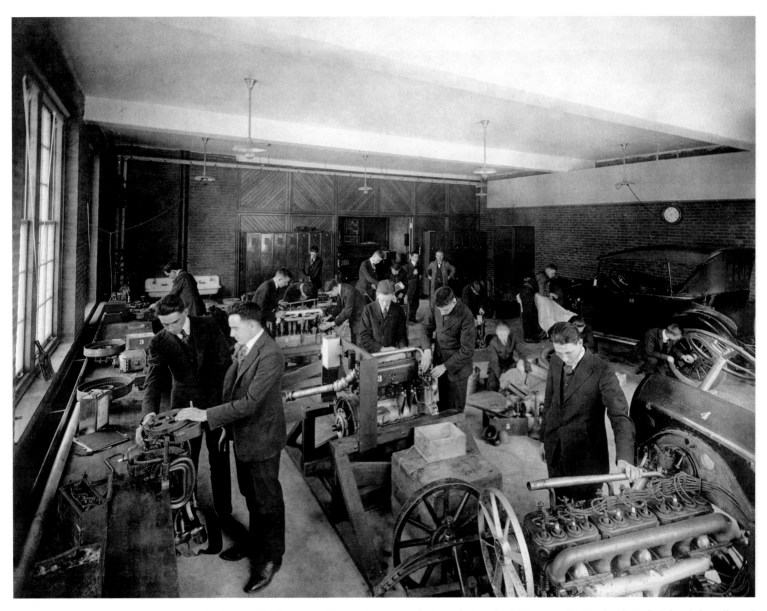

Architects William R. Miller and Raymond Mayo designed additions to the Portland High School that allowed for an expansion of home economics, industrial arts, and physical education programs. This auto repair class was photographed around 1920. The students are dressed in coats and ties, which may indicate that this photograph was taken outside normal class hours.

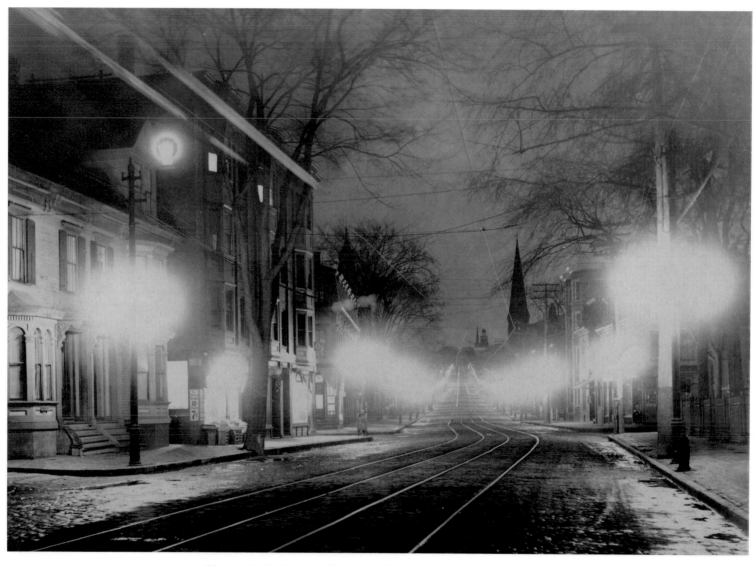

The Portland Company fabricated all manner of cast-metal products, including these streetlights illuminating Congress Street in Portland around 1920. The city ordered decorative poles that would hold the globe lights, electric wiring, and the trolley's electric overhead lines.

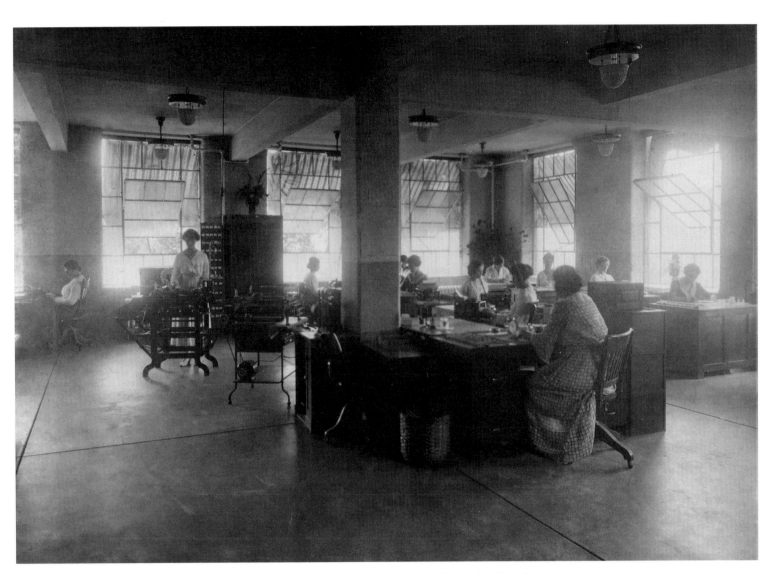

Women workers at the Gannett Publishing Company in Augusta are shown here producing the *Kennebec Journal* around 1929. The Gannett Publishing Company had its beginnings in 1888, publishing *Comfort* magazine and expanding to include many of the state's newspapers, including the *Press Herald* and *Sunday Telegram*. It bought the *Kennebec Journal* in 1929.

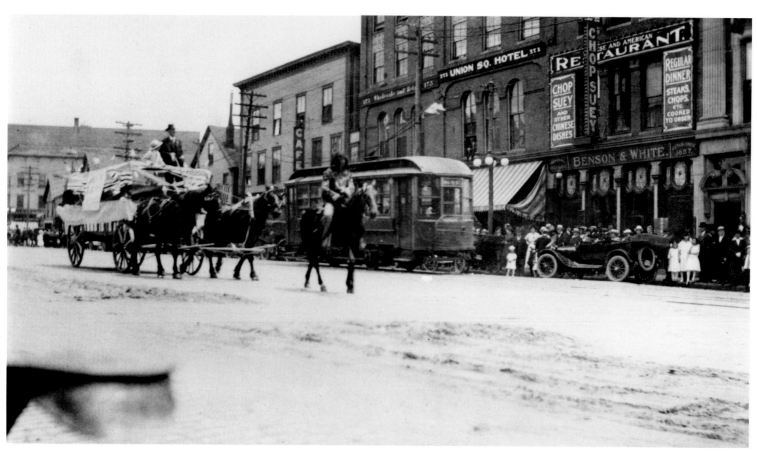

In this view from around 1920, a parade seems to be in progress in Lewiston along Main Street. A lone horse and rider precedes a large wagon driven by a man in suit and tie and young girl in a hat and dress, with onlookers at the sidewalk and upstairs windows. A Chinese restaurant (which may be the Oriental Restaurant) advertises chop suey and regular dinners.

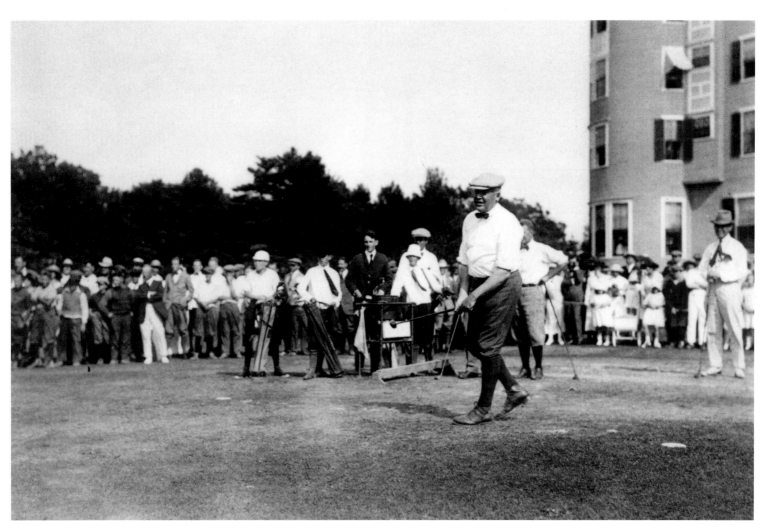

President Warren G. Harding (1865–1923) is shown golfing at Poland Spring House July 6, 1921. The Poland Spring House was a popular destination for the rich and famous during the Roaring Twenties. The luxury hotel included all modern conveniences, recreational facilities, and the invigorating and famously curative waters of the nearby springs.

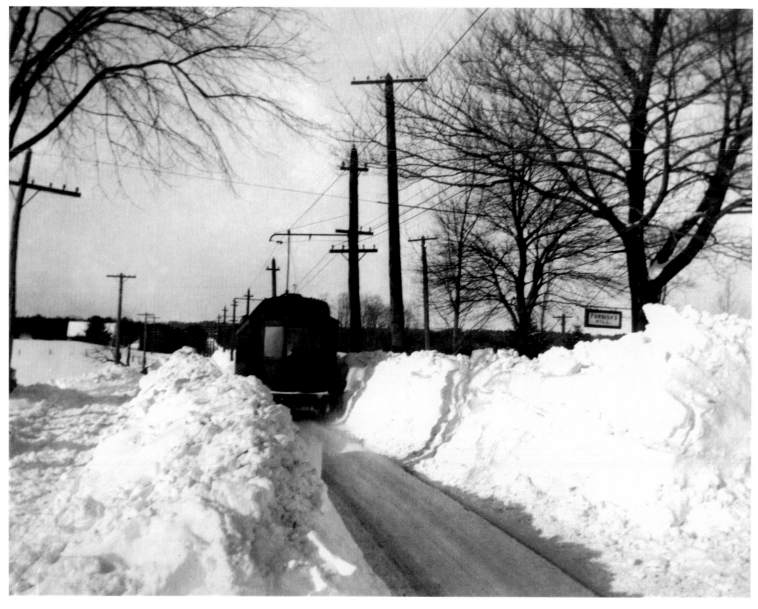

During the winter of 1923, employees of the Portsmouth, Dover & York Street Railway struggled to keep the road open and clear of snow. This car is headed out of North Berwick for Dover, New Hampshire, on the last day of the railway's operations, March 17.

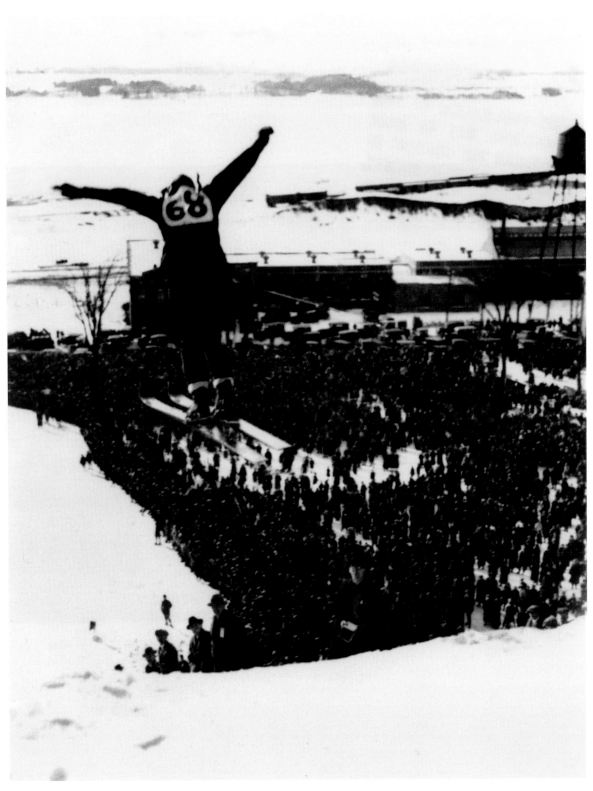

Portland celebrated a Winter Carnival in 1924 that included many winter sports such as sled dog racing, the snowshoe dash, skating, and ski jump competitions. A large wooden ski jump was built on the Western Promenade by Birger Olsen. More than 5,000 spectators came to see the jump competitions.

The Rayville School children in Otisfield were visited by Cumberland County Public Health Association workers around 1925. The county was engaged in a large-scale initiative to improve the health of the children. This school was located at the intersection of the Jackson Brook Road and Rayville Road.

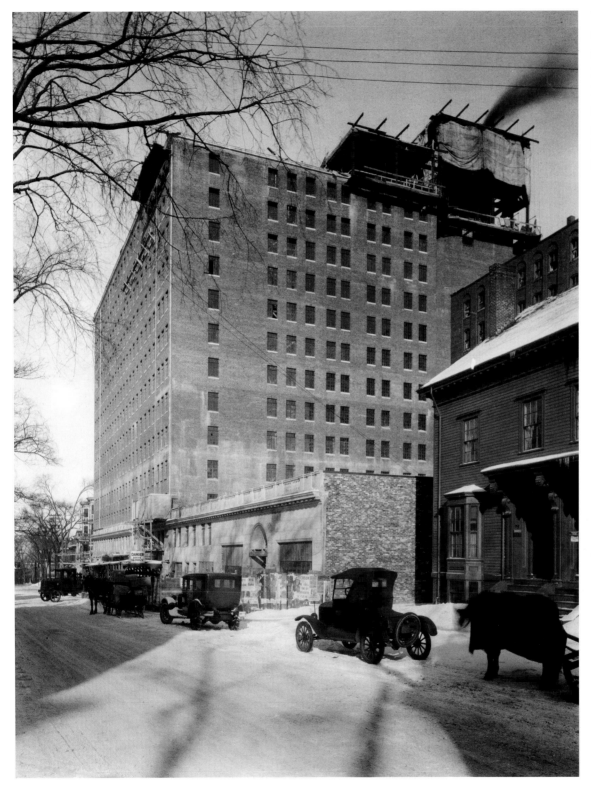

The Eastland Hotel in Portland was built as an addition to the Congress Square Hotel in 1926-27. Here on January 12, 1927, construction continues at the top of the building. Once completed, the entire complex became the largest hotel north of New York City.

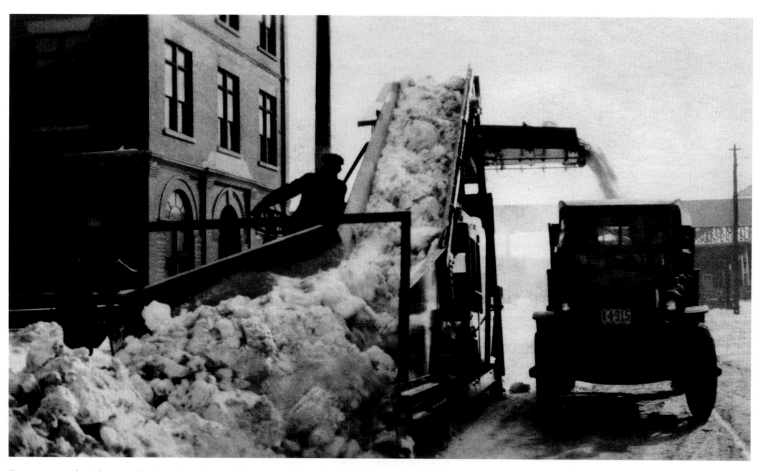

Snow removal under way during the winter of 1927-28 in Portland shows the efficiency of the Sargent snow loader, manufactured by the Portland Company. What cannot be seen is the tracked vehicle beneath the loader, called a Cletrac crawler. Beside both is a Mack truck receiving its load of snow.

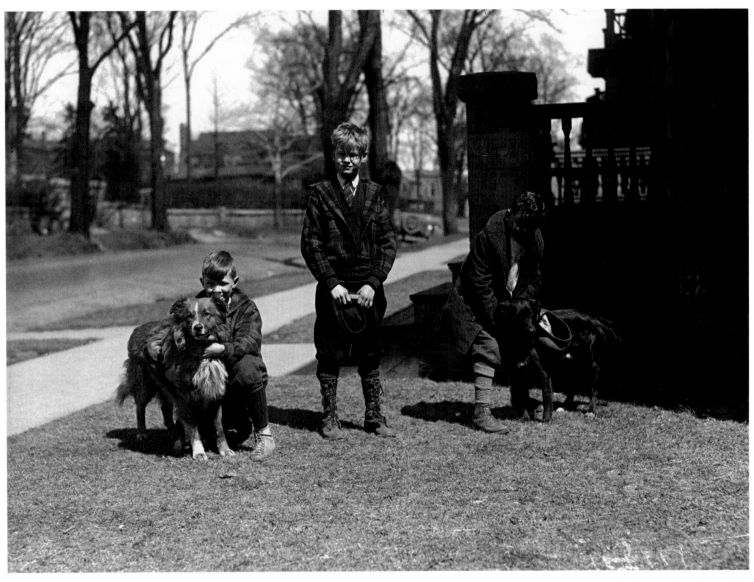

These three boys show off their pet dogs to a *Portland Press Herald* photographer during "Be Kind To Animals Week" in the spring of 1927. A contest usually accompanied the event sponsored by the American Humane Society.

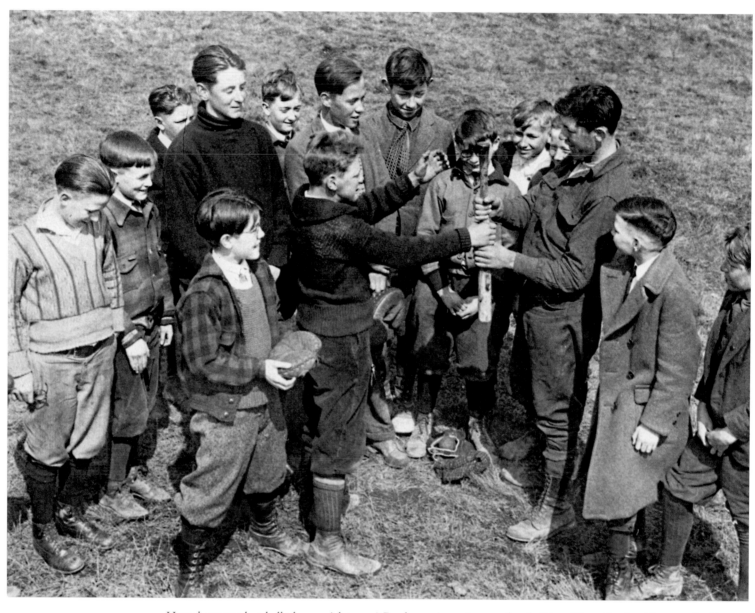

How do young baseball players pick teams? By alternating grips on a baseball bat. These Portland boys are looking on while the captains see who gets to select the first player on a cold day in 1927.

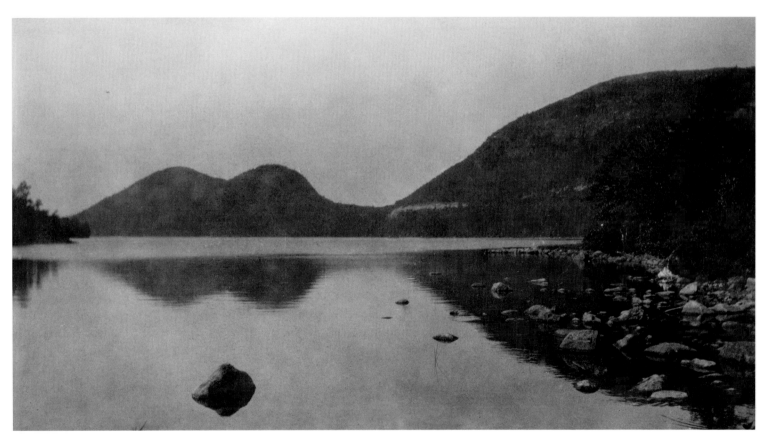

This view of Jordan Pond with the two Bubble mountains in the distance was taken in 1927 in Lafayette National Park, renamed Acadia National Park two years later. In 1919, President Wilson signed an act establishing the area on and around Mount Desert Island as a national park.

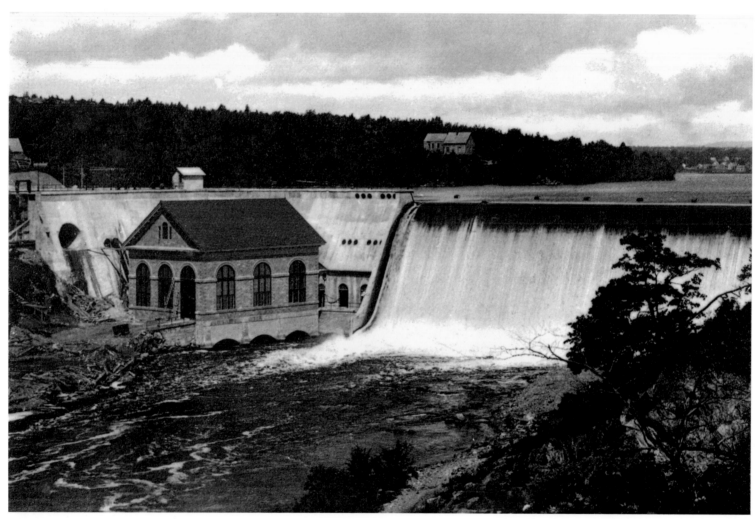

The Union River runs through Ellsworth, and photographer A. Thompson captured this image of the power-generating station and dam as they looked around 1930. The dam was built in 1907 and creates Leonard's Lake, also shown.

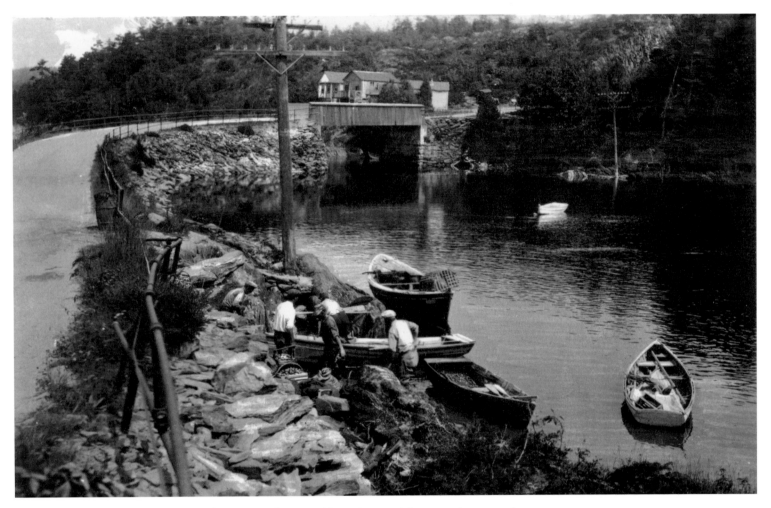

Lobstermen are pulling in one of their dories around 1930, with equipment, lobsters, and traps, at the base of the Orr's Island bridge. This bridge connects Orr's Island and Great Island. The lobster fishing industry was changing at this time—the demand for live lobsters was overtaking that for canned lobster meat and more fishermen were choosing to enter the field.

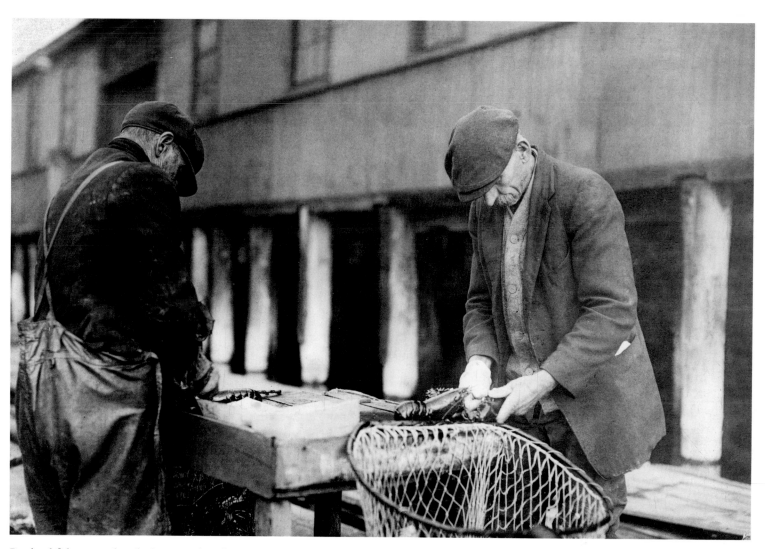

Portland fishermen plug the large crusher claws on a catch of lobster around 1930. Alfred Enden, photojournalist for the fishing industry's trade magazine *Atlantic Fisherman,* photographed these men at work on the wharves of Portland. The crusher claws are plugged so that handlers are protected from injury. In the late 1920s, lobster fishermen may have received between 10-14 cents a pound for their catch.

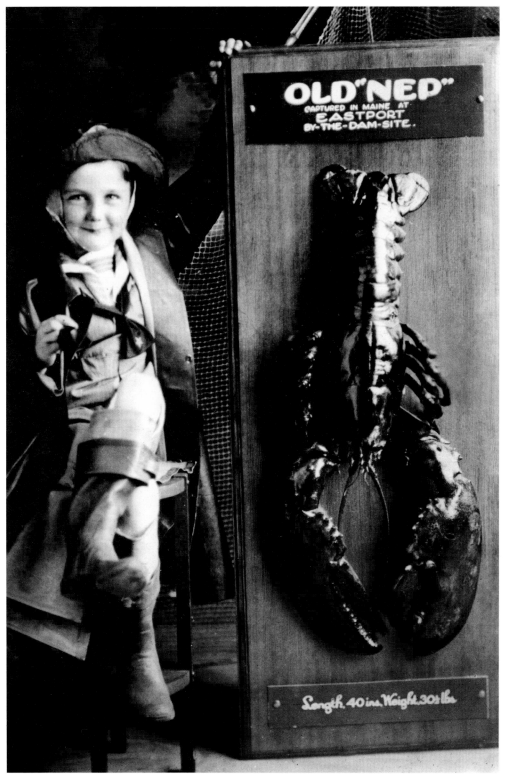

A very young "lobsterman" sits beside this very large lobster named "Old Nep" at the Acme Theater. The lobster was caught near Eastport, weighed in at 30.5 pounds, and was 40 inches long. Fred G. Milliken, photojournalist for the trade magazine *Atlantic Fisherman,* took this photograph around 1930.

This image of the coastal fishing village of East Machias in Washington County was captured expressly for making postcards. The Wittemann Brothers Postal Card Company sent photographers into the New England countryside from the 1920s to the 1940s to photograph local scenery for the cards.

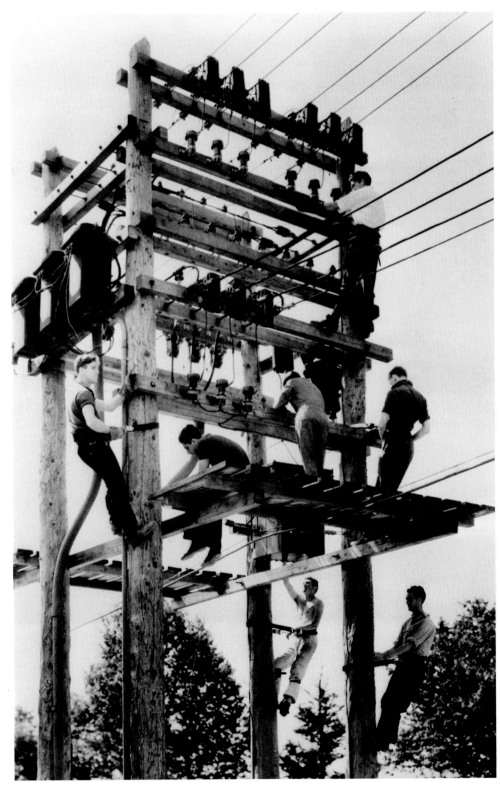

President Franklin Delano Roosevelt signed the National Youth Administration program into law in 1935 at the encouragement of his wife, Eleanor. The program was designed specifically to address the problem of unemployment among Depression-era youth. Shown here are young men of Maine, enrolled in this government program, working on utility poles sometime between 1935 and 1943.

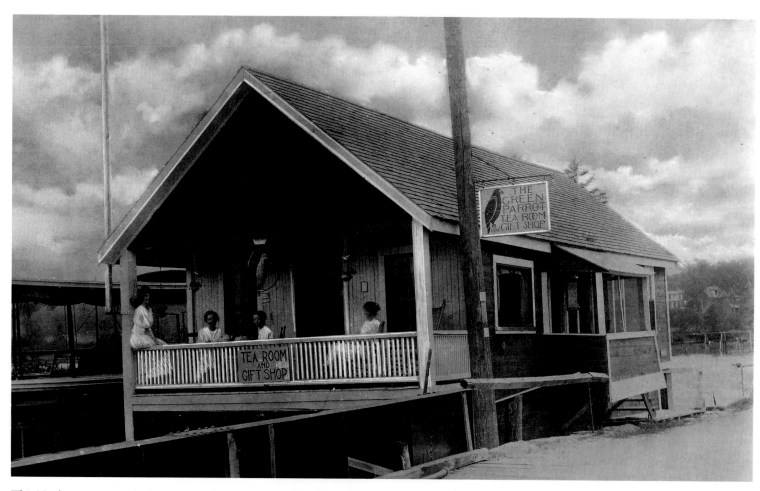

This Naples restaurant, the Green Parrot Tea Room and Gift Shop, is set up to attract tourists with the decorations on the small porch. These women are enjoying tea while a Wittemann Card Company photographer takes a picture, around 1930. With automobile travel becoming easier and train service expanding, vacationers flocked to rural Maine during the summer months.

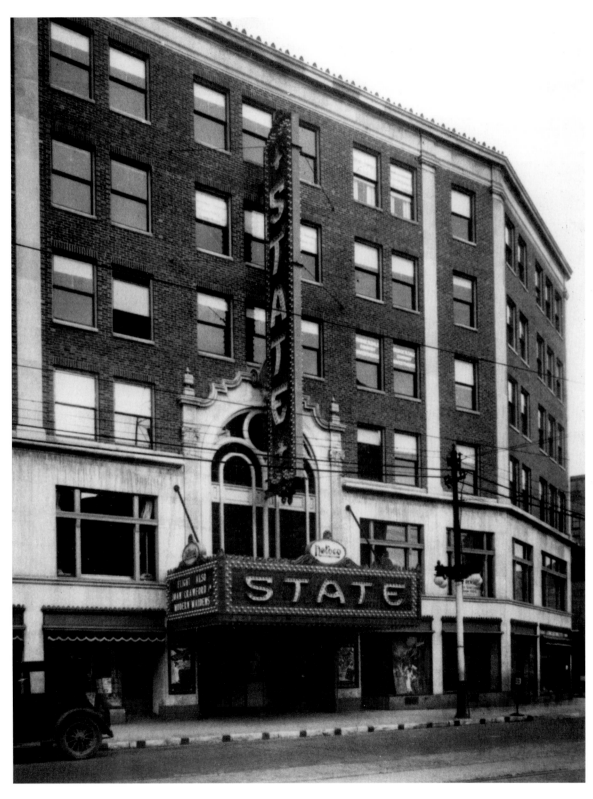

The State Theater on Congress Street opened its doors November 9, 1929. Designed by Portland architect Herbert W. Rhodes in an Italianate style with Spanish motifs, this theater included the most up-to-date projectors, seating, and amenities. Ushers used forty different hand signals to communicate with one another.

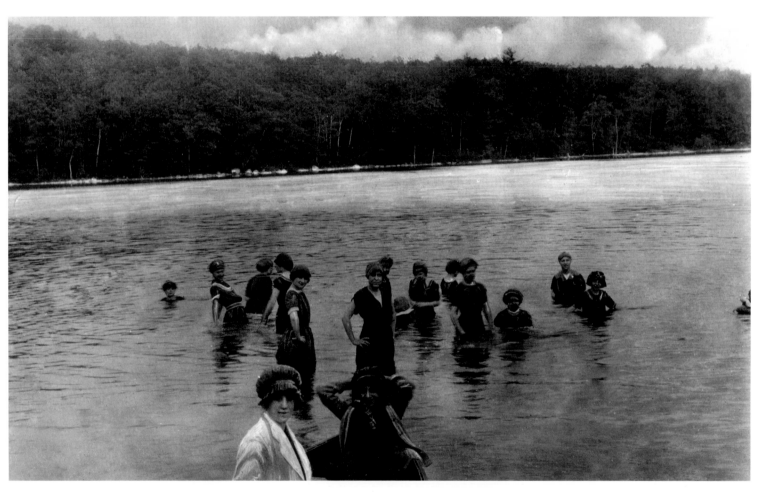

Hundreds of thousands of children have spent time in Maine attending summer camps. The Lakes Region of Maine offers a full array of camps because of the number of lakes and ponds available for swimming and boating activities. These girls are enjoying the water at a camp in Naples around 1930, dressed in swimming attire and bathing caps.

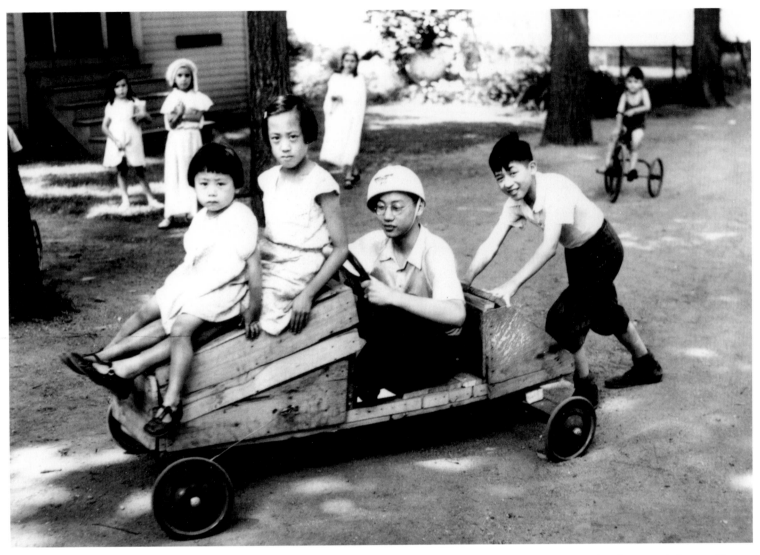

Doris, Josephine, Richard, and Edward Goon ride their go-cart at their home in Arlington Place at Woodford's Corner in Portland. The Goon family owned a laundry nearby. A national youth soapbox derby competition was started in 1934 and races were held in Portland, which may have inspired these children to build their own soapbox derby cart around the same time.

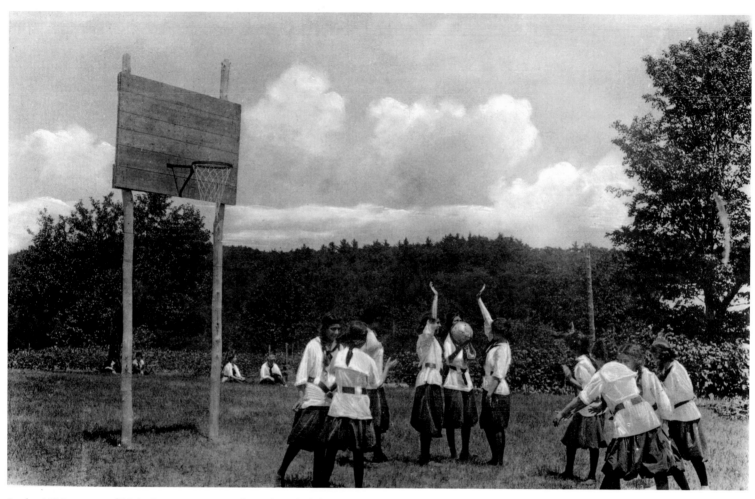

In the 1930s, many of Maine's summer camps for girls included sports activities such as basketball, swimming, and boating. Naples, with its lakes and ponds, hosted a number of camps. By 1940 there were 41 camps for girls in Maine.

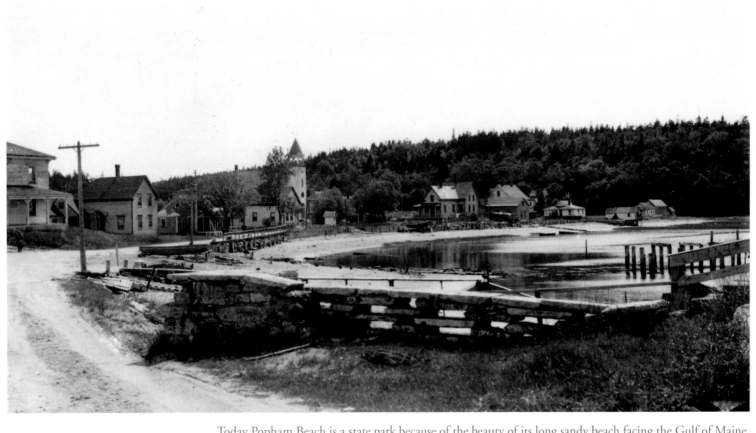

Today Popham Beach is a state park because of the beauty of its long sandy beach facing the Gulf of Maine. This photograph, taken by a Wittemann Brothers Postal Card Company employee around 1930, shows a quiet cove and rural village scene near the shoreline.

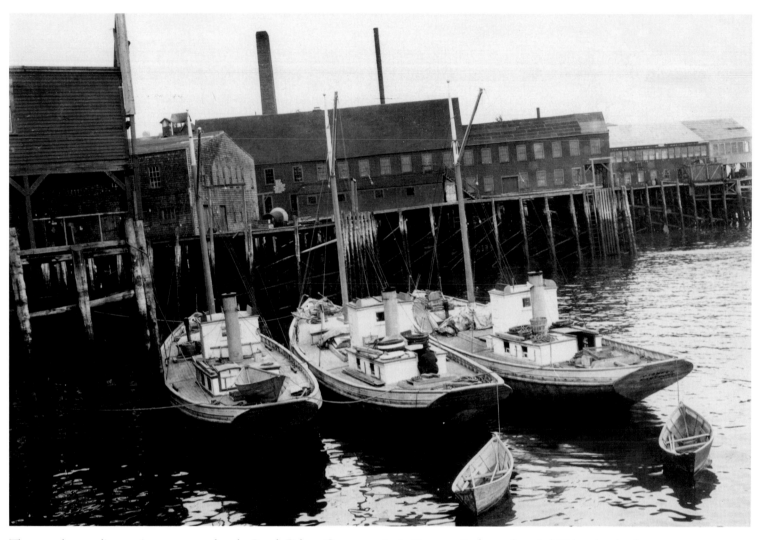

These modern sardine carriers are moored at the Booth Fishery Company pier in Eastport. Each vessel carried 60 hogsheads of fish, cost about $15,000, and ran on 60-horsepower crude oil engines. Canneries in Eastport in 1930 included B. H. Wilson Fisheries, J. W. Beardsley & Son, Booth Fisheries, and E. A. Holmes Packing Company.

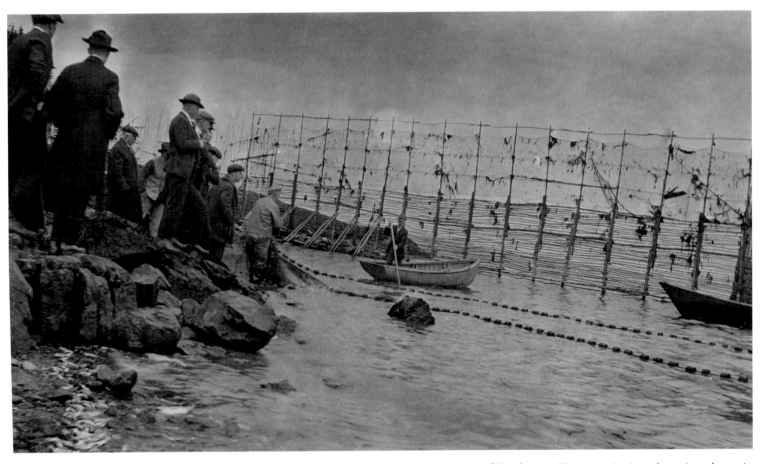

Herring weirs are commonly used in the Bay of Fundy area. Herring swim into the weir and men in seining boats, seen here, draw the edges of the weir net closed, trapping the fish. Some of the men on shore are dressed in suits, suggesting that a special event is in progress. Photographer Fred Milliken for the *Atlantic Fisherman* caught this scene in Eastport around 1930.

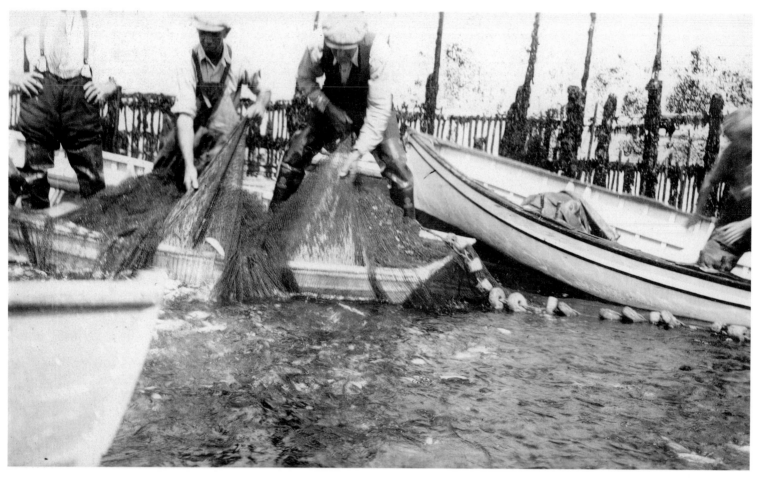

Herring nets full of fish are being pulled into seining boats and the catch will then be taken ashore to the canning factories. These fishermen are working out of Eastport in 1931. Photojournalist Alfred Elden for the *Atlantic Fisherman* magazine captured this image.

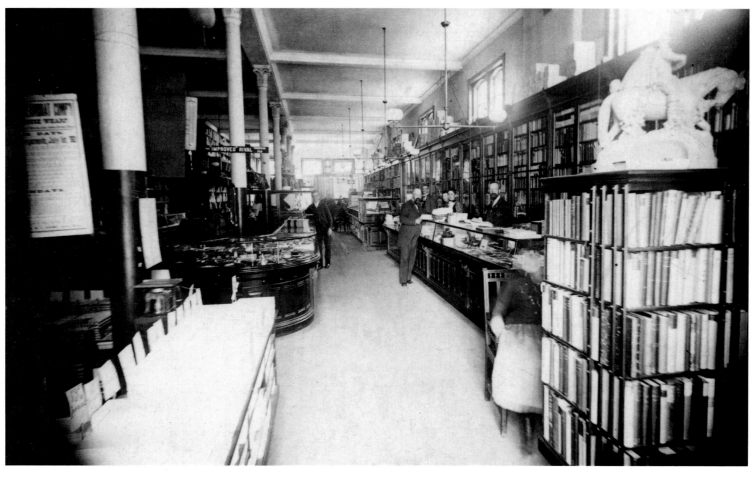

The Loring, Short & Harmon store in Portland was located in the Baxter Block on Congress Street in the 1930s. The company was one of the largest manufacturers of blank books in the country, and also sold stationery, wallpaper, books, and toys. Shown here is the book department.

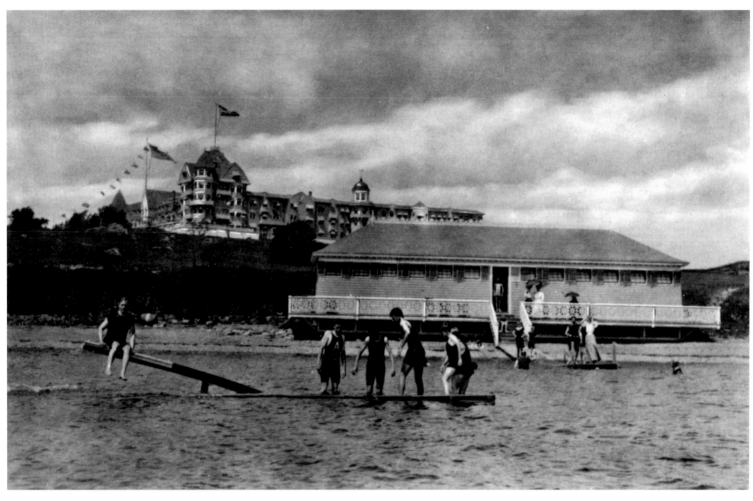

The Samoset Hotel in Rockland was named after the Abenaki chief who was the first Native American to greet the *Mayflower* pilgrims in 1621. At the time this photograph was taken in the 1930s, the Samoset was owned by the Ricker family, the same family that owned and operated the Poland Spring House resort. These bathers are enjoying the swimming area.

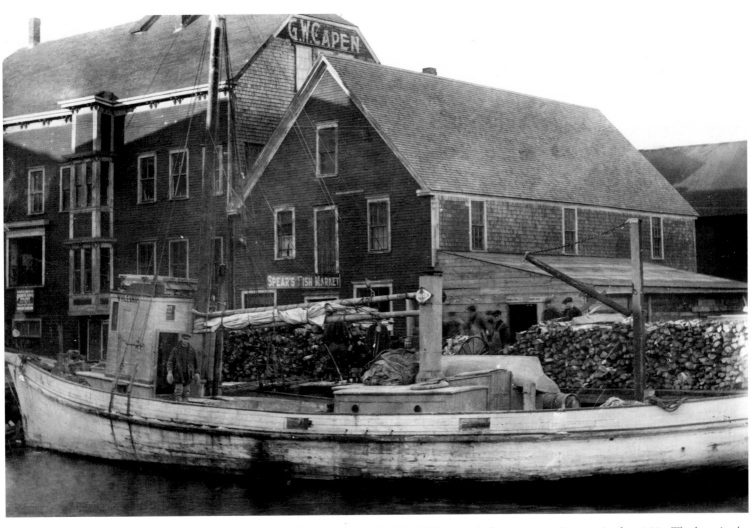

Photojournalist Fred G. Milliken took this picture in Eastport in the 1930s. The boat in the foreground was formerly the yacht *Bess,* built in 1881 and owned by the Vanderbilt family. In 1917, Booth Fisheries Company purchased the boat, using it to transport 90 hogsheads of herring daily to the factories on shore. Her new name was *Whileaway.*

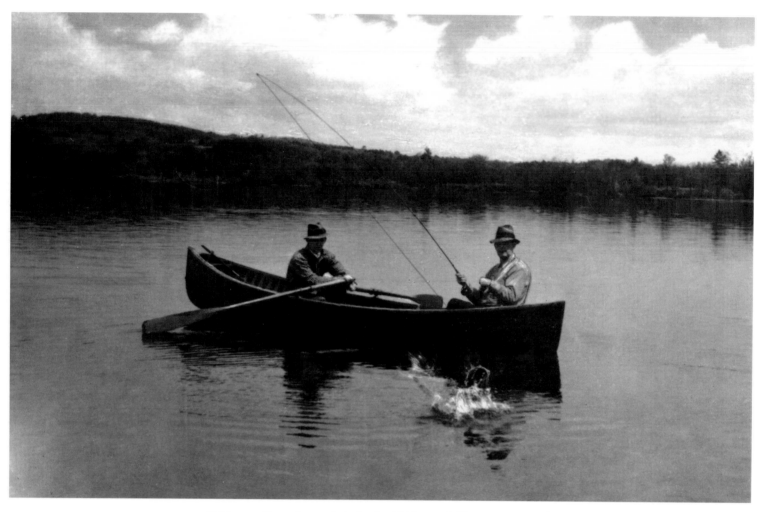

Fishing on Damariscotta Lake in the 1930s near Jefferson was one of many popular summertime activities for vacationers to Maine. The large lake in the midcoast region of Maine was accessible by train and automobile. Damariscotta means "abundance of little fishes." Fishermen were likely to catch brown and lake trout, Coho salmon, northern pike, pickerel, small mouth bass, and white perch.

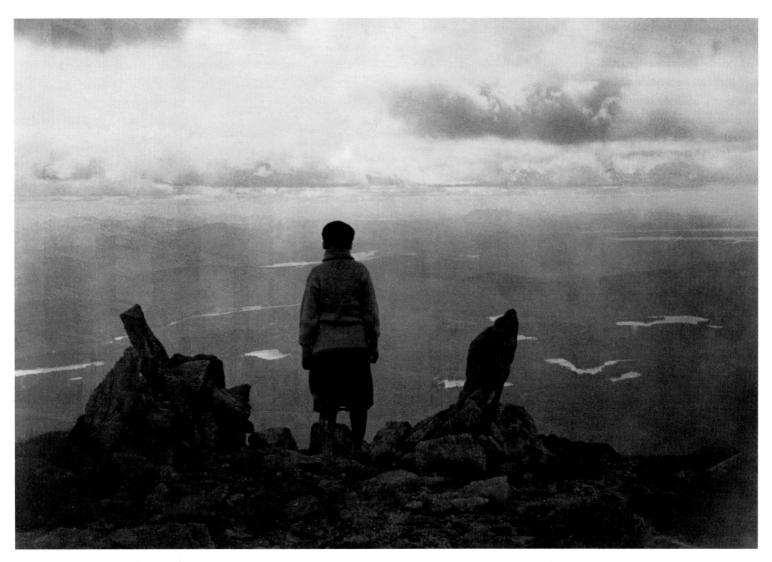

In 1931, Emmie B. Whitney of Lewiston is on a hiking trip at Mount Katahdin with her photographer husband, G. Herbert Whitney, and friend Charlotte Millett of Gorham. Emmie Whitney (1880–1943) was a newspaper writer and editor for the *Lewiston Journal*. As today's northern terminus of the 2,000-mile Appalachian Trail, Mount Katahdin offers spectacular views.

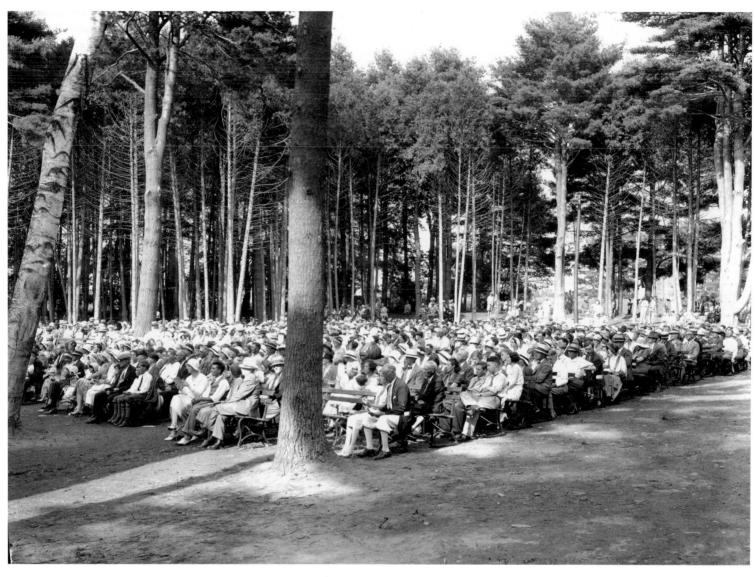

Eastern Music Camp on Lake Messalonskee in Sidney opened its doors to musician-campers in 1931. This forest clearing seats 3,000, and the "Bowl," the outdoor performance area outside the view of the camera, can hold a 500-piece orchestra. Today this property is owned by the New England Music Camp.

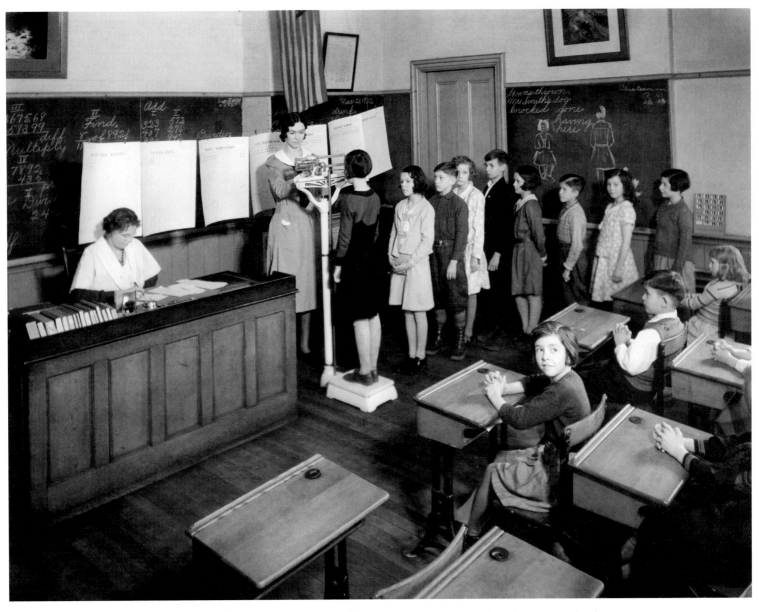

In the years following World War I, health education and screening became an important part of an elementary school child's education. These children at the North School in Portland in 1932 are being weighed, and most probably also attend physical and health education classes. The flu epidemic of 1918, and the poor health of draftees entering the war, contributed to the expansion of public school health programs.

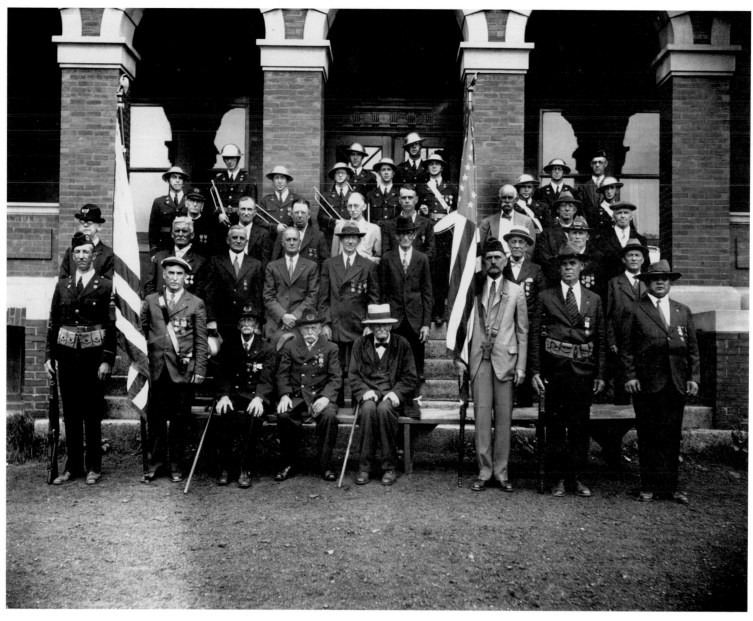

Veterans of many wars gathered on August 27, 1932. At front are three elderly veterans of the Civil War—Frank C. Towry, Isaac Pray, and Robert Cutts. At right may be veterans of the Spanish-American War (1898), and at back the younger men wearing helmets are veterans of World War I (1914–1918).

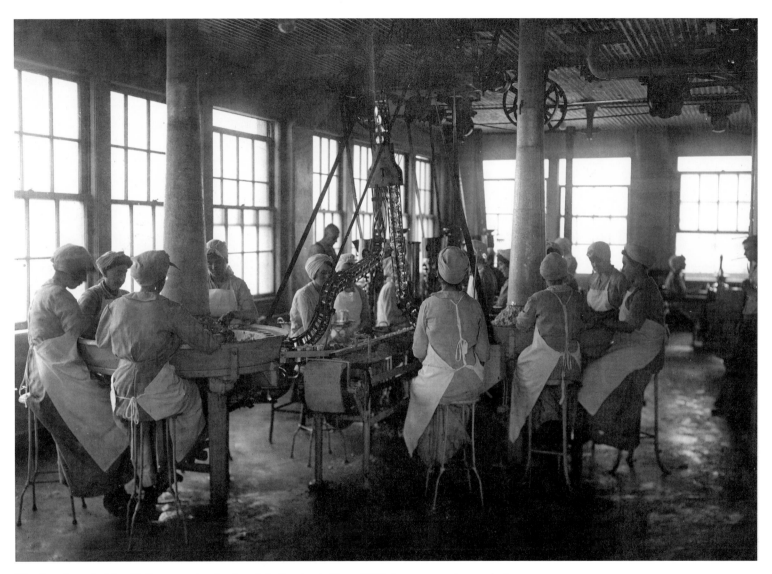

The Burnham & Morrill Company is a landmark in Portland. Since 1867 the company has packed foods of all kinds—notably lobster, corn, and fish in the early days, but beginning in the 1920s "Brick Oven Baked Beans." In this photograph from 1934, Alfred Elden of the *Atlantic Fisherman* magazine records employees packing fish flakes.

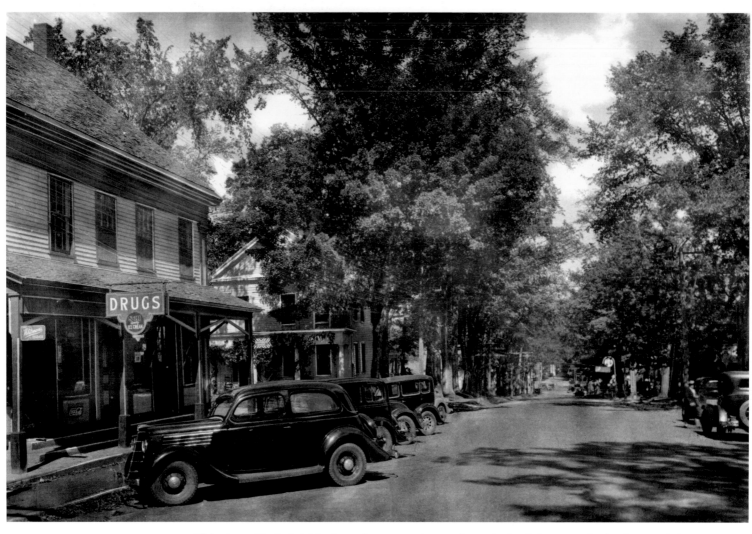

This view of Bethel's Main Street from around 1935 shows the local drugstore, barbershop, and elm trees in the background. Over the years, the barbershop was run by Fred Hall, Harry Swans, and Herschel Walker, among others. Bethel lies on the Androscoggin River and is home to the Bethel Inn and Gould Academy.

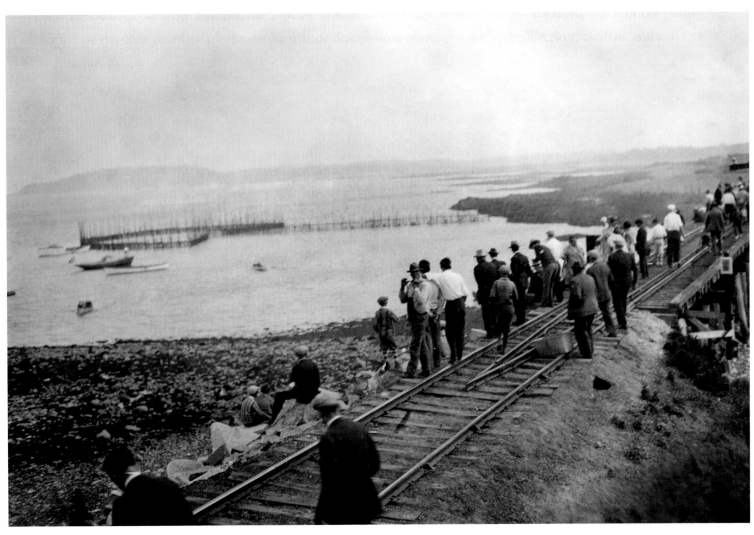

Fred G. Milliken photographed the only Passamaquoddy Indian fishing weir in Maine around 1935 for the *Atlantic Fisherman.* Here at Pleasant Point in Washington County, spectators line the railroad bridge while the seining boats begin bringing in the catch.

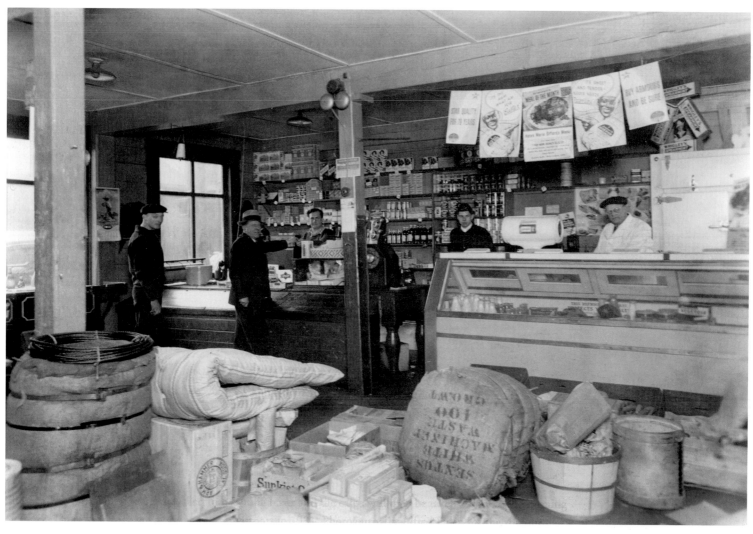

Interior view of the products and employees of the Sargent, Lord & Company ship chandlery, located at 10-12 Commercial Wharf when this image was recorded on April 6, 1937. The company opened in 1878 and supplied ships with provisions and equipment such as rope, sail, maintenance supplies, tools, and groceries.

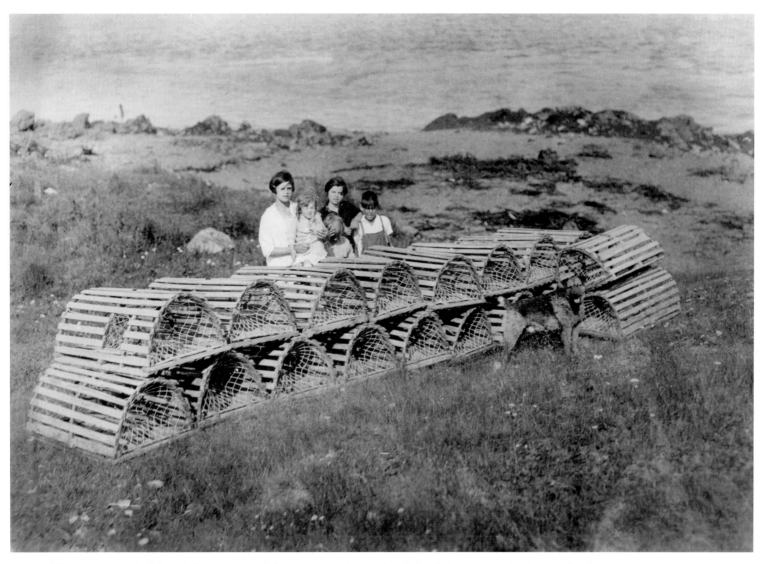

Fred Milliken photographed these lobster traps and the young people standing behind them on April 26, 1937, for the *Atlantic Fisherman*. His caption says, "Regulation lobster traps used by Frontier Maine fishermen at Eastport. Very few Eastport boatmen take to lobster fishing . . . these traps are valued at $2.00 each."

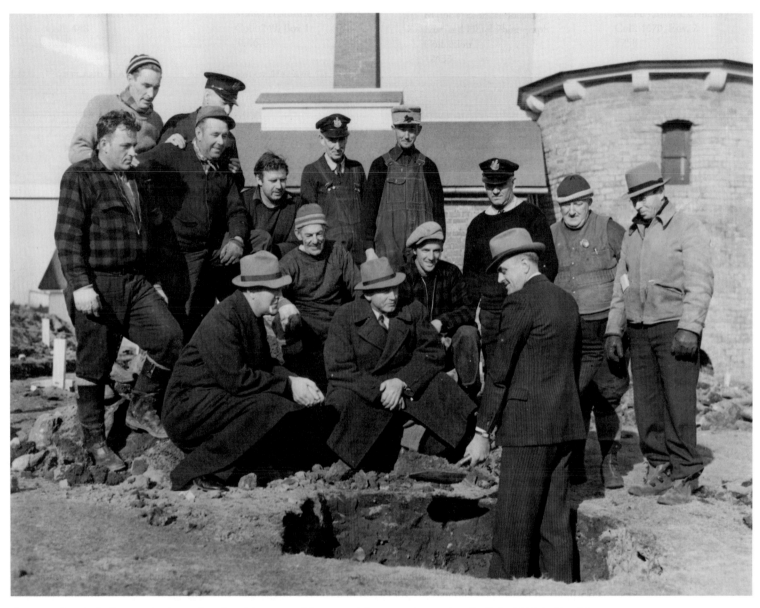

Governor Lewis O. Barrows is shown here breaking ground for a new lobster-rearing station, built in 1938 in Boothbay Harbor. Looking on are Sea and Shore wardens, Boothbay Harbor workmen, Senator George Wentworth, Fisheries Commissioner Arthur R. Greenleaf, and Earle Perkins. The Maine lobster-fishing industry was growing and changing with the public's increased demand for live lobsters over canned lobster meat.

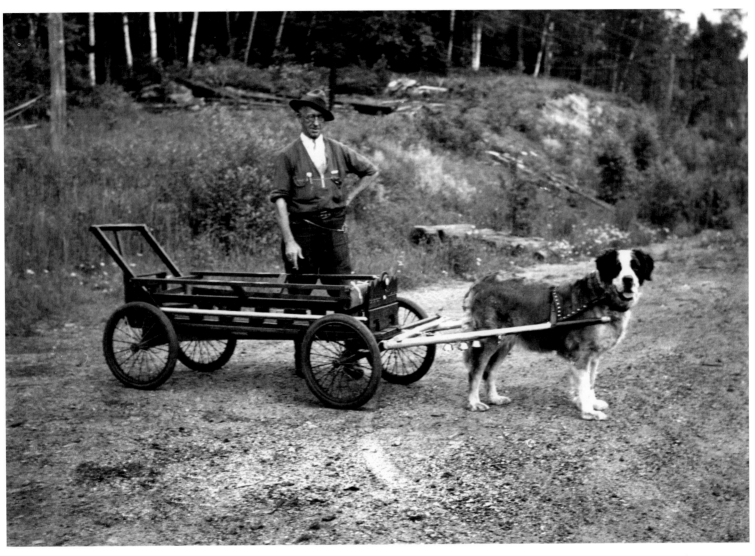

Cliff Hill and his dog Sally pose for G. Herbert Whitney on July 17, 1938. Cliff Hill was proprietor at the Oquossoc Dam Camps, where he had built a small recreational area called "Nature's Playground." This campground was in the Rangeley Lakes region and attracted people interested in hiking, hunting, and fishing.

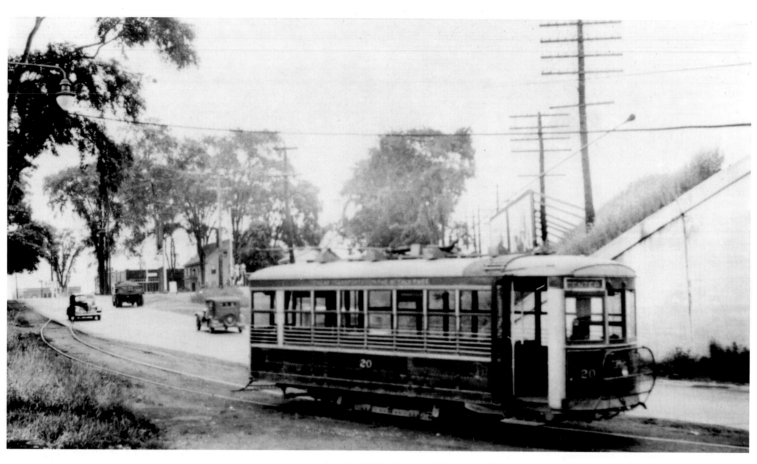

In 1889, Bangor Railway and Electric opened the state's first electric railroad line.
The Atlantic Shore Railway, Portland Railroad, Bangor Railway & Electric, and the Lewiston, Waterville and
Augusta Street Railway linked together to connect Maine from the Kennebec Valley to Kittery, then on to
Boston and New York City via the railroads. In 1939, however, when this Bangor trolley was photographed,
reliance on trolley travel was fading.

LIVING IN MAINE

(1940–1980)

It is not easy to live in Maine. For the most part, it's a struggle. The long, harsh winters of snow and ice that block streets and create washboard roads make travel challenging. Venturing outside without layers of clothing and boots is not recommended. To keep homes heated is difficult. The reward for these challenges is brilliant sunshine reflecting off the white snow and the glitter of ice hanging from tree limbs.

The short but muddy springtimes challenge any outdoor work—the mud interferes with travel into the woods and renders any dirt road impassable. The color of the new leaves and rising temperatures, however, dim the memories of winter trials.

Summers are punctuated by blackfly and mosquito hatches that hinder enjoyment of the outdoors. But the weather in summer is wonderful, with plenty of sunshine and little humidity. Before winter returns, autumn unfolds, with its stunning array of fall foliage that cheers the heart, preparing Mainers for the long, harsh winter to come.

The difficult environment has shaped the character of those who have lived here. Mainers are reticent, self-reliant, independent, ingenious. Maine has chosen as its state motto "Dirigo," which means "to lead." And though the state has had its share of great statesmen and public leaders, it may be that Maine leads by example more than by rhetoric.

People are drawn here for the beauty of the land and sea and slower pace of living. It is the intangible qualities embodied here that give rise to the attraction—the underlying knowledge that to live in Maine is not easy, but the struggle brings out the best in a person.

There is an old joke about an out-of-state traveler. The man was lost and stopped to ask for directions. The old Yankee farmer he asked answered, "You can't get there from here."

So true. But it's worth the trip.

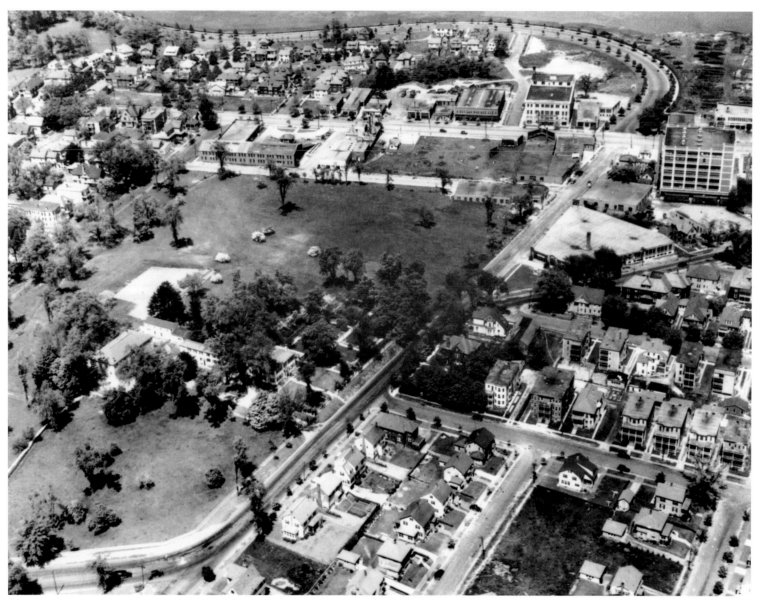

This aerial view of Portland taken around 1940 shows the Deering Estate at center flanked by Forest Avenue, Bedford Street, and Baxter Boulevard. This land was purchased by the Portland Junior College in 1946 and is now the site of the University of Southern Maine. The tall building in the distance at right is the National Biscuit Company's (Nabisco's) bakery facilities, now the University's Glickman Library.

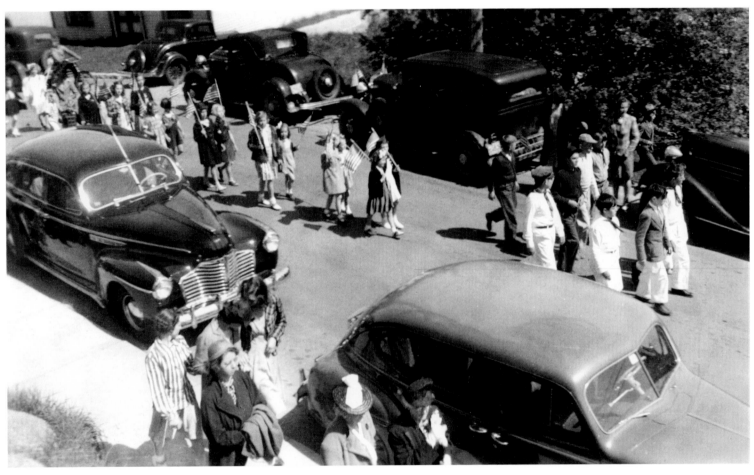

This Memorial Day parade around 1940 on Deer Isle with parade marchers holding flags features girls' and boys' scouting groups. Memorial Day observances began after the Civil War with survivors decorating fallen comrades' graves. Today Maine residents observe the holiday by holding parades, usually with veterans in attendance, and visiting and decorating veterans' and family members' gravesites.

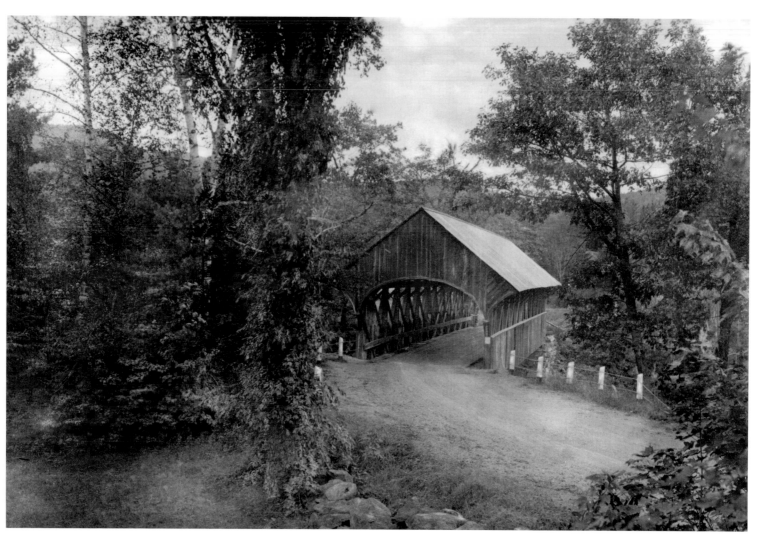

The "Artist's Bridge" in Newry, near Bethel, spans the Sunday River and is considered one of the most photographed and painted covered bridges in the state. Of the 120 covered bridges that once dotted Maine, only 8 original bridges remain. Around 1940 when this photograph was taken, automobile traffic was still permitted to cross. In 1958, traffic was suspended.

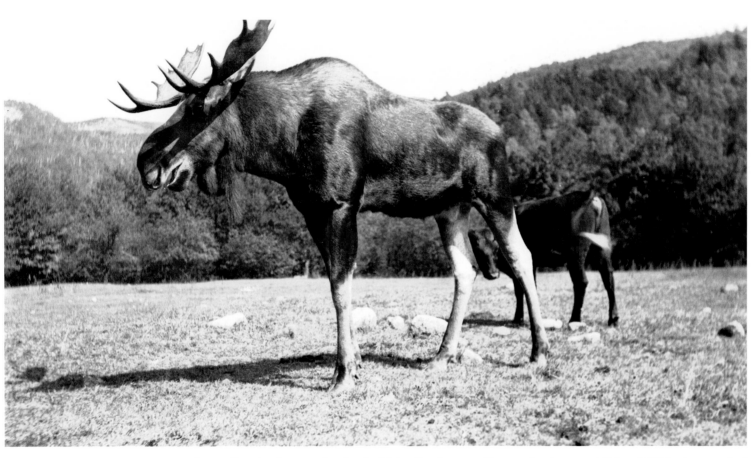

George French, photographer for the Maine Development Commission between 1936 and 1955, photographed this bull moose and a domesticated cow to promote the natural beauty of Maine and encourage tourism. The animals are standing in a pasture in Stoneham.

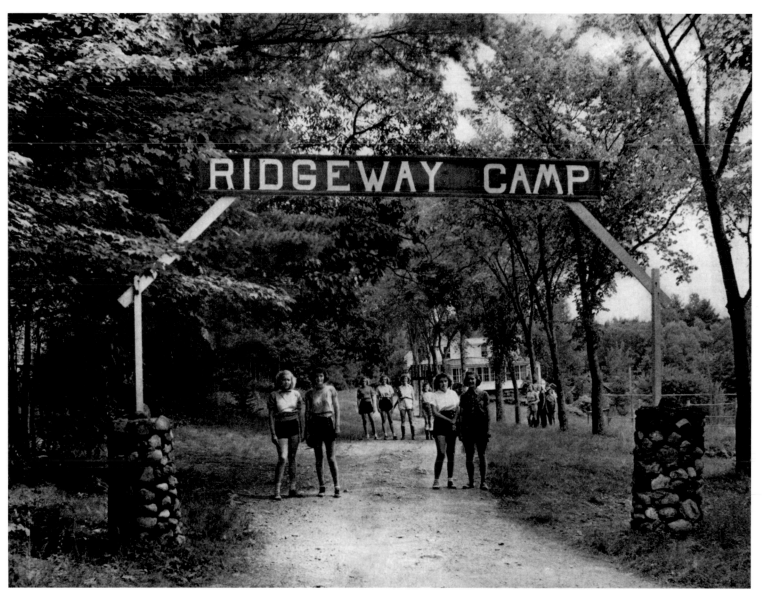

Girl campers are standing along the entryway to the Katharine Ridgeway Camp in Jefferson, around 1940. The camp, which promoted the "physical, mental, moral, and social development" of girls from ages 7 to 21, operated from 1923 to the 1940s on the shores of Clary Lake.

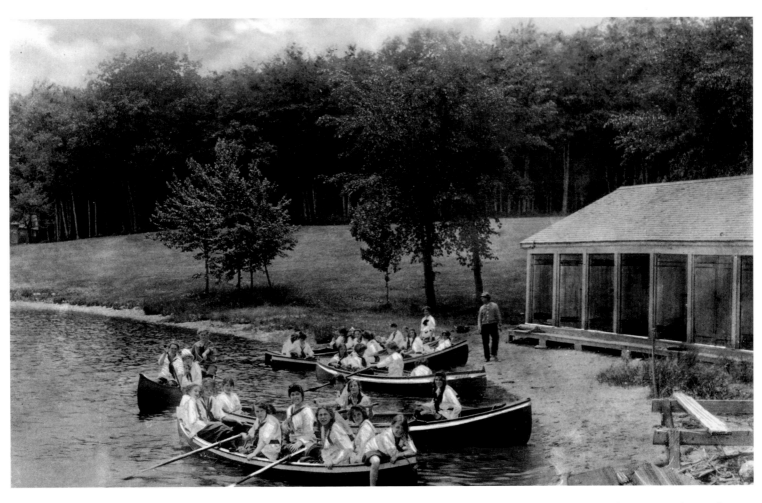

Campers in Naples during a summer in the 1940s enjoy an excursion by canoe. Girls' camps in the Naples area at that time included Wyonegonic, Fernwood, Walden, Tripp Lake, and Mataponi. These girls are very likely from Camp Mataponi on Sebago Lake.

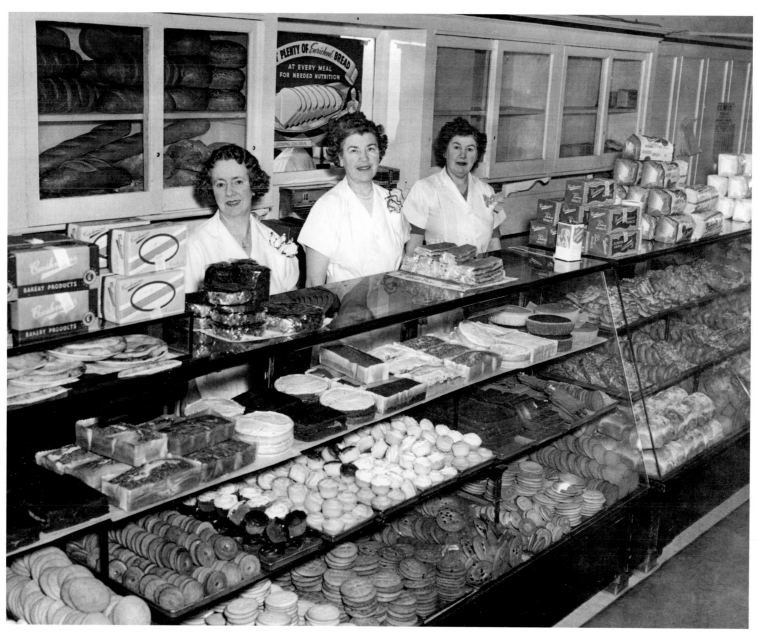

Employees of Cushman's Bakery in Portland stand behind a display counter filled with cookies and cakes, around 1940. When Nathan Cushman brought his bakery business to Portland from New York in 1915, he made French and Viennese breakfast rolls. After four years of losing money, he switched to baking doughnuts and biscuits and watched his business profits skyrocket. Home delivery and employee profit-sharing were hallmarks of this business enterprise.

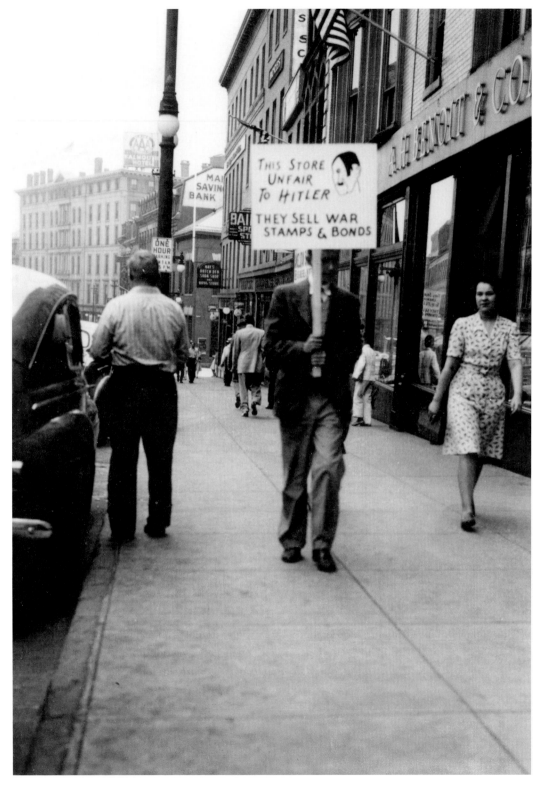

The A. H. Benoit Company supported the war effort by selling war stamps and bonds. This man is walking along the sidewalk in front of the Benoit store on Middle Street in Portland in 1942 carrying a sign that says, "This store unfair to Hitler. They sell war stamps & bonds." During both World Wars, the United States Government sold stamps and bonds to the public in order to support the troops.

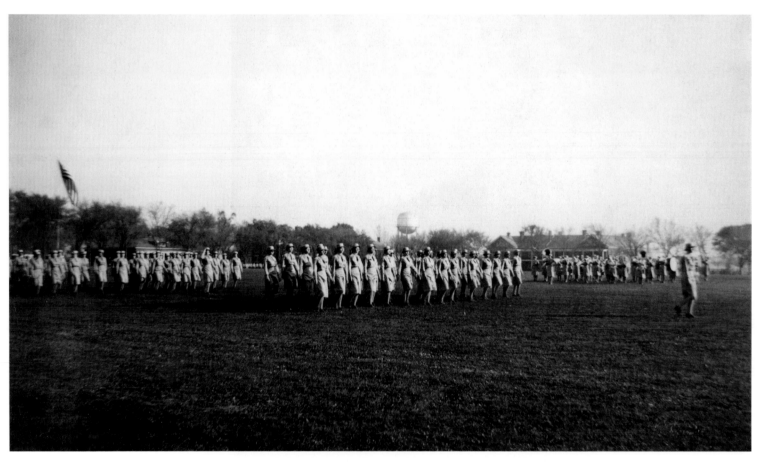

In 1941, the Women's Army Auxiliary Corps was created by Congress to work with the Army. In September 1942 a WAAC unit assembled on the parade grounds at Fort Williams in Cape Elizabeth. Fort Williams served as the headquarters of the Harbor Defenses of Portland during World War II. In 1943, the WAAC units were renamed Women's Army Corps (WAC) and became part of the U.S. Army.

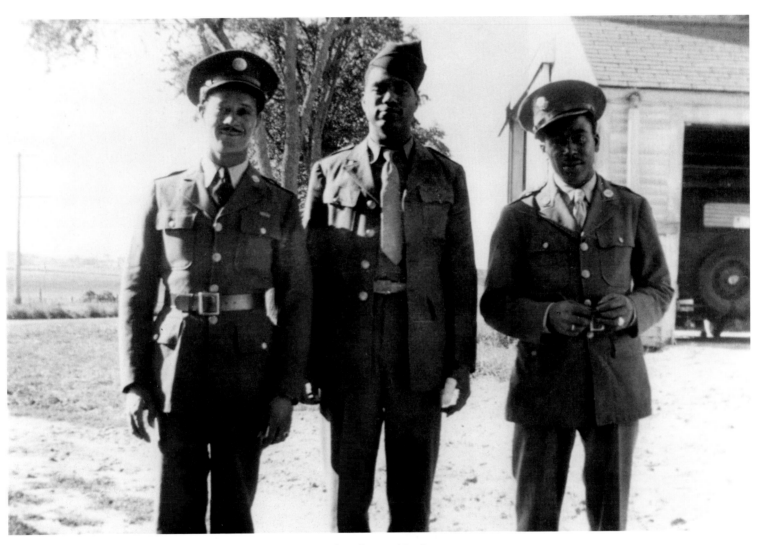

These three soldiers pose for the camera in front of the Arthur Atkins farm in North Yarmouth in 1942. They were stationed in North Yarmouth to guard the Grand Trunk Railroad bridge over the Royal River.

The Women's Army Corps from Fort Williams on Cape Elizabeth march along Portland's Congress Street in front of the W. T. Grant building in 1944. Fort Williams was headquarters for the Harbor Defenses of Portland during World War II and these women were stationed there.

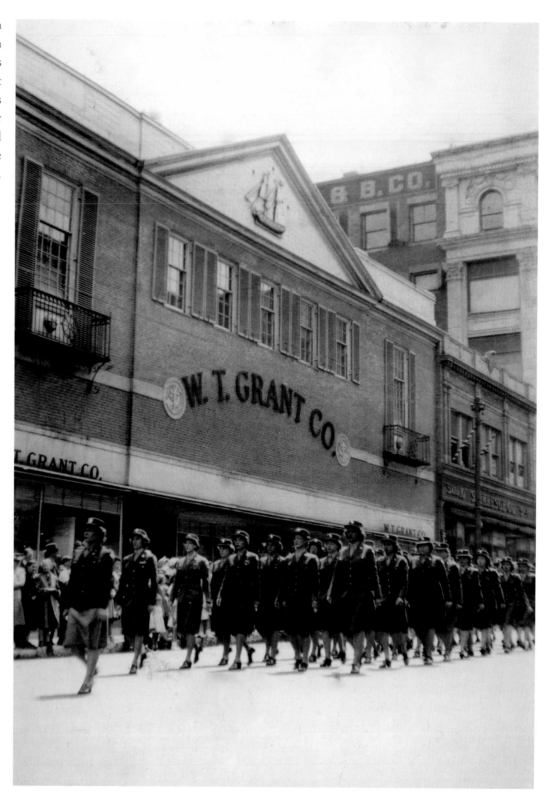

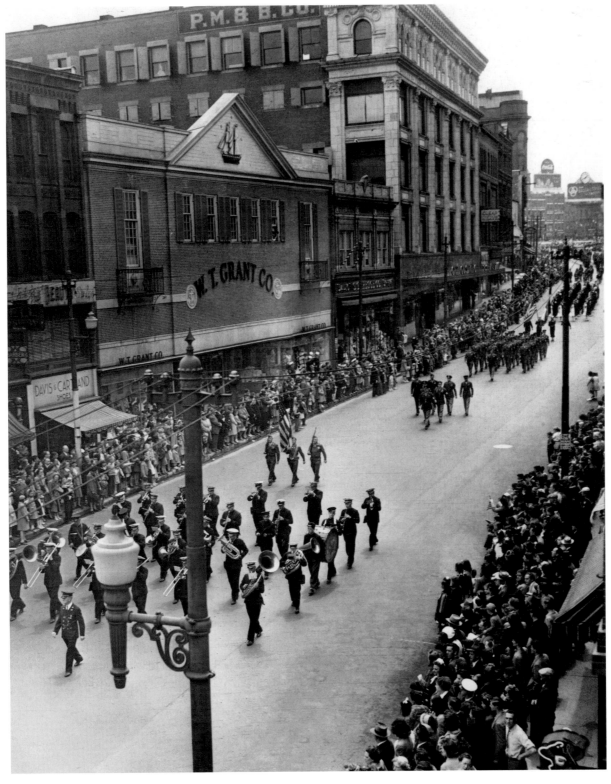

Portland's 1946 Flag Day parade as seen looking toward the W. T. Grant building on Congress Street. Flag Day was initiated by Woodrow Wilson in 1916 to be observed on June 14. Chandler's Band musicians are playing as they pass by. This band was formed in 1872 and is still in existence today.

This house in Paris Hill is the birthplace of Hannibal Hamlin (1809–1891), as it appeared in 1948. Hannibal Hamlin served in the state legislature, the United States Congress and Senate, as Maine's governor for less than two months in 1857, and vice-president of the United States with Abraham Lincoln.

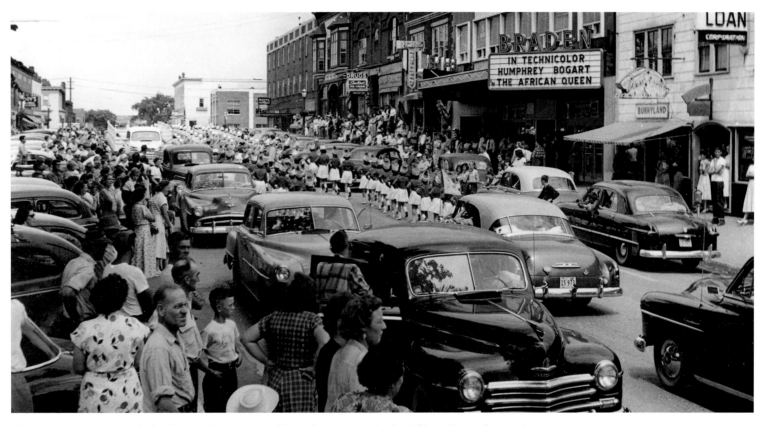

The cinema marquee in the background announces, "Humphrey Bogart in the African Queen," a movie released in 1951 starring Bogart and Katharine Hepburn. In the foreground a parade with cars and marchers is in full swing in Presque Isle.

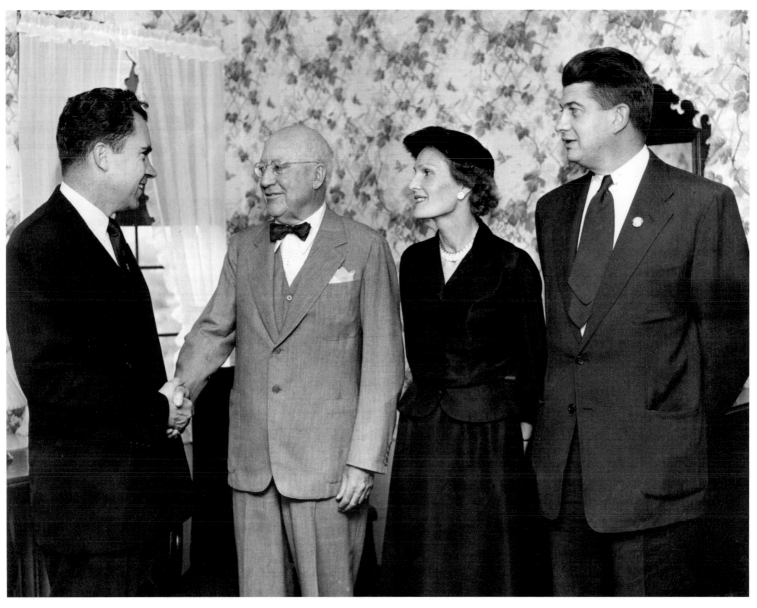

Guy P. Gannett (1881–1954), Richard Nixon, (1913–1994), Pat Nixon (1912–1993), and Fred Scribner, Jr., meet in Augusta. Dwight D. Eisenhower selected Richard Nixon as running mate in 1952, and it is possible that this meeting is part of a campaign stop. Guy P. Gannett owned Guy Gannett Communications, which included the *Portland Press Herald, Evening Express,* the *Kennebec Journal,* and radio station WGAN.

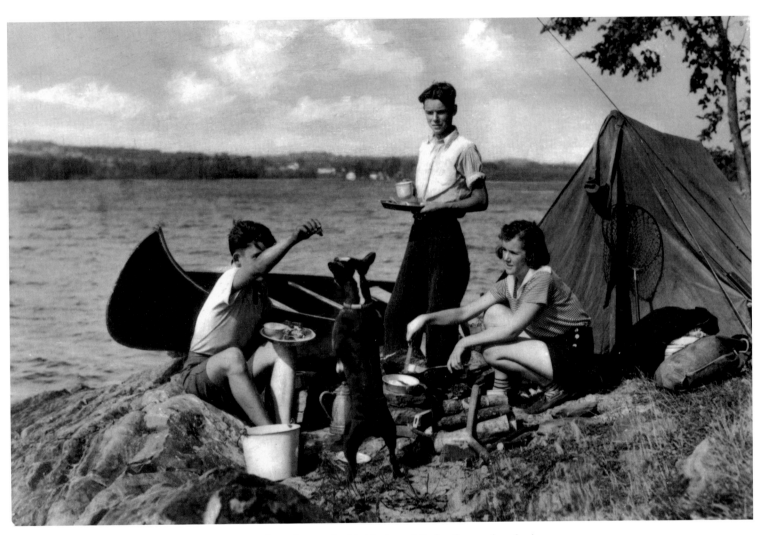

Around the campfire at Damariscotta Lake, a boy shares his meal with his dog while family members look on. This photograph includes many of the necessary elements of a summer camping expedition in Maine: canoe, tent, fishing gear, pet dog, campfire, firewood, metal plates, bucket, and lake in the background. It was taken around 1950 by a professional photographer for the Wittemann postcard company.

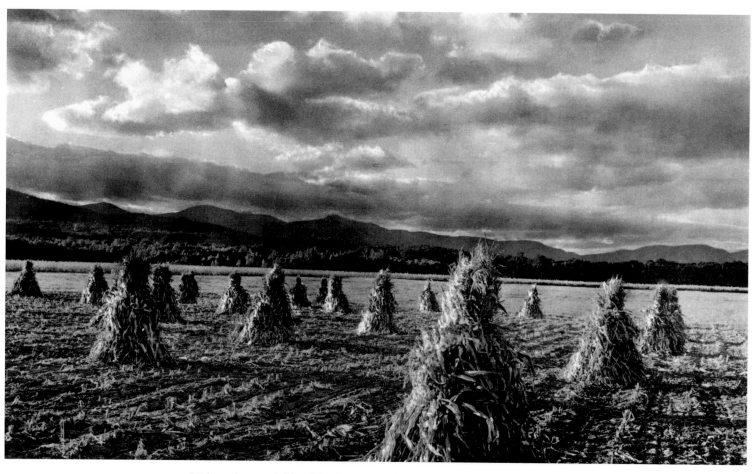

"Where the cornfields of Fryeburg meet the foothills of the White Mountains," wrote Parsonsfield photographer George French around the 1940s. Fryeburg is known for its rich agricultural lands along the Saco River. Prior to 1822, the Saco flooded its banks in the spring, leaving rich sediment on the fields. A rerouting of the river changed this pattern, but the fields are still productive. The Burnham & Morrill Company ran nearby shops for canning corn.

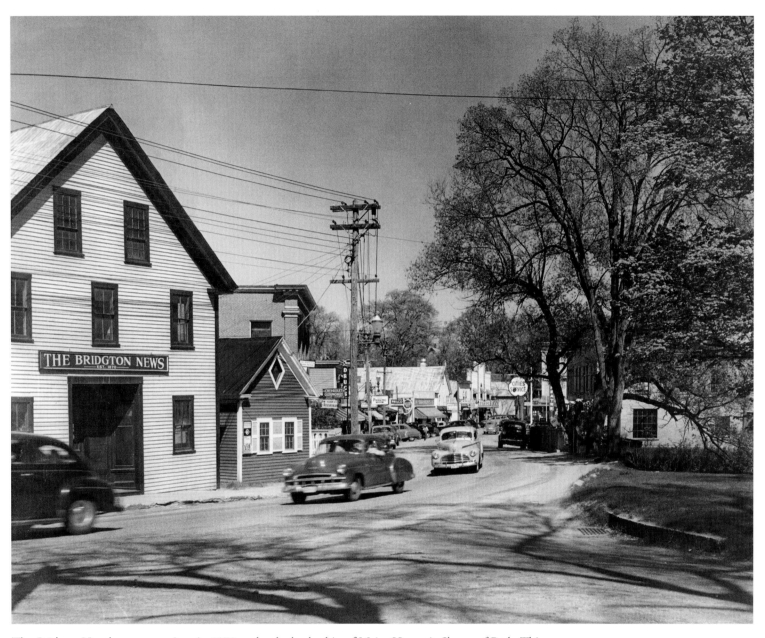

The *Bridgton News* began operations in 1870 under the leadership of Major Henry A. Shorey of Bath. This photograph shows the building at 44 Main Street around 1950. In the 1970s, this building was razed when Route 302 was redone. The *News* has been owned and operated by the Shorey family for 137 years.

The sun silhouettes three swimmers at Damariscotta Lake near Jefferson, around 1950. Cabins, lodges, vacation homes, a state park, excellent fishing and boating, and serene views like this make Damariscotta Lake a treasured vacation destination.

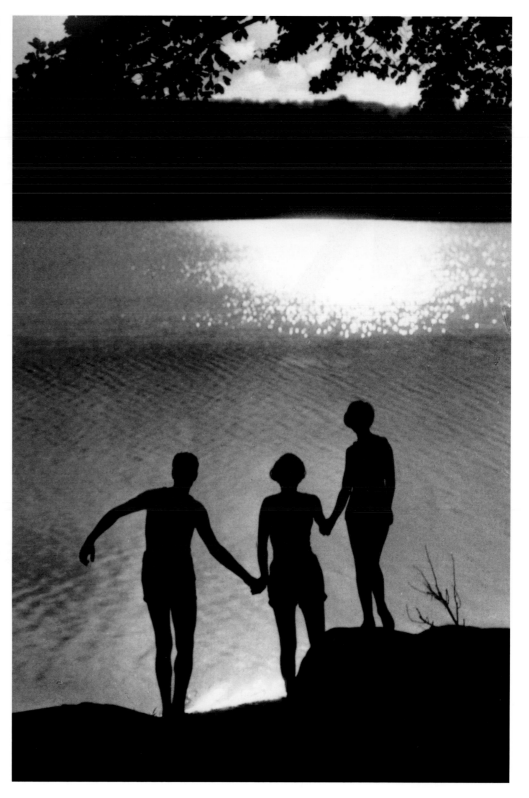

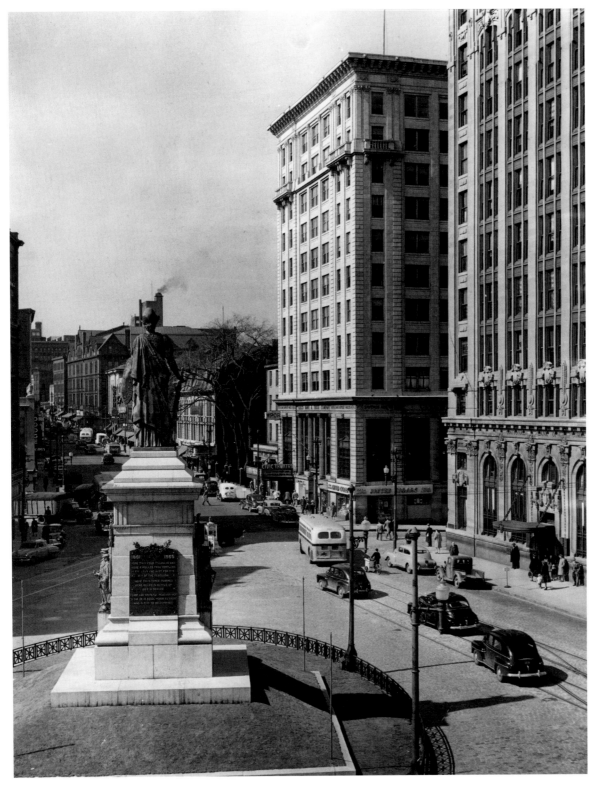

Our Lady of Victories, a monument to the four thousand men of Portland who fought in the Civil War, overlooks Portland's Monument Square around 1950. Automobiles and buses travel south along Congress Street, and the twin buildings Fidelity Bank and Trust and Chapman Arcade flank Preble Street.

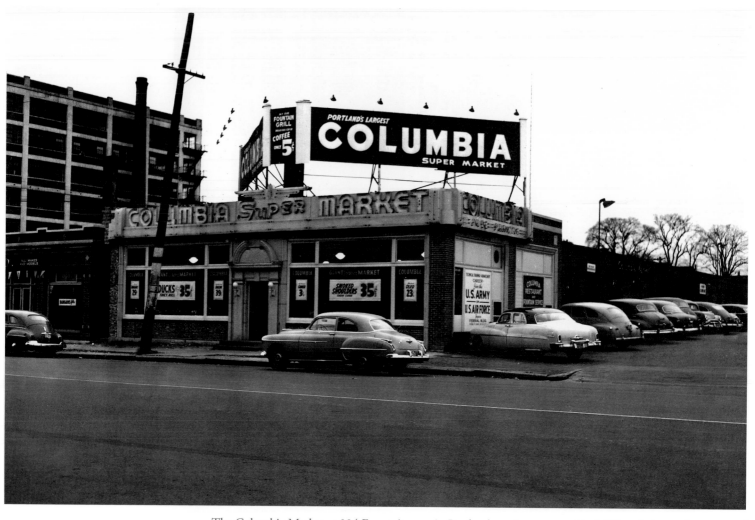

The Columbia Market at 334 Forest Avenue in Portland was incorporated in 1938 and sits on the corner of Bedford Street and Forest Avenue. The building in the background is the former National Biscuit Company, now the Glickman Library at the University of Southern Maine.

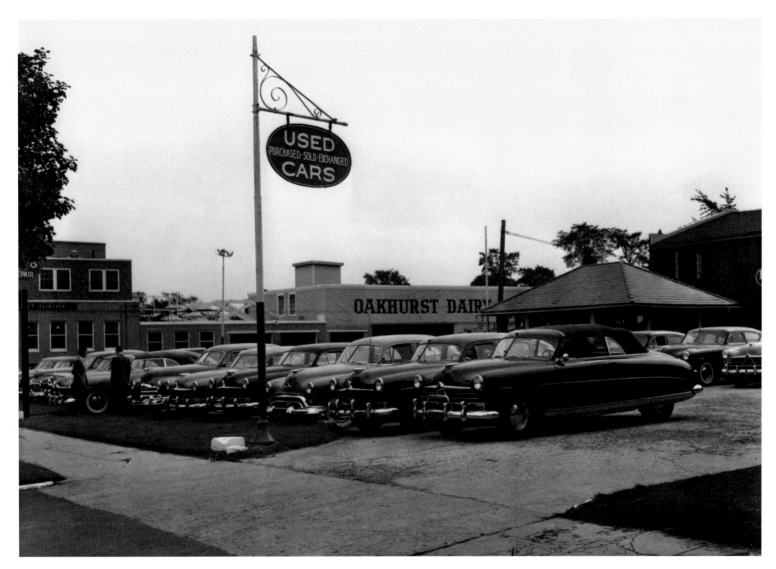

The Henley-Kimball automobile dealership and the Oakhurst Dairy at 364 Forest Avenue in Portland are open for business in 1951. The Oakhurst Dairy was started in 1921 by Stanley T. Bennett with two horse-drawn milk wagons. In 1973, the dairy bought the automobile dealership and expanded its facilities. Oakhurst Dairy has been owned by the same family for 86 years.

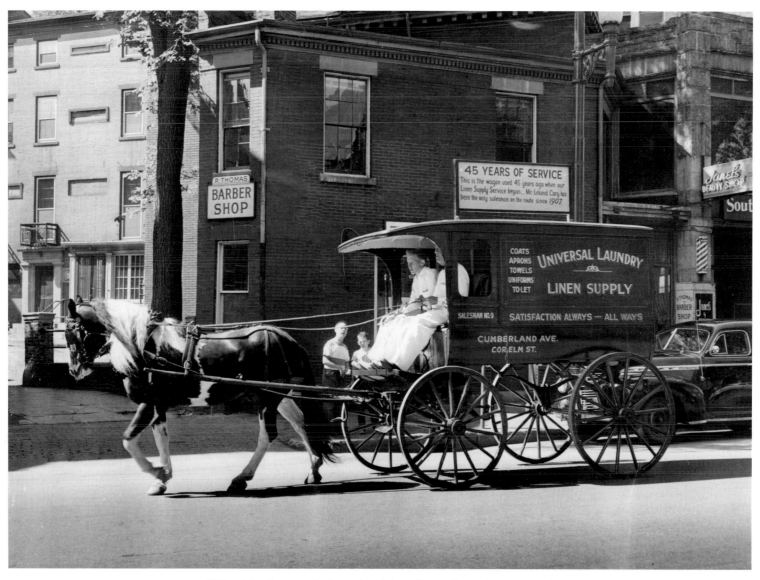

This 1952 photograph shows the Universal Laundry and Linen Supply wagon on Congress Street in Portland with a sign on top saying, "45 years of service. This is the wagon used 45 years ago when our Linen Supply Service began . . . Mr. Leland Cary has been the only salesman on the route since 1907." An older man is holding the reins, most probably Leland Cary himself.

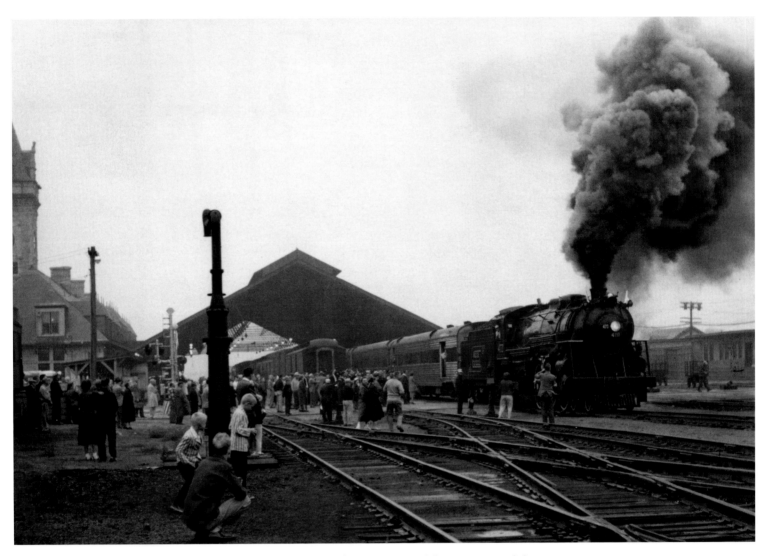

Portland's Union Station on St. John Street in 1954 is the scene of intense activity. The station served the Boston & Maine, Maine Central, and Portland & Ogdensburg railroad lines. An important event seems to be unfolding—many of the spectators hold cameras, including one of the young boys in the foreground.

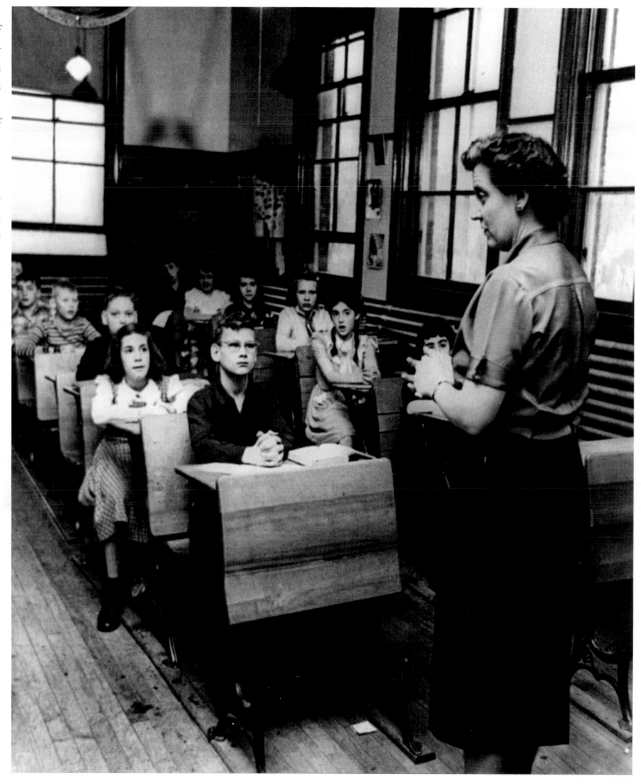

Mrs. Doris MacDougal, teacher and principal of the McLain Grammar School in Rockland, is ready to lead the class in a singing lesson, around 1954. The set of photographs to which this one belongs, taken by the U.S. Information Agency, was meant to inform foreigners about life and culture in the United States.

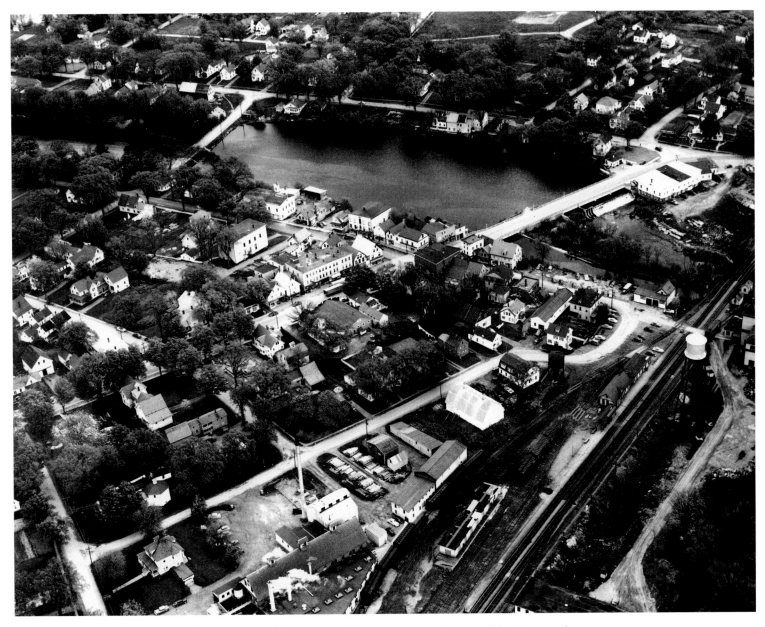

This aerial photograph of Newport from around 1956 shows the bridges over the east branch of the Sebasticook River. Newport is located snugly beside Lake Sebasticook midway between the Penobscot and Kennebec rivers. A woolen mill and bottling and canning factory were active industries here in 1956. Interstate 95 would arrive by the mid 1960s. Thirteen prehistoric archaeological sites are located near Newport, including the oldest-dated fishing weir in North America.

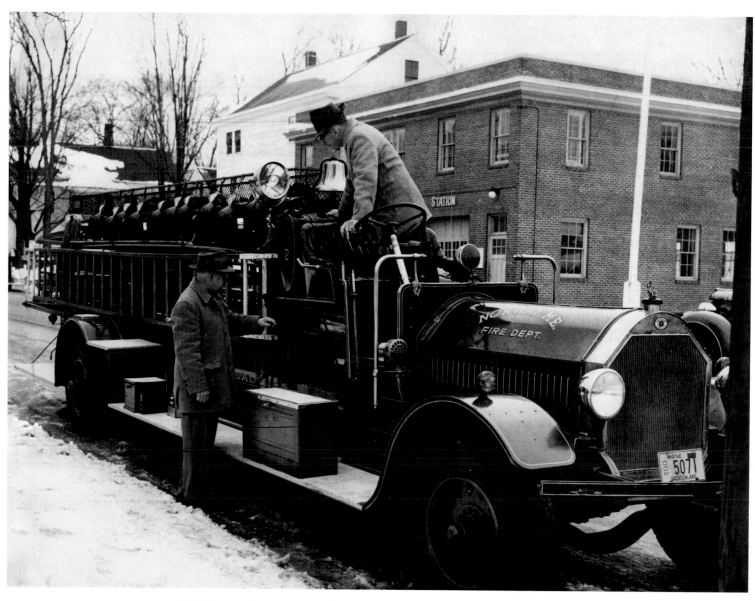

The Norway Fire Department's Seagrave ladder truck is shown parked outside the fire station in 1959. This ladder truck was built in the 1930s, one of Seagrave's Suburbanite & Metropolite series vehicles. Most fire companies in Maine, to this day, are manned by dedicated volunteers.

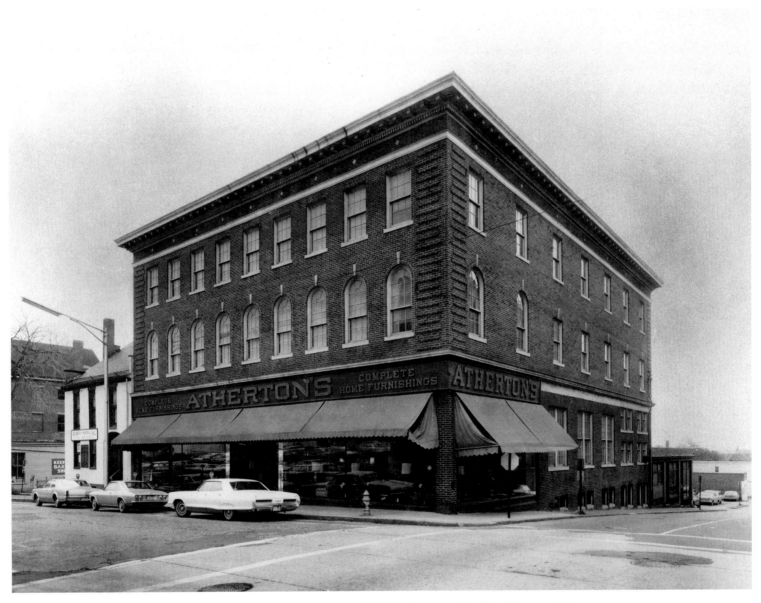

LeBaron Atherton created a thriving furniture business, beginning with the Lewiston store in 1897. He expanded the business to include stores in Waterville, Bangor, Portland, Brockton, Worcester, Springfield, and Pittsfield, Maine, as well as Haverhill, Massachusetts, and Kingston, New York. The Portland store, pictured here in 1960, was located on the corner of Free and Center streets.

The Wadsworth-Longfellow House in Portland is on the National Register of Historic Places. This 1960s photograph shows the large elms growing in front of the building. The family home of poet Henry Wadsworth Longfellow (1807–1882) is now part of the Maine Historical Society.

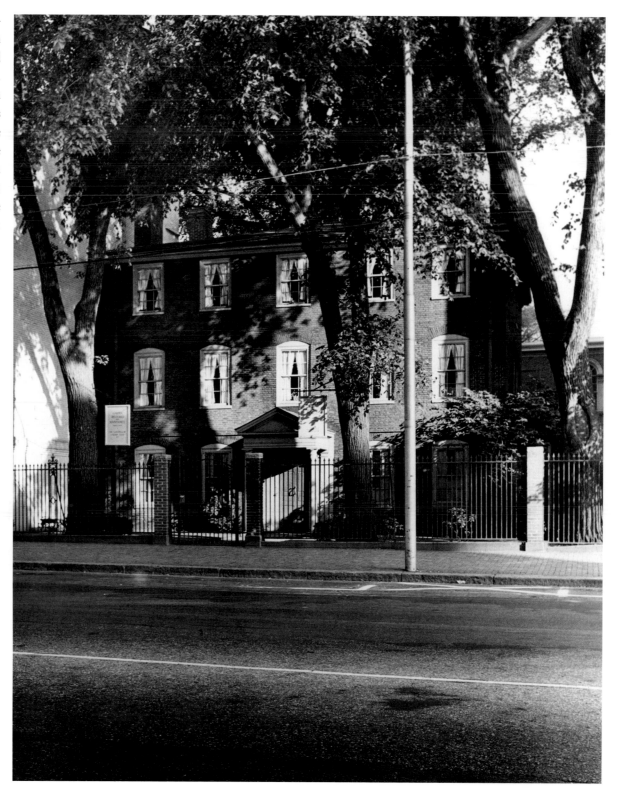

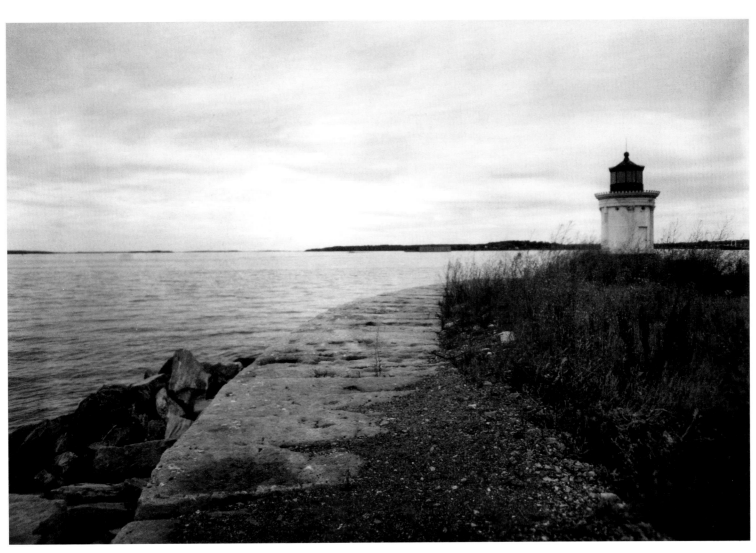

Portland Breakwater Lighthouse, photographed here in 1962, also known as "Bug Light," was modeled after an ancient Greek monument. A destructive storm in 1831 convinced residents that a breakwater and lighthouse were needed on the South Portland side of Portland Harbor. The original lighthouse was moved to Little Diamond Island around 1870, the breakwater was extended, and the present lighthouse was completed in 1875. Its cast-iron construction is unique among lighthouses.

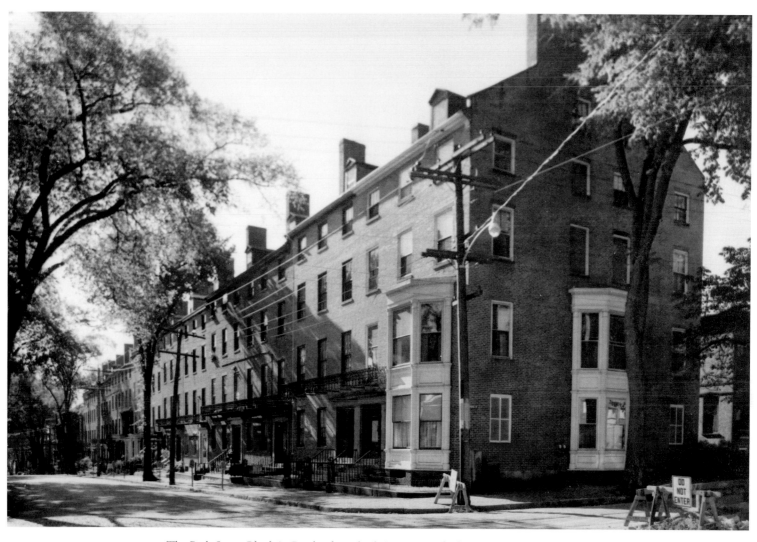

The Park Street Block in Portland was built in 1835 as the largest residence row complex in the state. Considered one of the greatest real estate projects of its time, these twenty, four-story individual townhouses, linked together, were extremely fashionable. The complex was built on Billy Gray's Ropewalk in Greek revival style. The last two units were a ladies hotel, and a private garden in the back was reserved exclusively for residents.

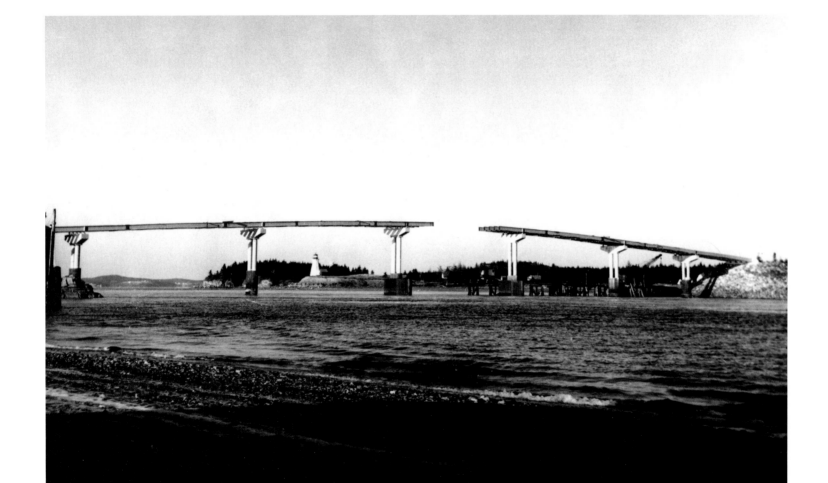

The Franklin D. Roosevelt International Memorial Bridge connecting Lubec, Maine, with Campobello Island in New Brunswick was completed in 1962, when this photograph was taken. Previously, visitors to Campobello Island would cross by car ferry or boat. FDR vacationed to Campobello Island in the summers, and today Canada and the United States jointly manage the Roosevelt Campobello International Park.

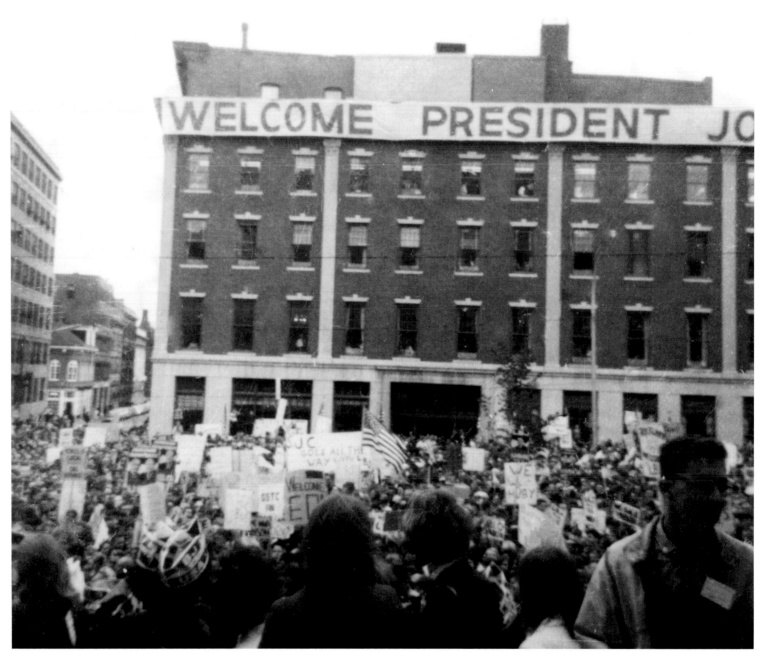

A crowd surrounds President Lyndon B. Johnson and his wife, Lady Bird Johnson, in Portland during a reelection stop on September 28, 1964. In the president's remarks at the airport, he joked about journalist May Craig, a White House correspondent for the *Portland Press Herald* who accompanied the president off the airplane. "I think this is the most wonderful welcome that May Craig ever received," he said. "And I want to tell you something else: She deserves every single bit of it."

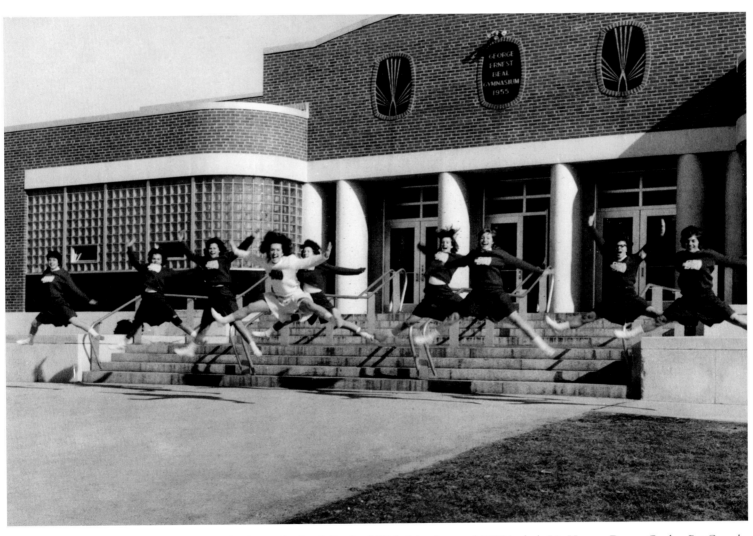

Cheerleaders at the South Portland High School around 1965 include Liv Harvey, Donna Conley, Pat Crangle, Judy O'Toole, Terry Langlois, Sue Gilmore, Noreen Massey, Cheryl Gordius, and Bev Logan.

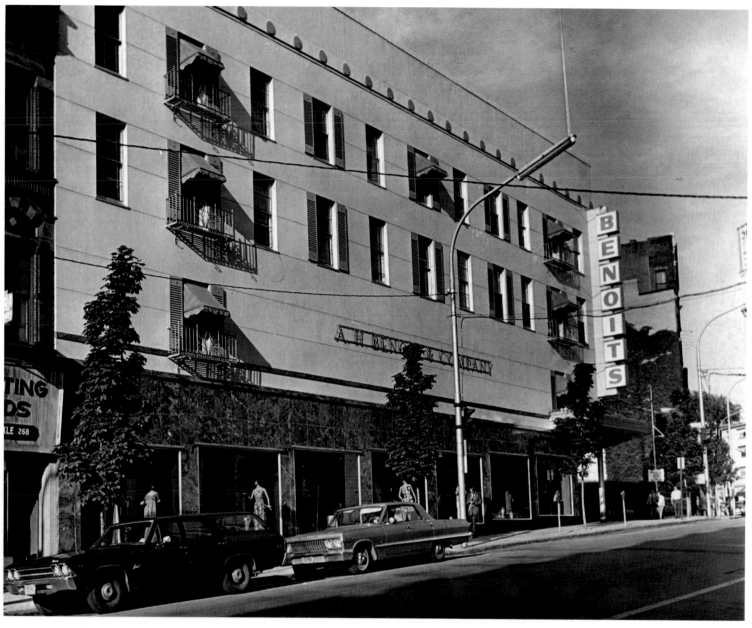

The A. H. Benoit & Company stores throughout Maine clothed Maine men for ninety years. In 1966, the company had stores in Westbrook, Portland, Biddeford, Brunswick, Lewiston, and Ogunquit.

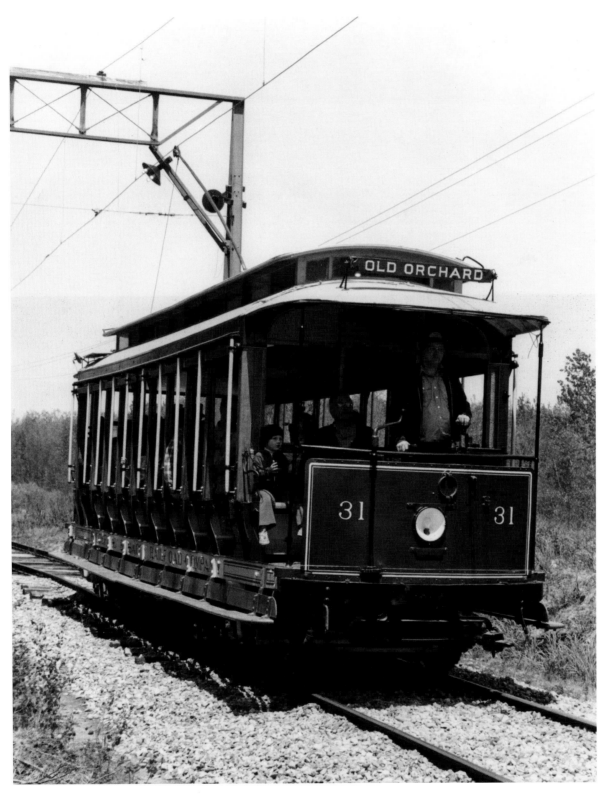

The Seashore Trolley Museum in Saco restored this car in 1975. Originally serving the Biddeford & Saco Railroad Company, car 31 ran between Biddeford and Old Orchard Beach in the early part of the twentieth century. Built in 1900, this car held twelve benches, with five persons to a bench.

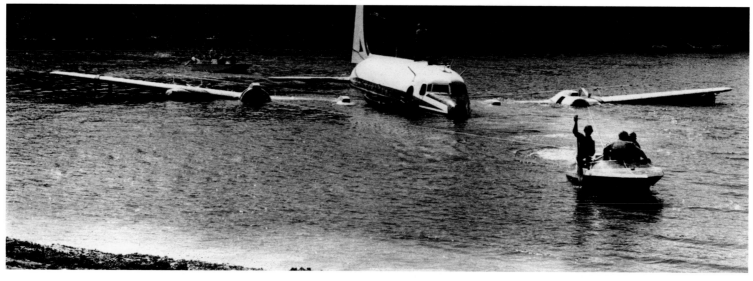

This airplane made an emergency landing in June 1979 at Eagle Lake in Piscataquis County. It was carrying 800 gallons of the pesticide Sevin-4 used to spray forests infested by the spruce budworm. No one was injured when a cockpit fire forced the plane down. One hundred gallons of the pesticide leaked into the lake, but the remaining liquid was successfully siphoned off.

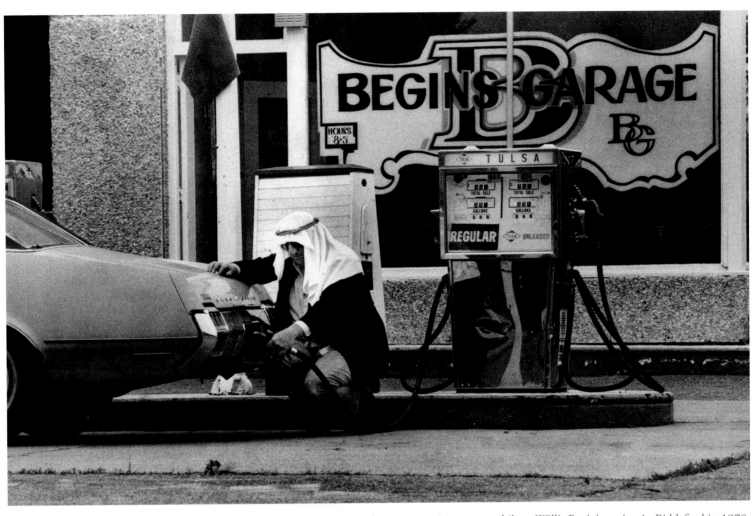

John Malone pumps gasoline into a waiting automobile at Willis Begin's station in Biddeford in 1979.
Owner Begin dressed his employee as a Saudi sheik in hopes of drawing business to his new location.
The gas cost 83.9 cents a gallon.

On June 18, 1979, these boys jumped off a ledge into the waters off Cape Elizabeth. Wayne Donoff, Daryl Miller, and David Miller enjoy a cooling splash and international fame as the photographer captures their derring-do on film.

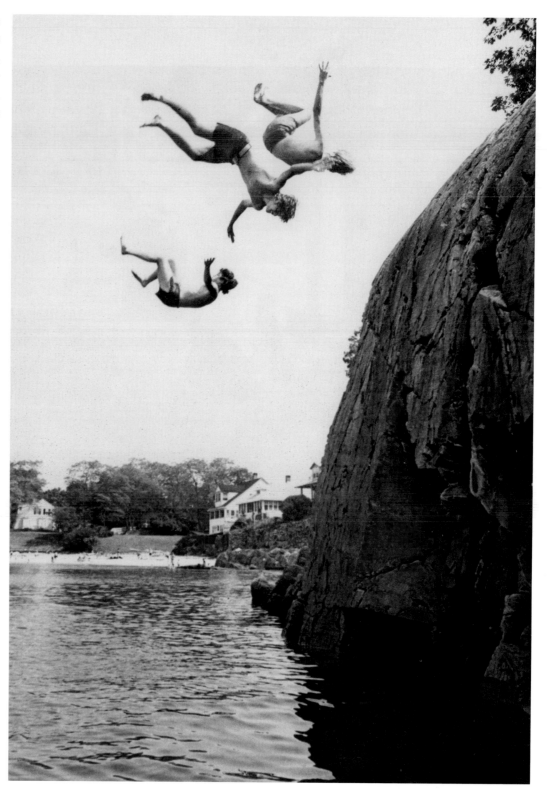

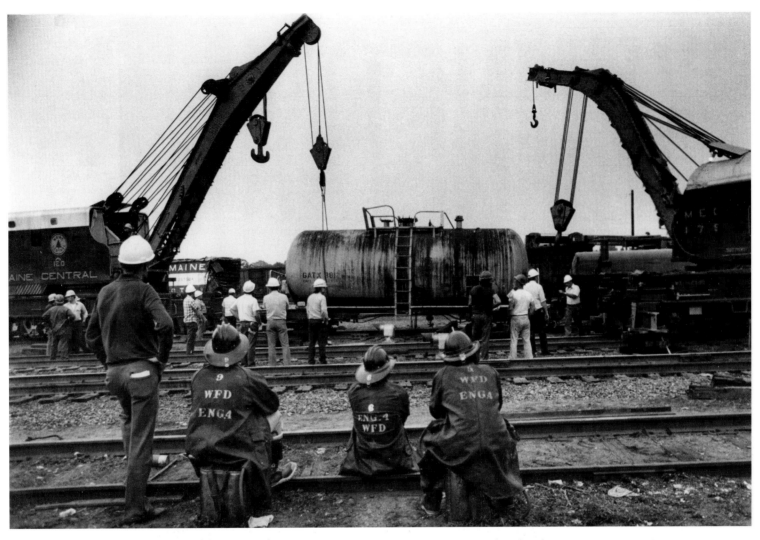

Crews of railroad employees and the Waterville Fire Department work to stabilize a Maine Central Railroad derailment in Waterville in 1979. Officials were concerned at the time about possible chlorine gas leakage.

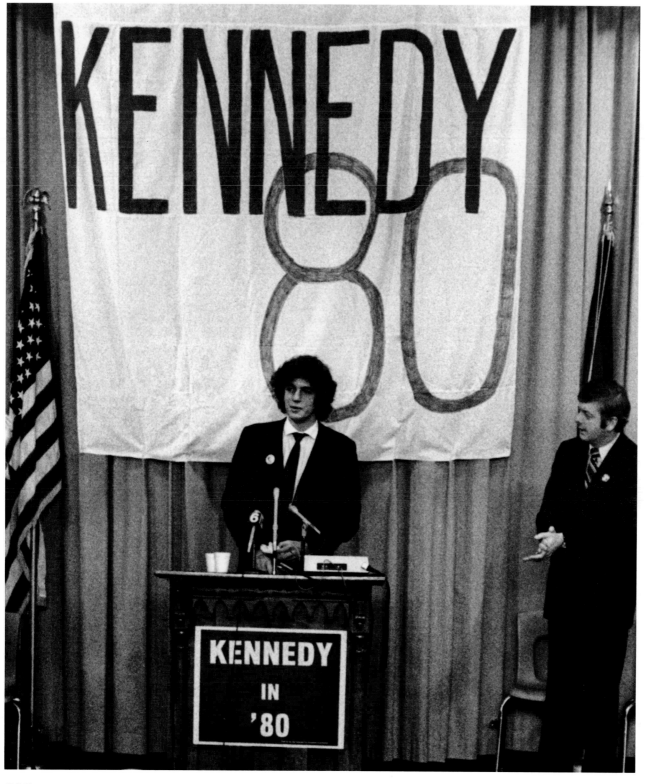

John F. Kennedy, Jr. (a student at Brown University), and Governor Joseph Brennan appear in Portland on December 8, 1979, supporting Senator Edward Kennedy's run for president of the United States. Senator Kennedy was running against incumbent Jimmy Carter. Carter defeated Kennedy for the Democratic nomination. In 1980, Republican Ronald Reagan defeated Carter for the presidency.

NOTES ON THE PHOTOGRAPHS

These notes, listed by page number, attempt to include all aspects known of the photographs. Each of the photographs is identified by the page number, photograph's title or description, photographer and collection, archive, and call or box number when applicable. Although every attempt was made to collect all available data, in some cases complete data was unavailable due to the age and condition of some of the photographs and records.

II **BOOTHBAY**
Maine Historical Society
6000

VI **SNOWDRIFT**
Maine Historical Society
Coll. 242, B30-1-10
8647

X **J. G. DEERING & SON LUMBER MILLS**
Maine Historical Society
Coll. 1922, Photo #1
9360

2 **WAR OF THE REBELLION**
Maine Historical Society
Photographs--Military--Civil War
1012

4 **MAJ. GEN. JOSHUA L. CHAMBERLAIN**
Library of Congress
LC-B813-1859

5 **PORTLAND AFTER A FIRE**
Library of Congress
LC-DIGG-ppmsca-09960

6 **HORSE-DRAWN STEAM ENGINE**
Maine Historical Society
Coll. 242, Box 30 11-7
8678

7 **PORTLAND FIREFIGHTERS**
Maine Historical Society
Coll. 456, Box 1/13
22694

8 **DESTRUCTION**
Maine Historical Society
Coll. 2033
1354

9 **ST. STEPHEN'S EPISCOPAL CHURCH**
Maine Historical Society
Coll. 2033
1350

10 **RUINED BUILDINGS**
Maine Historical Society
Coll. 2033, #468

11 **TENT CITY**
Maine Historical Society
Coll. 2033, #489
1352

12 **TENTED ENCAMPMENT**
Maine Historical Society
Coll. 1976
1185

13 **MARKET SQUARE**
Maine Historical Society
Photographs--Portland--Streets--Congress Street
4155

14 **MUSICIANS**
Maine Historical Society
Photographs--Bridgton
5782

15 **MAINE MILITIA**
Maine Historical Society
Photographs--Military--Civil War
5447

16 **FAMILY AND FRIENDS**
Maine Historical Society
Coll. 1329, Photographs--Scarborough
83

17 **FALMOUTH HOTEL**
Maine Historical Society
Photographs--Portland--Streets--Middle Street
20860

18 **BUXTON'S**
Maine Historical Society
Coll. 797
5757

19 **MARKET BUILDING**
Maine Historical Society
Photographs--Portland--Streets--Monument Square
20897

20 **DOWNTOWN EASTPORT**
Maine Historical Society
Photographs--Eastport
1214

21 **CONGRESS STREET**
Maine Historical Society
Photographs--Portland--Monument Square
11426

22 **LONGSHOREMEN'S BENEVOLENT SOCIETY**
Maine Historical Society
Photographs--Portland--Processions
4192

23 **UNION MUTUAL**
Maine Historical Society
Photographs--Portland--Streets--Congress Street--3-399
20514

24 **WADSWORTH-LONGFELLOW HOUSE**
Maine Historical Society
Coll. 2113
11335

25 **PORTLAND HOUSE**
Maine Historical Society
Photographs--Portland--Streets--Forest Avenue
1213

26 LISBON FALLS FLATS, 1882
Maine Historical Society
Photographs--Lisbon Falls
5559

27 LAKE MARANACOOK GROVE
Maine Historical Society
Photographs--Portland--
Streets--Congress Street--
400-599
20594

28 GRAND ARMY OF THE REPUBLIC PARADE
Maine Historical Society
Photographs--Portland--
Processions
20319

29 A. C. MAGUIRE
Maine Historical Society
Photographs--Cape Elizabeth
5734

30 PORTLAND CITY HALL
Maine Historical Society
Photographs--Portland--
Streets--Congress Street--
400-599
20592

31 TABLE ROCK AND KINEO MOUNTAIN, 1888
Maine Historical Society
Coll. 447, Box 1
1022

32 PEDESTRIANS ON MIDDLE STREET
Maine Historical Society
Photographs--Portland--
Streets--Middle Street
13765

33 YORK BEACH
Maine Historical Society
Photographs--Old Orchard
Beach
1167

34 SEASIDE PARK
Maine Historical Society
Photographs--Old Orchard
Beach
5988

35 D. W. HESELTINE APOTHECARIES
Maine Historical Society
Photographs--Portland--
Business Enterprises
20262

36 SWEDEN STREET
Maine Historical Society
Photographs--Caribou
1163

37 GRAND TRUNK RAILROAD TERMINAL
Maine Historical Society
Photographs--Portland--
Railroad stations
5787

38 BRUNSWICK CANOE CLUB
Maine Historical Society
Photographs--Brunswick
6005

39 RICHMONDS ISLAND
Maine Historical Society
Photographs--Cape Elizabeth
4157

40 EASTERN RAILROAD
Maine Historical Society
Coll. 242, 33-48
5937

41 FOUNDRY, PORTLAND CO.
Maine Historical Society
Coll. 242, Box 29 10-3
8073

42 SOLDIERS AND SAILORS MONUMENT DEDICATION
Maine Historical Society
Portland--Streets, Monument
Square
16498

43 TROLLEY
Maine Historical Society
Coll. 1920, box 1/19
7946

44 BEARBROOK LANDING
Maine Historical Society
Coll. 447, v. 4
5882

45 BOWDOIN COLLEGE BASEBALL TEAM
Maine Historical Society
1997.437.2
12388

46 GUNBOAT VICKSBURG
Maine Historical Society
Coll. 562, Scrapbook
11596

47 CENTRAL FIRE STATION
Maine Historical Society
Coll. 423, Box 4/9
12492

48 MUSTERING SOLDIERS SPANISH-AMERICAN WAR
Maine Historical Society
Coll. 1532 5/8
1039

49 TEAMS HAULING SNOW
Maine Historical Society
Coll. 423, Box 6a/45
13708

50 NO. 2 WESTBROOK, WINDHAM & NAPLES RAILWAY
Maine Historical Society
Photographs--Westbrook

52 THREE-MASTED SHIP
Maine Historical Society
Coll. 562-Scrapbook
11602

53 CABIN OF THE BEATRICE
Maine Historical Society
Coll. 404, Box 28
6288

54 BLUE HILL FAIR
Library of Congress
LC-USZ62-104190

56 ORR'S ISLAND WHARF
Maine Historical Society
Coll. 448
6492

57 STANLEY STEAMER
Maine Historical Society
Coll. 404, Box 28
6293

58 SNOWSHOE TRAIN
Maine Historical Society
Coll. 548 v. 6
6032

59 BASEBALL IN WATERVILLE
Maine Historical Society
Coll. 797
7723

60 OTTAWA HOUSE
Maine Historical Society
Coll. 423, Box 3/14
12157

61 PORTLAND FERRY
Maine Historical Society
Coll. 242, Box 35-19
7642

62 TUG ON THE WAYS
Maine Historical Society
Coll. 242, Box 29, 5/5
7639

63 PORTLAND HEAD LIGHT
Maine Historical Society
Coll. 797
13848

64 OAK POINT CAMPS
Maine Historical Society
Photographs--Portage Lake
5569

65 CENTER SCHOOL HOUSE
IN ATKINSON
Maine Historical Society
Coll. 90, 18/4
7798

66 PRIMARY STUDENTS
DANCING
Maine Historical Society
Coll. 808, F.6
10393

67 RAILROAD EMPLOYEES
Maine Historical Society
Photographs—Portland—
Railroads—Electric railroads
6024

68 RIDING CLUB
Maine Historical Society
Coll. 404, Box 28
6290

69 PRESIDENT ROOSEVELT
VISITS PORTLAND
Maine Historical Society
Photographs--Portland--
Famous People
156

70 PERCY AND SMALL
SHIPYARD
Maine Historical Society
Photographs--Bath
4197

72 THREE ALARM FIRE AT
BROWN'S WHARF
Maine Historical Society
Coll. 242, Box 35 fl. 35/41
12406

73 WINTER HARNESS
RACING
Maine Historical Society
Photographs--Poland Spring
5479

74 AUTORACING
Maine Historical Society
Photographs--Old Orchard
Beach
1129

75 FISKE HOUSE
Maine Historical Society
Coll. 423, Box 3/6
12151

76 PORTLAND FIRE
Maine Historical Society
Photographs--Portland--City
Halls
6884

77 KNOX AUTOMOBILE ON
CASCO BAY
Maine Historical Society
Coll. 242, Box 30/5
11526

78 NOON HOUR
Library of Congress
LC-DIG-nclc-01696

79 NOON HOUR
Library of Congress
LC-DIG-nclc-01694

80 DEERING OAKS PARK
Maine Historical Society
Coll. 1920, Box 2 #161
7450

81 LUBEC PUBLIC LANDING
Maine Historical Society
Coll. 1670, Env. 3
11410

82 BRUSH AND COLE
AUTOMOBILES
Maine Historical Society
Coll. 242, Box 30, 1-1
8648

83 PORTLAND COMPANY
MECHANICS
Maine Historical Society
Coll. 242, Box 30, 10-3
8682

84 PINE BEACH
Maine Historical Society
Coll. 560, #1223
7769

85 SHIP CONSTRUCTION
Maine Historical Society
Coll. 242, Box 39 20/1
11915

86 THREE YOUNG
LABORERS
Library of Congress
LC-DIG-nclc-00972

87 SARDINE CANNERIES
Library of Congress
LC-DIG-nclc-00939

88 CARTONERS
Library of Congress
LC-DIG-nclc-00934

90 WORKERS
Library of Congress
LC-DIG-nclc-00945

91 CUTTING SHED
Library of Congress
LC-DIG-nclc-00944

92 BLACK HEAD
Library of Congress
LC-USZ62-121698

93 NAN DE GALLANT
Library of Congress
LC-DIG-nclc-0094494

94 SANFORD HIGH SCHOOL
Maine Historical Society
Photographs--Sanford
5572

95 KNOX-MARTIN TRACTOR
Maine Historical Society
Coll. 242, Box 30 9-6, GPN
Box 128, 18
12019

96 SKI RACERS
Maine Historical Society
Coll. 155, 3/2
6279

97 WOODSMEN
Maine Historical Society
Photographs--OS--Box 7
1199

98 WRITING ON THE BOARD
Maine Historical Society
Coll. 808, Fl. 6
10396

99 HERRING DRYING
Maine Historical Society
Coll. 1670, FF 2
11417

100 NORTH PARISH
CONGREGATIONAL
CHURCH
Maine Historical Society
D-155
9752

101 KINGFISHER FISHING
VESSEL
Maine Historical Society
Coll. 554
7641

102 HATS AT THE A. H.
BENOIT CO.
Maine Historical Society
Coll. 242, Box 29 5-6
7745

104 CHAPMAN SCHOOL
PATRIOTISM
Maine Historical Society
Photographs--Portland--
Schools--Lincoln
10587

105 EAST MACHIAS
Maine Historical Society
Coll. 448
6584

106 PORTLAND RAILROAD
COMPANY CAR
Maine Historical Society
Photographs—Portland—
Railroads—Electric Railroads
6019

107 SANTA CLAUS VISITS
NORTH SCHOOL
Maine Historical Society
Coll. 808, fl. 6
6120

108 KING'S CHAPEL
Maine Historical Society
Coll. 1826, Box 1/18
17687

109 POURING LIQUOR
Maine Historical Society
Coll. 2093, Box 2/6
16100

110 FIFTH INFANTRY BAND
Maine Historical Society
Coll. S-765, 28/17
17874

111 BAY OF NAPLES INN
Maine Historical Society
Coll. 448
6702

112 SWIMMERS IN NEWAGEN
INN
Maine Historical Society
Coll. 448
6699

113 LECTURE HALL
Maine Historical Society
Coll. 249, Box 1
5647

114 TYPING CLASS
Maine Historical Society
Coll. 249, Box 1
5646

115 AUTO REPAIR CLASS
Maine Historical Society
Coll. 249, Box 1
5640

116 PORTLAND STREET
LIGHTS
Maine Historical Society
Coll. 242, 40/8
5635

117 GANNETT PUBLISHING
COMPANY
Maine Historical Society
Coll. 2010, Box 16
6163

118 MAIN STREET
Maine Historical Society
Photographs--Lewiston
10372

119 PRESIDENT HARDING
Maine Historical Society
Coll. 448
6752

120 LAST DAY OF A STREET
RAILWAY
Maine Historical Society
Coll. 865
14228

121 SKI JUMPER IN
PORTLAND
Maine Historical Society
Photographs—Portland—
Sports
81

122 RAYVILLE SCHOOL
Maine Historical Society
Coll. 552
7684

123 EASTLAND HOTEL
Maine Historical Society
Eastland Hotel Photograph
Collection
12433

124 SARGENT SNOW LOADER
Maine Historical Society
Coll. 242, 40B, 16-25a
8945

125 BE KIND TO ANIMALS
WEEK
Maine Historical Society
Coll. 1949
17671

126 CHILDREN PLAYING
BASEBALL
Maine Historical Society
Photographs--Portland--
Sports
116

127 JORDAN POND
Maine Historical Society
Coll. 548, Box 1, v.1
15012

128 DAM ALONG THE UNION
RIVER
Maine Historical Society
Coll. 448
6591

129 LOBSTERMEN ON ORR'S
ISLAND
Maine Historical Society
Coll. 448
6518

130 PLUGGING CRUSHER
CLAWS
Maine Historical Society
Coll. 1670, FF 2
11158

131 OLD NEP
Maine Historical Society
Coll. 1670, Env. 2
7758

132 EAST MACHIAS
Maine Historical Society
Coll. 448
6589

133 UTILITY POLE WORK
Library of Congress
LOT 7264

134 NAPLES RESTAURANT
Maine Historical Society
Coll. 448
6615

135 STATE THEATER
Maine Historical Society
Photographs--Portland--
Theaters
12894

136 SUMMER CAMP
Maine Historical Society
Coll. 448
6595

137 GOON CHILDREN
PLAYING
Maine Historical Society
Coll. 2080, Box 5
10375

138 GIRLS PLAYING
BASKETBALL
Maine Historical Society
Coll. 448
6831

139 POPHAM BEACH
Maine Historical Society
Coll. 448
6524

140 MODERN SARDINE CARRIERS
Maine Historical Society
Coll. 1670, Env. 3
7716

141 GETTING READY TO UNLOAD WEIR
Maine Historical Society
Coll. 1670, Env. 2
7660

142 SEINING THE SARDINE WEIR
Maine Historical Society
Coll. 1670, Env. 1
11407

143 LORING, SHORT & HARMON
Maine Historical Society
Photographs--Portland—Business Enterprises
20264

144 SAMOSET HOTEL
Maine Historical Society
Coll. 448
6565

145 FORMER VANDERBILT YACHT
Maine Historical Society
Coll. 1670, Env. 3
7722

146 A STRIKE!
Maine Historical Society
Coll. 448
6696

147 ON KATAHDIN, 1931
Maine Historical Society
Coll. S-6196, Misc. Box 178/1
12869

148 AUDIENCE
Maine Historical Society
Coll. 1814, Box 1/10
17811

149 WEIGHING IN
Maine Historical Society
Coll. 808, Fl. 6
6122

150 VETERANS
Maine Historical Society
Photographs--Military--Veterans
4164

151 FILLING FISH CANS
Maine Historical Society
Coll. 1670, FF 2
11194

152 MAIN STREET
Maine Historical Society
Coll. 448
6587

153 FISHING, PLEASANT POINT
Maine Historical Society
Coll. 1670, Env. 3
7910

154 SARGENT, LORD AND CO.
Maine Historical Society
7649

155 LOBSTER TRAPS AND WOMEN
Maine Historical Society
Coll. 1670
7667

156 NEW LOBSTER-REARING STATION
Maine Historical Society
Coll. 1670, Env. 1
7651

157 CLIFF HILL AND DOG
Maine Historical Society
Coll. 553, No. 2
1387

158 BANGOR HYDROELECTRIC
Maine Historical Society
Bangor 46
6016

160 AERIAL VIEW
Maine Historical Society
Photographs--Portland--Views
21041

161 MEMORIAL DAY PARADE
Maine Historical Society
Coll. 90, 18/2
7804

162 COVERED BRIDGE
Maine Historical Society
Coll. 448
6583

163 COW AND MOOSE
Maine Historical Society
2006.238_001, Coll. 4015
22504

164 KATHARINE RIDGEWAY CAMP
Maine Historical Society
Coll. 1921, f. 22
9869

165 CAMPERS
Maine Historical Society
Coll. 448
6620

166 CUSHMAN'S BAKERY
Maine Historical Society
2004.391
16534

167 WAR PROTEST
Maine Historical Society
Photographs--Portland--War Efforts
21080

168 WOMEN'S ARMY CORPS PARADING
Maine Historical Society
Coll. S-6135, Misc. Box 187/12
17243

169 SOLDIERS
Maine Historical Society
Coll. S-5695
75

170 ARMY CORPS
Maine Historical Society
Photographs--Portland--Processions
17241

171 CHANDLER'S BAND
Maine Historical Society
Photographs--Portland--Processions
20321

172 BIRTHPLACE OF HANNIBAL HAMLIN
Maine Historical Society
Photographs--Paris Hill
5582

173 PRESQUE ISLA PARADE
Maine Historical Society
Photographs--Presque Isle
197

174 GUY P. GANNETT
Maine Historical Society
Coll. 2010, Box 14/3
6117

175 FAMILY CAMPING
Maine Historical Society
Coll. 448
6596

176 CORNFIELDS
Maine Historical Society
Coll. 448
6575

177 THE BRIDGTON NEWS
Maine Historical Society
Photographs--Bridgton
5975

178 SWIMMERS AT DAMARISCOTTA
Maine Historical Society
Coll. 448
6599

179 MONUMENT SQUARE
Maine Historical Society
Photographs--Portland--
Streets--Monument Square
20895

180 COLUMBIA MARKET
Maine Historical Society
Photographs--Portland--
Streets--Forest Avenue
1204

181 OAKHURST DAIRY
Maine Historical Society
Photographs--Portland--
Neighborhoods--Deering
20276

182 UNIVERSAL LAUNDRY WAGON
Maine Historical Society
Photographs--Portland--
Business enterprises
20263

183 UNION STATION
Maine Historical Society
Photographs--Portland--
Railroads--Union Station
22436

184 MRS. DORIS MACDOUGAL
Library of Congress
LOT 7508

185 BIRD'S-EYE
Maine Historical Society
Photographs--Newport
5574

186 SEAGRAVES LADDER TRUCK
Maine Historical Society
Photographs--Norway
5541

187 ATHERTON FURNITURE STORE
Maine Historical Society
Photographs--OS
10767

188 WADSWORTH-LONGFELLOW HOUSE
Maine Historical Society
Coll. 2113
11423

189 PORTLAND BREAKWATER
Maine Historical Society
Coll. 445, Box 1
13057

190 PARK STREET BLOCK
Maine Historical Society
Coll. 445, Box 1
13058

191 INTERNATIONAL BRIDGE
Maine Historical Society
Photographs--Lubec
5549

192 WELCOME BANNER
Maine Historical Society
Photographs--People--
Johnson
9540

193 CHEERLEADERS
Maine Historical Society
Photographs--South
Portland--Schools
21648

194 BENOIT'S CLOTHING STORE
Maine Historical Society
Coll. 554
7873

195 AFTER PRESERVATION, 1975
Maine Historical Society
STM Car 31_08
8782

196 PLANE RESCUE
Maine Historical Society
Coll. 1880, 1/4
5630

197 BEGIN'S GARAGE
Maine Historical Society
Coll. 1880, 1/4
5625

198 BOYS COOLING OFF
Maine Historical Society
Coll. 1880, 1/4
10644

199 TRAIN DERAILMENT
Maine Historical Society
Coll. 1880, 1/4
10647

200 KENNEDY
Maine Historical Society
Coll. 1880, 1/8
10657